The Changing Shape of Art Therapy

of related interest

The Revealing Image
Analytical Art Psychotherapy in Theory and Practice
Joy Schaverien
ISBN 1 85302 821 5

Healing Arts
The History of Art Therapy
Susan Hogan
ISBN 1 85302 799 5

Art Therapy – The Person-Centred Way, 2nd Edition
Art and the Development of the Person
Liesl Silverstone
ISBN 1 85302 481 3

Art Therapy, Race and Culture
*Edited by Jean Campbell, Marian Liebmann, Frederica Brook,
Jenny Jones and Cathy Ward*
ISBN 1 85302 578 X pb
ISBN 1 85302 579 8 hb

Tapestry of Cultural Issues in Art Therapy
Edited by Anna R. Hiscox and Abby Calisch
ISBN 1 85302 576 3

Art Therapy in Practice
Edited by Marian Liebmann
ISBN 1 85302 058 3 pb
ISBN 1 85302 057 5 hb

Art Therapy with Offenders
Edited by Marian Liebmann
ISBN 1 85302 171 7

Arts Therapists, Refugees and Migrants
Reaching Across Borders
Edited by Ditty Dokter
ISBN 1 85302 550 X

Foundation and Form in Jungian Sandplay
Lenore Steinhardt
ISBN 1 85302 841 X

The Changing Shape of Art Therapy

New Developments in Theory and Practice

Edited by

Andrea Gilroy and Gerry McNeilly

Jessica Kingsley Publishers
London and Philadelphia

First published in the United Kingdom in 2000 by
Jessica Kingsley Publishers Ltd,
116 Pentonville Road,
London N1 9JB, England
and
325 Chestnut Street,
Philadelphia, PA 19106, USA.

www.jkp.com

© Copyright 2000 Jessica Kingsley Publishers

Library of Congress Cataloging in Publication Data
A CIP catalog record of this book is available from the Library of Congress

British Library Cataloguing in Publication Data
A CIP catalogue record of this book is available from the British Library

ISBN 1 85302 939 4

Printed and Bound in Great Britain by
Athenaeum Press, Gateshead, Tyne and Wear

Contents

Introduction

The Changing Shape of Art Therapy presents key issues in the work of leading art therapy theoreticians in Britain, all of whom have helped to shape the development of art therapy theory and practice over the last fifteen years. We hope that it will add an exciting new dimension to the development of art therapy theory, underpinned as it is by the cornerstones of individual art therapy, group art therapy, aesthetics and clinical practice.

The idea for the book came from the first two 'Theoretical Advances in Art Therapy' (TAAT) conferences, held in Birmingham in 1993 and 1995. Proposed by McNeilly in 1991 at an Annual General Meeting of the British Association of Art Therapists, the conference is now a firmly established, three-yearly event. The aim of the conference series was to create a venue in which art therapy theory could be addressed. At that time the art therapy literature had begun to grow but the profession was without a regular, collective arena for the exploration and elaboration of theory that was particular to the discipline, previous art therapy conferences having focused on particular issues such as the impact of therapy on the creative process (British Association of Art Therapists 1983) and research (Gilroy *et al.* 1989; Kersner 1990). Most of the chapters herein were initially presented as papers at one or other of these two conferences, but here the authors have expanded and developed their ideas.

It will be seen that the fundamental significance of our primary discipline of art, and of the art in art therapy, permeates this book. This emerged as a dominant theme in the early stages of the book and, in our view, reflects an interesting development in art therapists' thinking about their work. Authors pay close attention to the art-making process (Dalley, Case, Killick) and to the aesthetic responses of art therapists (Dalley, Schaverien) and their clients (Case, Schaverien). Several contributors (Dalley, Skaife, McNeilly) speak to the importance of holding the tension between what are sometimes

construed as opposites – art and therapy, images and speech, beauty and ugliness, subjectivity and objectivity, doing and thinking – and arguing that the dynamic interplay between these elements is inherent to the practice of art therapy. The theoretical developments described seem to us to represent a deepening integration of art therapists' thinking about art with their thinking about psychotherapy, resulting in new formulations and new 'shapes' within which to think about the theory and practice of art therapy.

The opening chapter, '"Our Lady of the Queen": Journeys around the maternal object' by Caroline Case, was the keynote address to the first 'Theoretical Advances in Art Therapy' Conference in 1993. Case illuminates the environmental factors that surround art therapists and their clients. She discusses the projective processes of three children in response to a picture of Jane Seymour by Hans Holbein and describes how imitation and identification, through the copying of this image as well as drawings of herself, develop into what she calls a 'refractive transference'. Case develops her ideas about silence, countertransference and aesthetics, relating the art therapist's looking at the art work to the maternal gaze and to containment. She also explores the aesthetic properties of a silence in which client and therapist have matched experiences of union and distinctiveness, relating this to the internal world of the infant being given form by the mother that gives rise to subsequent moments of aesthetic response to painting and poetry.

In her clinical examples Case describes the children's split reaction of fear and affection to the Holbein, showing how the threatening and benevolent aspects of 'Queenie's' watchful gaze enables a play between reality, fantasy and dream, and past, present and future to occur. In this context Case also revisits the triangular relationship in art therapy, but in terms of strangulation (rather than triangulation) within the potential space. She explores the aesthetic dimensions of copying the Holbein; it may be an attempt to make something one's own, an idealisation, identification and emulation of the external world, or an act associated with cheating, dishonour and a lack of originality. Other responses to the Holbein elaborate Case's description of the refractive transference as a term that encompasses the thinking, containment, projections and transferences of very disturbed children that may be split between the art therapist and different aspects of the setting, all of which involve 'journeys around the maternal object'. Thus Case describes a new star shape which, she suggests, offers more room for manoeuvre within the therapeutic space.

Joy Schaverien's chapter 'The triangular relationship and the aesthetic countertransference in analytical art psychotherapy' addresses similarities

and differences in British art therapy practice. She asks what exactly art therapists mean when they refer to the 'triangular relationship', a term that has become common currency in art therapy theory. Schaverien explores this familiar shape and proposes that the triangle of image, client and art therapist is constellated differently according to the client group and the particular environment in which the therapy occurs. Schaverien takes the issue further with her discussion of the profession's name – art therapy or art psycho-therapy – and suggests that perceptions may differ according to the setting and the client group, exploring the effect this may have on the art therapist's approach to transference and countertransference. Schaverien re-states the stages of the triangular relationship, each involving a gaze, the life *in* the picture and the life *of* the picture, but goes on to describe the activation of what she calls the 'dynamic field'. However, this field is not always active and depends on differences within the triangular constellations, the primacy of the image and the depth of either the art-making process or the therapeutic relationship.

Schaverien also discusses the aesthetic effects of imagery that are central to some of the forms of art therapy that she describes. She considers the familiar concepts of diagrammatic and embodied images (Schaverien 1991) which, she suggests, are likely to be of lesser and greater aesthetic quality respectively. According to Schaverien it follows that the embodied image becomes a significant agent of healing as it gives rise to an aesthetic engagement, and thus a dynamic field within the triangulation, that is more distinguishable than that of the diagrammatic image. Schaverien expands on the three categories of art therapy she has identified (art therapy, analytical art psychotherapy, and art psychotherapy) through exploration of the differing stages of art-making and the therapeutic process, examining the role of the therapist in relation to these stages and to the primacy of the image. She emphasises the primacy of the art object in all, but distinguishes between them in terms of the differing figure/ground relationships. This she interweaves with theories around triangulation, the history of the profession and her own personal development as an art therapist. Schaverien suggests that differences in art therapy practice that are reflected in the debate about the name of the profession create an opportunity for creative discord.

'Back to the future: Thinking about theoretical developments in art therapy', by Tessa Dalley, was the keynote address to the second TAAT Conference in 1995. She makes reference to the film of the same name and to the first TAAT Conference keynote address (Case 1993), and in so doing demonstrates her chapter's theme of having to look back in order to go

forward. Certain key questions drive the chapter: as well as 'What if...?' there is 'What is happening now?' and 'What am I doing at this moment?' Dalley emphasises the importance of the momentum of time, of a continuum of development that occurs for the human infant as it separates from parental figures, drawing parallels between this and the development of art therapy as a profession. She identifies the debates that have characterised the development of art therapy in Britain, outlining the principal theoretical frameworks and new areas of practice, discussing the present changes in mental health care that impinge on the profession and its practice. Dalley considers 'critical moments' and events in the life of individuals and in the life of the art therapy profession that mark the passage of time and wonders where we might be if these moments had not occurred. She describes how such critical moments are central to clinical work and how they punctuate the development of the profession, claiming there is now space within art therapy for a variety of initiatives, for tension and for difference.

The space within and the notion of containment, container and the contained are central to Dalley's exploration of the tensions between making and not making images, the effects of this on the art therapist, and the attack on thinking when 'floods of images' are produced. Dalley describes how this can give rise to feelings of intrusion which threaten containment, and considers the notion of a claustrophobic claustrum in terms of the art therapy room and the session itself, developing an idea similar to Case's exploration of triangulation and strangulation. Dalley relates her notion of a claustrophobic claustrum to casework and develops the idea of finding sanctuary, of having an enveloping skin that holds and can be found through the image. Dalley shows how images can simultaneously express claustrophobic anxieties, the need to escape and the need for containment, and discusses the capacity to symbolise, and the dire consequences of an inability to do so, linking this to the fear of devouring and/or being devoured. She also pays attention to the aesthetic responses of the art therapist that are engendered by the client's art-making process as well as by the completed work, elaborating upon this to include discussion of the Tate Gallery's 1995 exhibition 'Rites of Passage'.

Katherine Killick's chapter 'The analytical art psychotherapy setting as a containing object in psychotic states' again demonstrates the significance of the environment in which clinical work takes place. She shows how the theory underpinning art therapy with psychotic people has developed from the work of the pioneers of the profession. Her central point is that there is potential for containment in the art therapy room itself, likening the room to

a containing skin wherein primitive processes can be absorbed by the physical environment and the concreteness of the art materials, a process which enables symbolic representation to evolve. Killick shows how, as art therapy progresses and the art materials come to play a mediating role, there is a strengthening of ego structures which enables a sense of self to emerge. She uses the concepts of intrusive identification and projective identification to understand the early stages of art therapy with psychotic clients and to describe how clients are able, through art therapy, to move from one to the other. Killick demonstrates how the art therapy room is able to accommodate a wide range of intrusive activity, and shows how psychotic clients signal rather than symbolise their ongoing sense of catastrophe within the matrix that is the art therapy room.

Sally Skaife, in her chapter 'Keeping the balance: Further thoughts on the dialectics of art therapy', debates Schaverien's formulations about transference to the image and the series of frames in which art therapy takes place. She uses dialectical theory to develop ideas about the interplay between the image-making process in art therapy and the verbal therapeutic relationship, drawing upon work with both groups and individuals. She explores whether there is conflict between art and verbal psychotherapy in groups, or if the issue is more to do with polarities or a duality of theoretical models. The ensuing tension is related to the dominance of words and the subordination of images, involving a probable loss of aesthetic experience in the making and viewing of art work. However, Skaife argues equally that the subordination of verbal discourse might involve the group itself losing the potential for the expression and resolution of conflict. Skaife coins the phrase 'eyes up, eyes down' to encapsulate this tension, 'eyes down' referring to a private, inner dialogue with the self and the 'eyes up' to a public, more precise dialogue with others. This leads her to explore differences between group and individual art therapy and adds another element to the discussion of the triangular relationship between image, the client and the art therapist that permeates this book.

Skaife also discusses the quality of attention art therapists give to clients' completed art work, and to art therapists' relationship to their own art work. She explores the dynamic administration of art therapy groups in an essentially physical sense, i.e. the quality of art materials and arrangement of the space. Like Schaverien, Skaife also addresses the different balance between verbal and non-verbal exchange to be found in various client groups, and suggests that the creative and therapeutic potential of this be harnessed in a

dialectical framework that accepts opposites as part of a dynamic process of change.

Gerry McNeilly, in his chapter 'Failure in group analytic art therapy', considers the equations of success with beauty and failure with ugliness. He considers the difficulties in addressing 'failure' in art therapy clinical practice and hence its limited discussion in the literature, but says that much can be learnt from exploration of work that 'goes wrong'. McNeilly suggests that the polarities of success and failure, health and illness, good and bad, and beauty and ugliness all contribute to a continuum of art therapists' clinical experience. He further suggests that there is a dynamic basis to clinicians' perceptions of their failures, as well as their successes, as they are based in subjectivity and can be linked to aesthetic appreciation. McNeilly considers this in the everyday context of clinical practice: of an aesthetic appreciation of clients' imagery which depicts, either directly or obliquely, painful feelings; of the 'happy accidents' in art-making which lead to an aesthetically satisfying new piece of work; of insight and change following open exploration of the therapist's 'mistakes' during the course of treatment. He also considers how the failure to achieve a primary objective of the therapy may be a secondary gain for the client, illustrating the importance of differing perceptions of success and failure in art therapy.

McNeilly describes the likely areas of error that can contribute to a failure in an art therapy group, such as faulty pre-group preparation and assessment, the constellation of the group members and the leader/s, drop-out, and the mis-timing of therapist interventions. Of particular importance is McNeilly's consideration of transference and countertransference responses and enactments which may lead to 'unsuccessful' therapy; these he illustrates through a case study of a 'failed' art therapy group. He describes the group as it started and discusses his responses as it immediately began to falter, continuing through to his eventual decision to close the group. McNeilly describes the ambivalence he and the group members felt about its cessation, and the eventual successful recognition of the dependent powerlessness that had dominated the art therapy group process. He discusses the group members' initial perception of failure through being unable to cope without help and entering therapy, and a sense of their later recovery and empowerment through being part of a 'failed' therapeutic encounter. This is contrasted with the art therapist's sense of inadequacy and incompetence, feelings which had some significance during times that are dominated by health-care economics, resulting in a fear of reprimand and great difficulty in working with powerfully negative feelings and thinking about what had

happened. McNeilly states that the ugliness of mistakes and errors that lead to failure are an inevitable, a necessary, part of the totality of clinical work. He concludes that for an experience of art therapy, or of art, to be satisfying for the client and the art therapist, and for the artist and the viewer, it has to be a whole which encompasses good and bad, ugly and beautiful – a view of art therapy akin to Klein's depressive position.

In their chapter 'Teachers, students, clients therapists, researchers: Changing gear in experiential art therapy groups', Dudley, Gilroy and Skaife also explore the points at which experience converges, separates and is different, and consider the influence of the total context in which the work of the art therapist takes place. The research described in this chapter took place within the context of higher education and explores the varying roles that the authors and members of their experiential art therapy groups encounter within art therapy education. The focus is on the balance between therapy and education in experiential learning, and the way in which tutors become role-model art therapists for trainees. Dudley *et al.* discuss the influence of organisational issues on their day-to-day work and particularly on their own art practice, and how this in turn is transmitted to students. They explore role-modelling in the context of transference and countertransference issues and the difference in their personal styles of leadership, and describe how they became aware of feelings of rivalry and envy, as well as anxiety about their adequacy as educators and clinicians. They also consider the influence of occupational motivation and transference in all aspects of art therapy education and describe how these can be worked with through the art made in experiential art therapy groups.

Dudley *et al.* outline their research methodology of collaborative inquiry and the use of continuing cycles of reflection and action. The exploratory, group-based model of research is reviewed and compared with the processes of groups in general with reference, for example, to leadership function and the containment of powerful emotions. This study of three peer group conductors, their working environment, and their practice as art therapy experiential group leaders, is related to the interplay of macro- and micro-systems, to other groups and subgroups within the organisation. Inherent to the discussion are the multiple and interconnecting roles of staff and students inside and outside the immediate context of an art therapy training course; issues such as the changes in mental health care, in art therapy clinical practice and in higher education funding are all ultimately part of both staff and student experience in experiential art therapy groups.

Containment plays a central role in the practice of art therapy. In this collection it is explored in a variety of ways, both within the therapeutic arena itself (Dalley, Case) and outwith the therapy in terms of the working and professional contexts (Dalley, Killick, McNeilly, Dudley *et al.*). What emerges is not only the importance of the therapeutic containment of the clients *by* the art therapist, but also the significance of the containment *of* the art therapist. The physical context of the session within an appropriate art room (Killick), the working environment at large (McNeilly, Dudley et al.) and the professional association BAAT (Dalley) are each identified as important arenas where conflict and tension are experienced and must be explored so that art therapy can continue to develop in the face of rapidly changing health-care services. It is noteworthy that such issues are high-lighted in this collection that has emerged from an arena, the TAAT Conference, originally designed to encourage creative and open dialogue between art therapists about the theory that underpins their work. It has enabled practitioners to speak to new ideas in the theory and practice of art therapy, perhaps because the arena of the conference itself is able to offer containment for the changing shape of art therapy.

References

British Association of Art Therapists (1983) *Inscape: Journal of Art Therapy*, April.
Gilroy, A., Hoskyns, S., Jenkyns, M., Lee, C., and Payne, H. (eds) (1989) 'Arts therapies research.' *Proceedings of the First Arts Therapies Research Conference*. City University, London.
Kersner, M. (ed.) (1990) 'The art of research.' *Proceedings of the Second Arts Therapies Research Conference*. City University, London.
Schaverien, J. (1991) *The Revealing Image*. London: Routledge.

'Our Lady of the Queen'
Journeys around the Maternal Object

Caroline Case

Introduction

This chapter is a continuation of a particular thread of inquiry exploring the dynamics around the making of images in therapy. It is in some way a series of questions about what else is happening in the room while paintings are being made. I have become fascinated over the last seven years by children's responses to a picture of Jane Seymour by Holbein on the wall of the therapy room (Figure 1.1). The picture was left on the wall of the room when I moved into it but it is of note that I chose not to remove it. I started off not particularly liking or disliking it, but have grown rather attached to it, coming to value its firm structure, along with the feeling that in each session it represents a sense of the unknown, that 'anything can happen'. This may correspond to the quality of the sketch as 'unfinished'. She fluctuates, sometimes representing 'Art', the third person who looks in on the therapy session, bringing a creative potential. At other times, a disciplined holder of analytical boundaries; an imaginary supervisor, a little severe, who accompanies me into the therapy situation and nudges me at moments of inattention; a benign presence; and probably all of these reflect aspects of myself while working. The room in which I work is kept the same as far as possible and unaltered between sessions, so that there is no children's work on the wall, unless within a child's session, when it would be put back in their folder at the end. The Holbein picture has stimulated my thoughts about the transference/countertransference dynamic and projective processes in therapy between the four corners of the picture itself, child, therapist and image made, as I hope the following chapter will show.

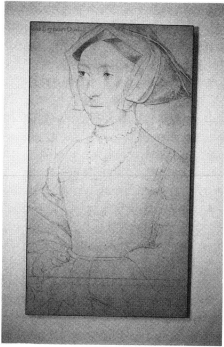

Figure 1.1 Hans Holbein the Younger – Queen Jayne Seymour

A review of progress in thinking about what else is happening while pictures are being made sets the background from which this present chapter has evolved. This is followed by a brief exploration of the Kleinian paranoid/schizoid position to give a theoretical framework to the split-ting-off and projection of parts of the self into parts of the room and its contents. Three different clinical examples are presented to challenge the idea of a triangular relationship in art therapy with children; could another concept be more useful? The Holbein is drawn by each of the children discussed and this gives opportunity also to reflect on copying, imitation and identification. Near the end of the chapter there is a discussion of objects and painting in therapy. In a sense a case is built up for finding different concepts in which to formulate ideas when working with children in a paranoid/schizoid state of mind. This may be shown by the splitting of self and split transference to the therapist and an aspect of the room, or by a manic defence, so that one finds oneself in a roundabout of activity involving denial, attacks and idealisation in rapid succession. I suggest a more useful way to conceptualise this than a triangular relationship is to think of it as a 'refractive transference'. I have in mind the image of water, where the child's

projections and transference hit the surfaces of the therapy room/therapist and refract in all directions, i.e. often obliquely. Water as the medium suggests lack of any firm structure in the child's mind, and the liquid state of psychic contents that can pour out, uncontained. Here one is working with more primitive processes where containment is not yet possible, so that we are before the possibility of potential space and a triangular relationship.

The concepts of an internal world and an external world can be a guide to us but are in fact rather arbitrary and shifting in practice. The concept of a triangular relationship in art therapy has become so established that it may misleadingly suggest that this is always so. Experience in therapy can be contained between client/therapist/picture, unless disturbance in clients creates a situation where internal world material frequently seems to shoot about the room and external objects are experienced internally, as well as internal ones externalised onto paper.

Review

An earlier paper (Case 1994) explored the importance of the therapist's own art work outside the session and awareness of how aspects of it were sometimes a 'reflective countertransference' in relation to difficulties with particular children. There are particular times in therapy where projective processes are very powerful and projective identification is being used massively by the client, where client's and therapist's psyches intermingle and both have to grow to accommodate each other. The client learns the language of the therapist and the therapist learns to recognise herself in the client and has work to do to accept, often unwillingly, and own these aspects if she is going to be able to help the client understand them too. This can happen both when clients are painting as part of their therapy and also, as I explored in the paper, when they are not able to paint and I am painting outside the session in order to 'see', to externalise their projection, to reflect on and reflect it.

It is helpful sometimes to think of the client and therapist meeting as two cultures which have to learn about each other and start off very confused as they both speak their different languages with many misunderstandings. Gradually the therapist learns how this particular client expresses his difficulties and the client learns that images and words can be found for unthinkable feelings previously expressed symptomatically.

The second aspect of this paper was to suggest that sometimes the image made is a *mise en scène* creation – so that child and therapist can find

themselves in a whole-made environment of the transformed setting. This is the art therapy room as installation. The difficulty here is to keep a space from which one can make observations, while sometimes being incorporated as part of the work of art (Case 1994).

A further line of enquiry (Case 1995a) has been to explore the silences that can occur before a painting is made, while painting or afterwards – discovering that when we lack the word we inhabit the silence, which becomes imbued with the affect we are unable to express verbally. The silences of our patients then become available to be understood through the countertransference in a way similar to how we might understand images for the quality they arouse in us. The countertransference here has an aesthetic quality in an absolute way, in that the silence forms a picture in our mind by our perception of the sensation of being in that silence. In a sense, the countertransference is always an aesthetic experience as we respond to the sensations evoked in us by the patient. We experience what is outside inside, as we bring our own response to it and then separate from it, as we understand. Every act of perception and sensation is imaginative and this is the essence of aesthetic experience, that an exchange takes place. This paper explored the need to stay with silence when experiences have become encapsulated beyond words and how the silence might be the first created image, long before an image is able to be made (Case 1995a).

This was the start of an interest in children's use of an aspect of the setting, a picture of Jane Seymour by Holbein on the wall. In this and a later paper the aesthetic moment in the transference was explored in terms of the experience of beauty and the corresponding inner transformation as we have that external experience of looking at something we find beautiful (Case 1996). For both children discussed, the experience was of some aspect of maternal containment and gaze – seeing mother looking at them with love of which they had an incomplete experience as babies. The latter paper showed how an object that is familiar and usually in the room – because of the constant environment – can be experienced in a new way. The two children discussed were both moved to paint or make for the first time in their therapy, experiencing some aspect of the therapist in the picture on the wall which was safer than having that experience directly with the therapist. Some inner aspect of experience was located there and I was also interested in the part that idealisation had to play and the need for idealisation for very deprived clients as a necessary stage. In an aesthetic moment there is a phase of union, a matching of experience and also a separating out and appreciation of distinction and

separateness. Both children were moved and able to paint alone after the experience of matching union with the picture on the wall.

Bollas explores the first aesthetic experience as the experience of the mother's 'form of relating': early aesthetic experiences with mother are transforming ones, as she comes to the baby, ending fears, changing unpleasant physical sensations of wetness, hunger and cold to good experiences (Bollas 1987). Bollas discusses how the mother processes a baby's existence by modes of being-with, as a form of dialogue, prior to the baby's ability to process existence through thought. He is really saying that the uncanny moments of being held by a poem or picture rest on those moments when the infant's internal world would be partly given form by the mother: '...each aesthetic experience is transformational and an "aesthetic object" seems to offer an experience where self-fragmentation will be integrated through a processing form' (Bollas 1987, p.33). Observing the children's experience with the Holbein picture suggested that the objects made following the aesthetic experience seemed to be able to express and integrate very dissonant and painful aspects of their experiences.

This series of papers has been moving around the centre of the therapy experience of client, image and therapist; sometimes outside the session, the therapist's 'reflective countertransference'. They have also considered the importance of the transformation of the whole setting, the client's use of *mise en scène* in communication, as well as the evocation of image through silence and the children's use of one aspect of the setting – a picture on the wall of the room.

The paranoid/schizoid position

Observations of different clients in the room suggest that it is children who are splitting off aspects of their experience, in Kleinian terms in the paranoid/schizoid position (Klein 1946), who are likely to have such intense transference to aspects of the setting.

> The paranoid/schizoid mode of generating experience is based heavily on splitting as a defence and as a way of organising experience. Whereas the depressive mode operates predominantly in the service of containment of experience, including psychological pain, the paranoid/ schizoid mode is more evenly divided between efforts at managing psychic pain through the defensive use of omnipotent thinking, denial and the creation of discontinuities of experience.

In a paranoid/schizoid mode, the experience of loving and hating the same object generates intolerable anxiety, which constitutes the principal psychological dilemma to be managed. This problem is handled in large part by separating loving and hating facets of oneself from loving and hating facets of the object. Only in this way can the individual safely love the object, in a state of uncontaminated security, and safely hate without the fear of damaging the loved object. (Ogden 1992, p.19)

The children's experiences of life would make it very difficult for them to be able to bear intimate communication directly to the therapist and for this reason aspects of the setting can become highly significant at particular phases in therapy. The effect of changes to the setting on the psychotic child has been noted in analytic literature – I would broaden these comments to include the psychotic part in ourselves. 'Any change is immediately noted, any unusual trace in the therapy room is immediately interpreted, every discontinuity in time revives violent fantasies of being torn away, excluded, falling, perhaps even disintegration, liquefaction, leaking away into nothingness, and so forth' (Houzel 1996, p.128).

It is important to distinguish or differentiate between symbolic use of the room and symbolic equation of an element of the room. For example, Ewan was in a furious rage wanting to know what was in my cupboard in the room, to which he was not allowed access, guessing correctly that it contained other children's work and my own belongings. He attached a piece of string through the keyhole in a fantasy of being attached to my cupboard insides by an umbilical cord, i.e. in sole possession of the insides. In this play he had some satisfaction in being in possession of the therapy room for himself in this session. He knew he was attached to a cupboard but it could also represent myself. Another child, Jane, frequently shuts the curtains, creating 'dark-time'. In this play no light (consciousness) is to be thrown on our activities and we exist in an undifferentiated dream world, where meaning and understanding have no place. She does this to shut out capacity for thinking about her and becomes unreachable. In her psychotic state a real shutter in her mind has been drawn with the shutting of the curtains – they are one.

In the first case Ewan is able to explore his fantasy through play in a more reality-based use of the room. In the second case Jane employs a psychotic process as a defence against thinking, very efficiently paralysing any sense of separateness from her so that the therapist experiences being sucked into being a figment of a dark dream world.

'Symbol formation' and 'symbolic equation' can sometimes be confusing. Hanna Segal formulated the term 'symbolic equation' and later Ogden clarified and discussed these difficult concepts (Ogden 1992; Segal 1957). A concept of space between the symbol and what is being symbolised aids understanding, Ogden suggesting that 'an interpreting subject comes into being' within that space. In practice it means that with Ewan I am able to talk of how he would like to be in possession of my cupboard insides and not have any rivals, either my own children or other children who come to therapy. The best way to do that seems to be to be attached by a string/umbilical cord as a baby. It is a serious play, with the string inserted through the keyhole, but when it is played out he is able to listen while I talk about it. Whereas with Jane the darkness literally creates something paralysing and mind-numbing in both of us, which is an experience of anti-thinking, and there is no space to play with light and dark and what it represents. It is an attack on the capacities of the therapist for this particular, very ill child.

> The achievement of symbol-formation proper allows one to experience oneself as a person thinking one's thoughts and feeling one's feelings. In this way, thoughts and feelings are experienced to a large degree as personal creations that can be understood (interpreted). Thus, for better or for worse, one develops a feeling of responsibility for one's psychological actions (thoughts, feelings or behaviour). (Ogden 1992, p.12)

In the paper, 'On the aesthetic moment in the transference' (Case 1996), the children's perception of the Holbein picture and subsequent making of art works of their own was discussed. Here, although there is a component of idealisation and splitting, both children seemed to be able to move from the Holbein to works of their own that contained aspects of very painful experience, and were able to find forms to contain this experience, one in painting and one in clay. The 'good' aesthetic experience seemed to help them find an idiom of their own – moving towards the ability to symbolise proper (Case 1996).

In this chapter consideration will be given to some related but differing experiences of children who have attempted to draw, to copy the Holbein picture; and to continuing investigation into image-making in therapy, aesthetic experience, and differing states of mind in therapy.

Clinical example 1

The star constellation: The splitting of projections and transference

Wendy was referred to me while she was at nursery, age 4, because there were growing concerns about her withdrawal from any social contact. During the first year of work with Wendy her fears were one of the major themes. She had great difficulty in distinguishing the fears in her head from events outside. A noise in the building could make her start with terror from me or a part of the room in the session, a momentary cross thought to me could mean that she would cower under the table as she imagined my fury of reprisals. During this period she stuck her tongue out at the therapist in contemptuous rebellion when a boundary had to be set and then cowered under the table in fear of the Holbein picture. She sometimes also referred to it affectionately as 'Queenie' when in an affectionate mood towards me. There was a lot of work on her separation anxieties from mother, and with mother on her fear of losing 'her baby'. The session from which I am going to quote is ten months into the therapy. Wendy is now communicating verbally much more readily and a powerful identification with her father is aiding her growing efforts at independence from mother. She needs to identify with a sense of 'otherness'. This early period could be summarised as one in which psychotic fears have made social contact seem perilous. She can rarely separate what is happening inside or outside of her head or body boundary. Lacking a body/mind boundary, she fears that mental contents and parts of herself might leak away, so she fears phenomena like water pouring down the plug-hole or toilets flushing. Fears of leaking away have kept her withdrawn and isolated socially. She now has a growing sense of reality that aids her moves into the world. There has been a lot of play with two puppets in the past weeks, White Rabbit and Black Dog. White Rabbit knows things and is scornful of Black Dog who does not know his numbers and letters and cannot read or write. At school she is struggling to understand that letters put together in one way spell a word with meaning and put another way are nonsense – how do you do this, what sort of trick is it? Black Dog usually represents the puzzled, frustrated, degraded self who is felt to know nothing, and White Rabbit the superior know-all who mocks and beats Black Dog.

SESSION

> The first part of the session she is playing. She then moves to the puppets and gives me Black Dog to put on and gets drawing materials. Black Dog is to watch her draw and I am holding the puppet so it is looking

enquiringly over the edge of the table at her drawing (Plate 1). 'I'm drawing you, Black Dog' – looking at the puppet carefully. 'You've got black face, two black eyes, nose, mouth…you're *black*.' She is now shading black, 'You haven't any legs…' She does the 'skirt' of the puppet and arms (legs added later). Now lines out from the figure in pink saying, 'Pink ears…you're a spider… I don't like spiders'. I asked what she didn't like about spiders, commenting on her not liking them. She replied, 'I like [name of a friend], I like [brother], I like [brother], I like Mum, I like Dad…', adding, 'I don't like worms. I don't like spiders.' She has now coloured in yellow all round the figure like a halo and smiled at the picture, she looked up at the Holbein smiling with pleasure, it's 'Our Lady of the Queen'. I commented on her looking at the picture on the wall and what she might be thinking. She said it's 'Aurora' (a character from the children's cartoon *She-ra*) – it's a princess. She now got a green colour, saying, 'It's lovely', and began to colour in green. I wondered aloud about our 'spider feelings' – things we felt afraid of – and our 'princess feelings' that we liked, and if perhaps they were both our feelings about ourselves. She said, 'It's Mummy.' Green all round, over the yellow too. She now called up the White Rabbit puppet to look at the drawing and I am to put the Black Dog puppet away. White Rabbit is teased because she didn't see it being made, 'You didn't see it!' Now, 'I'm going to do a witch' – she draws a green witchy face and puts marks in black, 'jaggy power', all around. It was now very near the end of the session and I talked of this. White Rabbit is put down and Black Dog brought up and now teased because he didn't see the witch being made. I talked of how sometimes the therapist and mummy could feel rather royal, 'Our Lady of the Queen', and how sometimes rather witch-like, especially at the end of the session and wondered if Wendy could feel like this, witchy and a princess at different times. We then put things away and ended the session.

Wendy's difficulties centre on keeping separate what is real and what is in her head, her imagination. Her everyday life is dominated by fears. She defends against her fears by evacuating out all unbearable emotion, anger, jealousies, and then the environment and other people become terrifying as they are invested with these unwanted parts of her.

In the puppet play the therapist is nearly always the denigrated, ridiculed, beaten and mocked Black Dog, and it has been hard work in the past weeks to verbalise what it feels like to be in this position – describing Black Dog's possible feelings. At school she feels terrible, depressed and stupid at not being able to learn what everybody else seems to, but defends against this by

a kind of superiority and silence, refusing to participate, leaving everyone else around her to experience frustration and exhaustion at trying to reach her. She needs first to experience the depression of her situation before the work of learning can begin.

There was a delightful quality about her almost 'stream-of-consciousness' narrative accompanying the drawing as she tells Black Dog what she is doing. As he represents the 'stupid' part of her, she can impress him with her abilities – she has frequently mocked him for not being able to draw. It is an example for this chapter of how art – drawing – can allow play with reality, fantasy and dream, past and present and future wishes. She began by drawing him, 'capturing him on paper', and some of the dynamic between artist and sitter can be felt. She is going to pick out the features of Black Dog that are important to her, but she is also observing him very carefully. She is talking to him, actually on my hand of course, as if he is alive and I am not really there – it's a very intense interaction. Black Dog is representing an emotionally poverty-stricken part of her – a deep depression.

The lines in pink coming out for ears actually have an association to spiders' legs – some enveloping aspect of an inner mother, perhaps a devouring aspect. She moves away from the too-dangerous 'spider thoughts' to what she likes – re-affirming her friend and her family as positive likes – and then is able to let two 'not likes' in, spiders and worms. I had an association rather sexual here – something about pink and black and the worm suggesting some sexual coupling of things and holes. Although her thoughts are wandering to likes/dislikes her hand is still drawing Black Dog and the yellow all round – a rather lovely sunburst effect to dispel these dark thoughts of sexual parents coupled together with her excluded. At different times in therapy she has commented on the Holbein picture, sometimes in fear, imagining that noises in the building are coming from the picture, usually in a disapproving way – as if there was a disapproving, angry mother disliking mess in the picture. She has also looked up and smiled at it as a beautiful, benign queen. She now smiles at her own picture, haloed in yellow, and up at the Holbein and says it is 'Our Lady of the Queen'. The picture of Black Dog is quite transformed by the yellow halo at this point and seems to have become the Queen, 'Our Lady' (Virgin Mary), the idealised and probably non-sexual mother. She now names it as 'Aurora', a character from the children's series She-ra. Aurora is a princess who can transform into She-ra, with special powers and a winged horse. The green starts off as lines out, with the yellow halo around it, but gradually works over the yellow, covering it. When I tried to talk about these two aspects of spider-part and

princess-part she said, 'It's Mummy.' The other puppet is now teased for being left out and missing what was happening, some more oedipal feelings here, to be felt by the puppet. She now draws a witch that is basically a black triangle with a face, but this is covered in by black, the whole picture surrounded by 'jaggy power'. There is now more teasing, this time of Black Dog who has not seen the witch being made. Awareness of triangular relations – mum with another, not with baby – seems to make a witch.

This picture was a very rare outcome in that one can still see some sense of contents of the picture at the end of the drawing. Nearly always, Wendy would begin, or have an impulse to draw or paint and begin an object, but the chaotic feelings aroused would be too much and clarity too hard to maintain. Mixed feelings would overwhelm her and the picture end up a sludge of mixed colour, the brush being dipped ever more maniacally into all colours. Here she has separated in herself a Wendy who has the ability to draw – seek clarity of line and vision – from an 'inept, unable to draw, Black Dog' part of herself, so it is possible to see the importance in development of splitting. The therapist has been able to embody the denigrated part of her – Black Dog – and transform that part by attempts to verbalise. She then has a more positive sense of being able to draw, perhaps under the sign of 'Our Lady of the Queen'.

It is interesting that she has sometimes experienced the Holbein as a dis-approving mother-on-the-wall who hates mess – to be hidden from – and sometimes she would glow in its presence – smile at 'Queenie', able to bask in its gaze. It is rather delicately tinted, on rose paper, which does give it a glow of warmth, but when she is afraid the eyes seem to stare crossly and coldly, a vivid sense of what we might feel as children in the eye of mother's approval or disapproval.

The finished picture shows her Black Dog self trapped in the jaggy power of the witch, the haloed, approved-of self lost in the green. It creatively conveys her difficulty and that of her mother, both entrapped in mutual pro-jections, which has made normal separation and development impossible. She has needed rebellious, negative feelings expressed to give her some distance from a smothering mother, but this brings disapproval from mother which, with her own projected fears and anger experienced as out there in the environment, has meant a very frightening world for Wendy.

The spacing out of different parts of her in the session is a move towards some differentiation rather than the total mess held together by withdrawal that was there previously.

Triangular relationship revisited

A theory or conceptualisation of art therapy that has served us well has been that of the triangular relationship. This notion arises from the idea of therapists working with art mediums and can be looked at in various ways; for example, the triangle of image, client, therapist, or image, conscious, unconscious. It has been most useful in distinguishing art therapy from other forms of therapy, particularly verbal ones. One could say that it has an outer-world function, while also offering a conceptualisation of the inner world with the idea of the image being communication or medium between inner and outer worlds of the client. Another triangle might be that of mother, child and transitional space, art and culture arising originally from transitional object phenomena (Winnicott 1951). Wood describes 'a triangulation around the potential space', how painting in the presence of the therapist alters the intention and the dynamic balance of someone painting alone: dyad becomes triad (Wood 1984). She describes also a triangulation in the mirroring process as the child has the reflection from painting and therapist. In her discussion of the triangular relationship she distinguishes

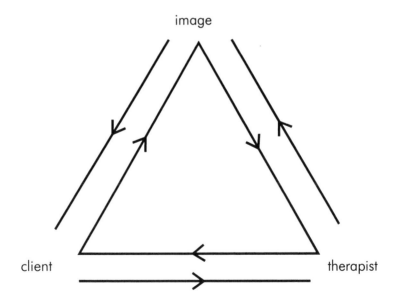

Figure 1.2 The triangular relationship

the psychoanalytic technique of the classical dyad transference, where the child's inner world is projected onto the therapist and the resolution takes place within the person of the therapist, and the different boundary of art therapy, where the expression and resolution of the projected transference take place within the picture-making (Wood 1984).

There is an enormous amount of tension in the profession around this boundary (Schaverien 1994; Skaife 1995). The development of art therapy training to encompass psychodynamic modes of thinking and personal therapy reflects a necessity to work with other processes outside the picture as well as to deepen understanding within the picture processes. The present lack of definition as to what kind of personal therapy trainees might be undertaking reflects the unease and tension of the boundary. Art therapists have moved the boundary, working with transference, countertransference and interpretation, both outside and inside the picture, as the profession has developed.

Further contribution to the concept of a triangular relationship was made at the conference of that name in Manchester in 1990. Christine Wood contributed an evocative image of 'art' as the third person sitting in the room with client and therapist and how 'any meeting between two people with a third silent person in the room might be a little strange'. She goes on very usefully to explore the tension of how to introduce art into the relationship so that it is not a distraction from the work of the therapy (Wood 1990). Speaking at that conference I took the image of the heart as a way of exploring the role of the image as mediator between inner and outer worlds – linking unconscious to conscious and being able to hold simultaneously thoughts and feelings that might be conflictive, ambivalent and also symbolising past, present and future wishes and aspects of the client, and attempting to explore one component of the art therapy process, the aesthetic experience, the inner experience of seeing outwardly and the inner experience of being seen, reflected by the therapist (Case 1990).

Joy Schaverien was the third speaker at this conference, and has made a huge ongoing contribution to the triangular relationship, exploring the transference and countertransference experiences through the picture (Schaverien 1990, 1992). These are constellated around the idea of the mutual desire and gaze of the client and therapist, which fires the therapeutic relationship. Schaverien explores the 'inextricably linked gazes' within this triangle, both when there is a 'two-way relating' with the therapist as witness, and a three-way relating, where the therapist is centrally involved in the transference.

Schaverien gives a very evocative description of two-way relating with patients and the need to eventually find a way forward to two-person relating, i.e. eventually the transference needs to be acknowledged and analysed. The picture, in two-way relating, is seen as the first 'Other', though it is probably a subjective object, i.e. created by the artist rather than a mixture of 'other' and 'me'. It is usual to think of a narcissistic engagement when there is a two-way relating, as opposed to a two-person relating, but the work of Balint on 'the area of creation' in therapy suggests there may be another need to withdraw from the therapist. Not only to withdraw but also to 'move to' a solution, to think alone, which is what he calls a 'no-transference situation' (Balint 1968).

One could question the use of the term 'witnessing' because patients in very early states of mind are not aware of being witnessed but may have withdrawn to think to themselves. To create something new within the protective ambience of the therapist, and this needs from the therapist the capacity to be with the patient, to emotionally contain, not to witness, which is a form of language more to do with the witnessing of traumatic memories or experiences being relived (Case 1997b).

There is an extremely solid contribution to art therapy literature in Schaverien's exploration of the triangular relationship; here is her conclusion on three-way relating, when the transference/countertransference is central, engendered through the picture:

> ... I have discussed the three gazes which form the triangle artist/ picture/viewer. These are the gaze of the therapist regarding the client and the picture, but also looking within, and the gaze of the client looking within through the lens of the picture and also looking outwards to the therapist. The third element, the apex of the triangle, is the gaze of the picture. This projects into the in-between space of the therapeutic relationship and engages the gaze of both people. The engendered gaze is the gaze which is engendered through the pictures and sometimes this may embody desire. The unconscious mix of the gazes of client and therapist may profoundly affect the transference and the counter-transference. Thus, the transforming potential of pictures in therapy may lead to a move from unconscious to conscious through the multiple gazes which this triangle creates. (Schaverien 1995, p.212)

In thinking about the triangular relationship I misread 'strangulation around the potential space', instead of 'triangulation around the potential space', realising on reflection that this was an inner reference for myself about my thoughts on current work with several children referred with symptoms

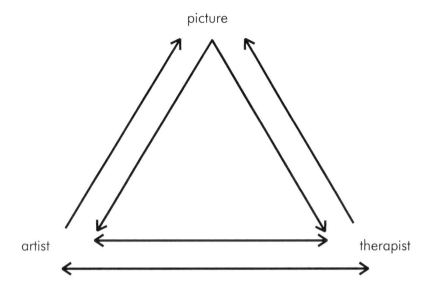

Figure 1.3 Three-way relating – The dynamic field (after Schaverien 1995)

including 'elective mutism' (Case 1997a). The strangulation around potential space here refers to their difficulties in separating from mother, and mother from them. This can be transferred into the therapeutic space as either a difficulty of establishing a potential space in which art could be allowed in – no space for the third person – or art is allowed in, with no space for a therapist. The therapist can gaze hopelessly at the picture and client from afar and is not allowed to make a contribution to either by the client. Here, the client wishes the therapist to feel excluded, as she feels excluded from the parental couple. It is possible to see here the precursor to the oedipal situation in the creation of a potential space and the development of a symbolic space with the ushering in of the Oedipus complex.[1] For the

1 Put quite simply, the Oedipus complex is a body of loving and hostile wishes which a child experiences in relation to his or her parents. Freud named the complex after the mythical Oedipus who killed his father and married his mother unwittingly. There are two aspects that may appear in varying degrees: one, desire for the death of the same-sex parent, the rival, in order to marry the parent of the opposite sex; two, the reverse, love for the parent of the same sex and jealousy of the parent of the opposite sex. It is resolved by identification with the parent of the same sex, and relinquishing of the parent of the opposite sex (realisation that we will not marry Mummy or Daddy and that they are a couple).

triangular relationship to work well there needs to be the development of a third position from which the relationships in the triangle can each be viewed.

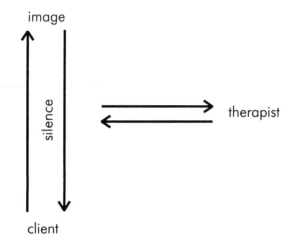

Figure 1.4 Strangulation around the potential space in elective mutism (a)

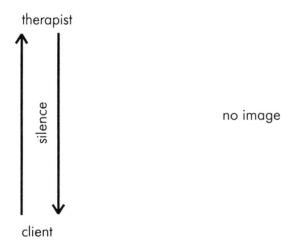

Figure 1.5 Strangulation around the potential space in elective mutism (b)

In children fiercely resistant to separation from mother, as can be seen vividly working with elective mutism, there is no room for a third (father) and this inhibits the use of a triangular relationship in therapy. Either there is no possibility of therapist and child reflecting together on the picture, or therapist and child feel glued together with no room for pictures. There is no way for a third position in the triangle to be viewed. Consequently one feels 'the strangulation of potential space'.

A further aspect to 'strangulation' is the limits imposed on trying to conceptualise work in art therapy by the notion of triangular relationship. It can be very useful, and every profession needs to set boundaries to its work, but I could also feel myself kicking against it when thinking of material that did not seem to fit – why not other shapes? Part of my questioning is not how to introduce art into the room for an adult client, but how do children introduce art into the room amidst a welter of fluctuating inner states, why does it happen when it does? Rather provocatively: do many children come in and paint or use other materials in art therapy without also engaging in other activities? Experience suggests it is rather rare to have a session when a child does just engage in materials, possibly because the level of disturbance is too high for there to be any idea that something (good) could be produced. In the session previously described, drawing is only possible when the 'denigrated, stupid' self is safely on my hand and then some inner play with images can take place.

This star constellation splits projections and transference to aspects of image-making, the setting and the therapist. The Holbein picture has aspects of the idealised mother, 'Our Lady of the Queen'. The image Wendy draws has aspects of a good (idealised) and bad (feared) mother in Queen and Spider and also shows the difficulties of resolution of the Oedipus complex where jealousy of mother's interest in father and siblings creates a Witchy Triangle. The power of the wish to remain a non-speaking baby glued to mother is shown in the trapping lines of jaggy power as mother and child wrestle with the imagined dangers of letting go of each other to allow growth. The therapist's hand becomes Black Dog, the denigrated, non-achieving self, and the rest of the therapist probably has some role as 'Father' in this session, allowing some differentiation. White Rabbit has aspects of the left-out sibling ('You didn't see') rivals to mother.

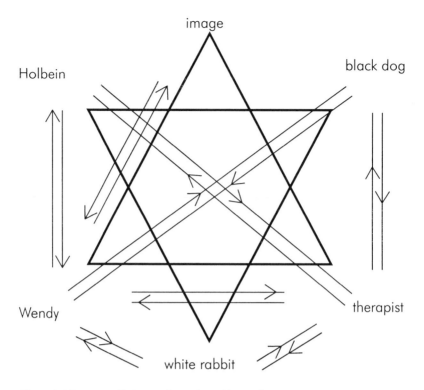

Figure 1.6 Star constellation – The session with Wendy

Clinical example 2

Simon: A journey around mother – A more standard art therapy session

Simon is an only child, referred initially for assessment to help workers with him and his family think about him and his difficulties. In the pre-assessment meetings I found that he aroused intense dislike within the people with whom he came into contact, who found his critical manner and comments quite unbearable. (For a discussion of assessment with children see Case 1998.)

Simon was born in extremely difficult circumstances amidst fears that mother or baby or both might die. The trauma of that time had not eased in mother when I met her, and she seemed to have the horror and anxieties of that time unabated, as if it were yesterday. Mother and Simon felt stuck in a mother/baby relationship, as if she could not give him enough, help him separate, or heal the rift in their bonding caused by the traumatic separation at birth through illness.

Simon dominated life at home, making it impossible for his parents to have a life together as a couple. Father found it difficult to form a father/son relationship as attention from mother was jealously fought for in the heat of oedipal dynamics.

SESSION

In this first session I am going to look at the interrelated flow of transference and countertransference while an image was being made.

Simon, now age 10, entered the room quite in control of himself and confident for one in such a new situation. He said that he would use clay after I had talked about our meetings. He told me that he had used clay at his old school – an old man had come in to do it. He told me about some previous work, made of clay, that he had at home and said that he would bring them to show me. While he was talking he spent twenty minutes making an old bent tree. I noticed that he used a lot of water so that the clay became very slimy. He was really smearing the pieces together and it was not actually being joined together very well. He then made a little clay seat for a swing and said that he would put it together next week.

It is possible to see Simon confidently in control of any anxiety in this new situation by choosing a material with which he is familiar. Rather than thinking about me and who I might be, the therapist is equated with a 'kind old man' whom he has met before. There was a positive regard from him in the expressed intention to show me some previous work. It felt that he had made a possible base, maternal or/and paternal, in which to play – the old bent tree – but that it was not as strong as it gave the impression of being – the slime-filled joins. There is a seat, but the two are not yet joined. It was as if it was a potentially rather fruitful image of childhood – the swing in the old tree – but I wasn't sure of its strength or resistance to pressure.

He now cleared away all the clay things absolutely, each tool carefully washed and the table cleaned thoroughly. He then began to scrub the table, after the clay had been removed, as if to get off old hidden stains, and he made a rather cold critical remark on how dirty this table is! I was put in touch vividly here with his capacity to arouse dislike of himself as it made me feel like a rather inadequate housewife who was neglectful of her work. The warmth in the room had been scrubbed away.

He then said that he would draw the picture of Jane Seymour, rather to my surprise getting it down off the wall and putting it on the table beside him. He began to draw it on white paper by a kind of dot-to-dot method, measuring the distance between parts of the picture, from the

picture to the paper, and joining up as he went (Figure 1.7). As he did each join he said, 'purrfect', 'purrfect', looking up to me – each time as if to challenge any question that might be around that it wasn't perfect. He criticised various materials and tools available and once got up to leave the room to fetch a pen from the waiting area. Although I stated that I thought there were adequate things to use here he overrode me, giving the impression that the materials were vastly inferior.

I was struggling with negative feelings towards him, irritated and trying not to react without thought. As he drew he said that he thought it was old – Victorian, eighteenth-century or something. He asked/told me to bring in some particular watercolours that he thought he would need.

Possibly the sense of him being a child and not a critical adult, rather than me as a criticised child and him a critical adult, was more alive in me as he thought it was ('Victorian or eighteenth-century') and I was able to ask him what kind of woman he thought she was. He said 'firm', 'decisions'. I said, did he feel that he needed 'firmness', and he said, 'I like art, it's fun, you can make things, and it's fun.'

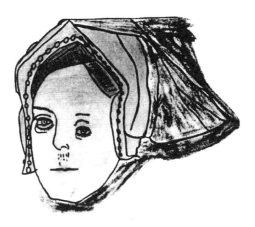

Figure 1.7 Simon's drawing

He then rather critically compared his past and present schools, ending by saying that he likes this one in the last two days and that he thinks he is going to like Wednesdays now (the day he is to come for sessions).

It's possible to see in his perception of the Holbein picture of Jane Seymour as 'firm', 'decisions', that he is really telling me that that is what he needs. I think he is saying that he needs firm boundaries wherein he can make things safely. At the same time he is contemptuously overriding attempts to give him that – my failure at that point to enforce the boundaries of the room when he walks out of the room to the waiting area. He both wants a structured boundary but is also critical and contemptuous of parents and what they can offer and their/my inability to enforce boundaries.

I then commented on his liking everything exact and wondered if he felt safer as I observed his dot-to-dot progress around the picture. He said that he wished they would invent something so that pictures in your head came straight out on paper, it would be easier, he laughed. He said that he thought of small pictures in his head. He couldn't draw them bigger. He liked having this big picture to draw beside. He then mentioned that he knew his mother had come to see me. He said that he would ask her if he could bring things to show me. He then wanted to know if he would get more time here, more than one hour a week, how long was it till he came again? I linked his wish to come with his wish to show what was in his head. As he left he referred to my bringing watercolours for next time as if this had been agreed between us in a very controlling way.

The material Simon was presenting to me in the session is very rich and gave me a lot to mull over both while he was there and afterwards. I was moved by a sense of his longing for support, both in the wish for a swing on a tree and for the 'firm', 'decisions' woman in the picture. He is a child who has lacked a playful childhood, with no ability to play and no friends. He has a bedroom full of the latest toys but no play companions. It is hard for the wish to play – the swing – to be joined to its support, means of playing – the tree. He has a wish to be looked after and is a very needy child, but asks in such a way that it elicits the opposite of help, putting people's backs up because contempt disguises his dependency needs.

There was a very fluctuating transference and countertransference feeling throughout the session. He aroused in me both warmth and concern, and interest in him and what he was making. There was a very positive hope for the therapy and its outcome in his wish to get 'pictures' out of his head and

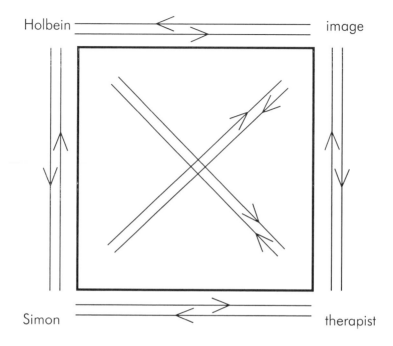

Figure 1.8 Interweaving triangles of a copied image

onto paper and his liking of the picture (and therapist) beside him. This is mixed with irritation and dislike as he criticises and projects feelings of inadequacy and contempt. He was powerfully able to let me experience depletion, inadequacy, contempt and a sense of not having the right supplies for the job. He is projecting and communicating his sense of inadequate means to do the job of life, but he is mainly evacuating these feelings, which I imagine are projected between the different family members at home.

In the wish to copy the Holbein picture there is a wish for a strong structure in which to rest, in parallel to a wish for a strong old tree to swing on. He desperately needs this external structure around the session so that he can safely play and let out 'pictures from his head' into the session. At the same time he attacks this wish and my ability to offer this space to him by his evacuating projections. There is a wish to copy the picture – almost trace – in the dot-to-dot method of drawing, and aesthetically he is drawn to the picture by its clarity of line. Another aspect of the Holbein picture is that

when it was taken down and placed beside him it was like having another person in the room. It enables him to split off and experience some qualities of mother/therapist in the picture and possibly gives him 'two adults' in the room to be with. He can control the picture-mother and tries quite hard to control me, but is very aware near the end, in his question of when can he come again, that the therapist is in control of the boundaries of the session.

COPYING AND IMITATION

In the wish to copy is perhaps the wish to make something our own. We talk of 'capturing' something on paper when we draw. Simon attempts to possess the Holbein for himself in his drawing, but also in his bold move to lift it off the wall without any reference to me. He then attempts to 'capture' this aspect of therapist/mother on paper in his dot-to-dot measuring process – a journey around the maternal object. For it not to be copied perfectly would have felt like a bit that had escaped him, suggesting some deficiency or lack in himself, which perhaps explains a need people sometimes have to have an exact copy of an image.

Another aspect of copying is perhaps a reaching out for what can be conceived as possible just ahead of what we can actually do. One cannot actually yet achieve it, but it is visible on a horizon. It might represent an ideal to aim for or a capacity that one wants to develop. Yet copying has ambiguous connotations. Children particularly need to imitate others around them in order to learn. Many of their early years are spent copying the actions and words of those slightly older than themselves as well as parental figures.

And yet there are worries about 'copying'. 'Copy-cat' is a term of derision, because it is dishonourable and cheating to copy in the wrong situation. It seems wrong to copy in a competitive atmosphere or when one is 'too old' to copy. 'Copy-cat' suggests a lack of originality and a fear on the part of the name-caller that someone copying them depletes them in some way. But copying another can also be flattering to the person because one can do something that is worth copying. In the sense of identification, it is also a wish to emulate a quality or characteristic of another to gain it for oneself.

To add a counterpoint to the copying of an aspect of the setting, a picture on the wall, brief mention will be made of some related but differing kinds of copying in therapeutic situations. First, children copying other children's work in art therapy groups: the need to emulate, to be as good as another, can be so strong that children can copy 'exactly' while not actually knowing what it is that they are drawing. In one art therapy group of children age 7–9 years there was a wish by a boy, Hassan, to emulate the skills of the girls in the

group who were more emotionally mature. Attracted to their ability to have an idea and draw or paint something to completion, he would sit with them and at first copy exactly. It was clearer, when he would sit opposite and draw what they did without comprehension of what the shape was, that it was some quality of theirs that he was attracted to, perhaps both control and skill but also being still, as he was a very restless, ill-at-ease child.

Group work where such dynamics become very visible between members of the group can give a clear sense of the powerful effect of the therapist and other members as real objects in a child's therapy as well as vehicles for trans-ference processes. Here, other group members' real qualities and abilities can be seen as well as the therapist's, who can have space to observe the processes in action.

Hassan went through a phase of copying as at times an almost ritual ori-entation into the work of the room and at other times, when he felt empty or depressed or desperate, 'having to copy'. The desperation arose from his great sense of emptiness and having no sense that he could produce something good from inside. It is perceived as being 'out there', as located in another person. The mechanism of projection has been used to save 'good qualities' from destructive/despairing feelings inside, and the person's good qualities are located outside for safety. It does not then seem possible to make something new or original from one's own inner direction. Hassan seemed eventually to be able to take back inside the projected-out qualities and move towards his 'own' work (Case 1985, 1992).

In a discussion of group analytic art groups Gerry McNeilly makes this interesting comment on 'copied pictures', in the context of one group member copying from another:

> On an unconscious level I view the process of copying in the art therapy group as a guard against one's self, and that part of the self which is chaotic and spontaneous. The guard I feel is placed in order to ward against such fears as being out of control and even of disintegration. (McNeilly 1989, p.165)

Copying in a group can have the effect of making the copied person feel irritated and frustrated, as if their ideas are being stolen or they are intruded upon, so that there is a complicated interplay of dynamics with which to work. If the child wishes to copy from some part of the therapeutic setting, a picture in a book or a picture on the wall, then it is easier to concentrate on the dynamics of the aesthetic quality/psychological quality in the choice of the object.

Second, working in a studio setting with both individuals and groups with art books available on a shelf, I have previously described one child's use of Impressionist pictures (Case 1987). Hyacinth copied pictures by Manet particularly, and also Picasso, wanting then to give the pictures to the therapist. The gift-giving aspect of some of these pictures shows concretely how qualities of the child can be projected out and located in the picture and then given to the therapist for safe keeping. In an interesting article Barrie Damarell writes about his experiences with clients with learning disabilities and the act of forgery (Damarell 1999). He suggests patients copying works of art and forgers share a wish to adopt a false and acceptable image for the spectator. He links his thinking to Winnicott's concept of a false self. Many of his patients have been unable to attract love and attention in their own right, for who they are. Damarell feels that they may have had to commit an act of self-forgery with which the community colludes to view as authentic. He also comments on Kuhns' ideas of us developing as individuals in culture through interaction with cultural objects. I feel that although there are undesirable aspects to copying for the client, there is also the possibility of it being a positive stage in development.

Third, there is the copying of aspects of the therapist herself in the body of the person. The first session after a break I arrived to find an adolescent child with her hair layered short in an identical cut to mine at the time. It was very different from her previous long hair and despite our many differences in appearance she had managed to look remarkably like me. She was a child who frequently withdrew into a heavy silence, and she immediately got materials and with a super-confidence began to draw a portrait, evidently intended to be herself by the initials on the jumper. She had extraordinary trouble with the face that kept going wrong and was wiped out and started and re-started continually. There seemed to be a fight going on internally as to which 'face' to put forward. I had been thinking of this identical haircut and wondering if she had tried to 'be' me for the break so as not to experience any separateness. I was able to talk about this and the difficulty of trying to find a face here that might match some of her feelings about the holiday break. She struggled on, painting, wiping and repainting every gesture several times, a great tension evident, and ended by triumphantly writing 'ME' beside it as if to refute all I had been talking about – and yet it is immediately recognisable as a portrait of myself (Case 1997a). Freud noted, 'Identification is known to psychoanalysis as the earliest expression of an emotional tie with another person' (Freud 1921, p.105).

A child will take a special interest in the parent of the same sex, would like to grow like them, be like them and take their place everywhere. Really they take that parent as a model. It is possible to see how out of identification, emulation – to strive to equal or excel, to rival successfully – and rivalry, jealousy and competition will arise. The identification with the same-sex parent will exist side by side with love for the opposite parent and the two will come together in the normal Oedipus complex. With any identification comes some ambivalence, because of the inherent rivalry and wish to take the other's place. With the child described above there is a wish to 'be me', to experience no difference between us and no sense of missing me in breaks, but also a wish to 'wipe me out' and take my place, at the same time wanting to model herself on me.

Clinical example 3

Tracey: The roundabout – The creation of discontinuities of experience

Tracey, age 9, was referred for her disruptive and boundary-less behaviour. She seemed to be in a perpetual state of manic flight, fast-talking, moving, lying confabulations, non-stop action, forceful and intrusive, and full of diversions when one attempted to communicate with her. In contrast to this ebullient manner and hidden by it is a thin waif-like child, like a stick buttoned up in a jacket, holding herself together and covered in a skin roughened by eczema. At home she now lives a more settled existence with mum and stable partner in a composite family, but in the past as a pre-school child has been sexually abused by her father, one of mother's several abusive partners. In the sessions she longs to make something 'nice' but each time there is a downward spiral of barely containable mess, clay goes to slimy, smeared water, paints to murky brown/black mixtures. She is not able to bear the pain of looking at the damage and distress inside, felt depressed, despairing and suicidal under her insistence on 'nice pictures', denying what was actually being made. In the session she flits from one rushed activity to the other, is on the tables, at the windows, out of the door, leaving the room in chaos at the end so that my 'insides' feel tipped upside down or inside out. This evokes the sense I have from her that her world was turned inside out and upside down by the abuse. She no longer knows what is 'good' or 'bad', 'right' or 'wrong', who is to be trusted, what is 'real' and what is 'not real'. One of the most painful qualities of working with her is to be with her while she 'play-acts' distress as a way of denying distress. The therapist will be tricked into responding to the actress who hides her real feelings, and she can

then be contemptuous if they are fooled. At the same time there is an appalling underlying feeling of triumph in this contempt, that no one can see 'my distress'.

SESSION 4 OF THERAPY

Tracey has twice drawn/painted the Holbein and here is brief mention of the first one, a whirlwind session very near to the start of working with her.

> She came in a whirlwind but complaining of not getting various things and is full of curiosity about a meeting obviously going on in the building. Early in therapy I am having to work very hard to attempt to contain her feelings, establish the boundaries of the session and room in the most basic way. A noise in the building will send her flying out of the room agape with curiosity, or she will attempt to wrench the window open and yell out, or insist she needs the toilet and race off down the corridor. She is very openly curious about me, asks intrusive questions and is constantly writing and saying that she loves me and 'giving' me things she makes.
>
> She draws a 'man fishing' and a 'duck' on a piece of paper and tells me I have to 'spot the difference', adding features to each to make them 'the same'. She is trying to score five out of five, wanting me to play this game, but it's utterly bewildering on a real level because they are different pictures. There is some reference here to 'Are there differences between people?' (adults/children), and the desire to reverse our rela-tionship – she is in charge of the game, I feel like the child. She wants to be in control of the relationship with me, not to be a needy child coming for therapy. She completes it, writes, 'To Caroline, lots of love, Tracey' on the back, 'Caroline' on the top, and sticks it to the wall, grabs a felt-tip and tries to start colouring in the Holbein with felt-tip – orange beads. (This has happened with other extremely disturbed children using the room – that they have tried to 'fill in' or 'complete' the picture.) There is a wish here to 'spoil' the picture, disfigure it I think, but it is also possible that the incompleteness or 'emptiness' is perceived as unbearable. To colour it in is also to say it is mine, in a possessive way. I stated that it was not possible to do this – she furiously drew 'fireworks' in felt-tip then brought herself out of this, an attractive quality in her, after I had inter-preted her possible feelings, and asked for tracing paper. She wanted to copy it. I explained I didn't have tracing paper but I would sit with her if she wanted to copy it.
>
> She then got paper and drew it rapidly in purple felt-tip pen (Figure 1.9). She was both being careful and concentrating and also laughing

wildly at the same time. She first tried to persuade me to do it but then settled into it. I was very moved by the little hands outstretched and she wrote 'To Mum and Dad' on the back and then the names of all her family on the front. I had a strong feeling of how much she longed to be picked up and loved by her family, to be happily contained within the family and by me here in therapy. I wondered to her about her wish to be mum and dad's 'princess'. The lines tangled in the headdress and stomach really suggest the turmoil in her 'insides' which I feel every session in the countertransference, here made visible in the picture. Then she rushed from this, very unsettled, fiddling and poking in the room, at the door, windows, upset by noise and the rain and hail outside. I talked about this and she grabbed clay and made clay pieces, which dried to look like scraps of cardboard, with the names of her family dug into them.

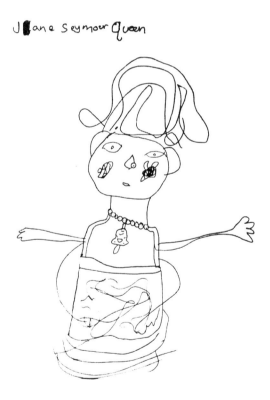

Figure 1.9 Tracey's drawing

At the start of the sessions her attempt at a 'spot the difference' competition is perhaps a need to be in control of the situation – she made the game, I am a player, to be marked out of five – and to experience the sense of winning and losing. She would like us to be 'the same' so that there is not a therapist and a child in need. At the beginning of therapy I could feel like an intrusive adult trying to hook her on a line, with her the duck. Most importantly her home situation and past abuse blur the differences between children and adults.

She is drawn to the 'emptiness' of the Holbein. As a sketch for a future work it is 'incomplete' and 'unfilled in'. She desperately wants to fill in all the spaces with colour – starting with the beads, pleading that she will colour it nicely if I will only let her do it, 'just the beads', but at the same time trying to colour in the face and excitedly scribbling while standing on a table.

Aesthetically the sense of lines and empty spaces matches a feeling inside that makes part of her concentrate to express that quality on paper. It can be characteristic of sexually abused children to wish to keep everything 'nice', to deny that there has been or could be again anything 'nasty' – as the abuse. A manic defence causes her to make it all 'exciting' and she laughs at the same time. The hands outstretched rather than clasped in the composed way of the portrait show her desperate appeal to be loved and wish to be held and contained. She continually tells me that she loves me in the sessions and sticks pieces of paper on the walls saying this, expressing her deep wish to bind us together and for me to love her. The sudden noise of rain and hail outside brought in some sense of the harsh reality of very deprived family circumstances and the sense of family members being scraps. Self-worth is very low in this extremely deprived family where the children often have to self-parent and be parents to their parents.

NINE MONTHS LATER

Although Tracey is still in a manic defence she is communicating in a way that is possible for me to understand and to decode, and talk to her about her needs, wishes, longings and defences. A space is developing in the session where she can enjoy me thinking about her. She still communicates a lot through action, but also play, singing, painting and talking. Some of her talk is confabulation, which I am able to understand as representing a wish.

Some way into the session:

> She told a confabulation of the clocks all being wrong and that she had
> come to school at 6.00 a.m. and only Mr _____ had been there. I talked
> of her wish to be the only girl in the school and to have Mr _____ all to
> herself, and her to be the only girl who came to me for therapy and my

favourite therapy child – to have me all to herself – and her jealous feelings of other children both here and at school.

She leapt onto the table and flew in a jump onto the chair which knocked back but was stopped by the wall. She shouted, 'Superman – super-ooper-man!' She said that I was not to worry about her and then that I didn't need to care for her – climbing up and leaping off several times, arms in the air as if she was flying and shouting out 'Superman' each time in a sing-song voice.

There was then some intermittent talk of her mother being ill and how she might die in hospital, ending in a squeak of laughter. I said how she felt she had to hide away worry of her mum and wish to be looked after herself, and had to build herself up into a Superman Tracey who cannot be hurt – strong enough to look after herself as well as her mum. She talked more of her mother's illness and I talked of her worry that mum might die, but also the need of a little Tracey to be looked after. She was now swearing and leaping and I said how hard it was for her to let herself feel a need for a little Tracey to be cared for.

She then suddenly settled down lying on the table. She asked for a pillow and I got one and she asked me to put a blanket over her – a tartan rug in the room. She then lay for some long while, occasionally changing position. I realised she was sneaking looks at me beneath closed eyelids and commented on her wish to be lying quietly with me but also having to 'keep an eye on me', worried that I was not thinking about her and might lose interest. Sometimes she lay almost completely under the blanket sucking her thumb. She then sat up under the blanket and sang me 'The Ugly Duckling'. I talked of her wish to turn into a swan, white and pure, and fear of being an 'ugly duckling' in brown feathers, as she felt when she felt badly about herself. She then sang another song about a duck going to town, and then a very coarse, 'funny' song about 'grand-mother's farts blowing the candle out'.

It is possible to see how a space for reflection and 'feeding' – the thumb-sucking – has gradually developed in the sessions, and there is room for her fears that she will always and only be a soiled, abused child, never a pure swan, to be expressed. The feeling that she is a soiled, unwanted, shitty girl is disguised and made coarsely into a toilet joke in the last song as a defence against these frightening and painful feelings. Shitty feelings overwhelm her and 'blow out' the warming contact between us. She can barely let herself feel warmth before she attacks it.

She now sat right up, letting the blanket go, and looked up at the Holbein, saying that she loved that picture. She then said that she would

like to have it with her always and took it off the wall, hugging it to her. She then said I was to shut my eyes and she was going to make a surprise for me. She put the picture down on the other chair and covered the table with the blanket and then laid out all the art materials – jars of pencils and felts, pastels, a palette of paint, water pots and brushes and three kinds of paper – like a special feast with the blanket as a tablecloth. A lot of admonitions to me 'not to look!', then said, 'There!', and let me see, and I exclaimed at the feast of materials and the surprise. She then put the Holbein propped up against the wall and sat opposite – adjacent to me, instead of opposite. She chose pinkish paper and a red pencil and began to draw the Holbein, asking me who she was exactly, and I explained. She asked if she could take this home with her as she wanted it with her, in her bedroom, and I reiterated the boundaries of our work, which involve all pieces of work staying in the room for the duration of treatment.

She drew the picture very carefully but quite fast, capturing it rather well, a long nose, big eyes and face long and narrow, and then the lips (Plate 2). She talked of the clothes and jewellery and how much she liked them and then decided to paint them. She did this with a large brush but very carefully. It really became a dress of 'all colours', very celebratory. I wondered to her if this picture was like a 'mother queen'. She replied that her mother was 'an art teacher' and 'a doctor', and how her mother couldn't choose and wanted to do both. She thought that she should be a doctor because then she could heal herself.

She had worked her way, painting, around the face except for the eyes which she'd done first, blue, and then the mouth, red. She had now painted the rest of the dress and jewellery and came back to the face. She suddenly dipped her brush in all the colours, then washed it saying, 'No, not black', and dipped it in them all again, and painted the face. Of course, this mixture came out brown and she painted it all over the face. The eyes and lips just barely showed, but then the paint spread over them. Looking at the face she said, 'She's a Paki!', with a shriek of laughter.

She now said that it wasn't finished, removed the paints with my help, and began to colour in the background – lots of pastel colours. She said, 'How carefully I'm painting it.' She became aware that the session was soon to end and began to colour brown across the top and then spread it down – it had been red at first. It began to be more and more difficult for her to maintain 'good' qualities in the picture. I talked of this and how difficult it felt for her near the end of the session, feelings of wanting to spoil 'good things' so there would be less to leave and feelings of being

pushed out of the session when it was time to stop. She now wanted to give it to me and I talked of her wish to give it to me and that I would keep it here in the folder with the rest of her work. Then a burst of questions at the very end about other girls that came to see me, what did they do here, did I keep their work, did they have a folder, etc. I talked of those feelings that were aroused particularly at the end, having to take leave and of our meeting for our session next week. She began to try to grab more paper, wanting to go on, as I escorted her out of the session.

In the first drawing she made of the Holbein she is attracted aesthetically to the quality of a sketch which contains the idea of fulfilment or future embodiment that the oil painting will have. It has a quality of 'coming into being' in the future – it holds promise but is at the moment a suggestion of what it might be.

The second drawing/painting of the Holbein emerges amidst very dense material as she uses many different forms to communicate both directly and indirectly. The pace of the session and leaping from one activity to the other shows the deep chaos inside and turmoil of feelings that she rushes ahead of, almost trying to outrun them in a manic defence against pain. I have called this the 'roundabout', the creation of discontinuities of experience, when children rush from activity to activity. She frequently communicates wishes or thoughts by lies/confabulations, which is not a very socially accepted way of communicating and arouses strong feelings and confusion in those who work with her as she insists on their truth. In a sense both staff and Tracey are 'right' as factually they are lies but emotionally contain a truth. She has developed a powerful physical defence of pain, attempting to be an invulner- able tough guy who cannot be 'touched'. There is a real worry about her mother, who has a condition which can erupt under stress, but underneath this is the powerful reality of a mother who has so much need herself that there is little available for Tracey.

A space has developed in the session where she can be 'still'. There is the possibility that I can think about her, rather than often feeling left behind in the tail of a tornado as she leaves the session. She enjoys the sensation of being in my thoughts though it is hard to trust that I will not lose interest if she is 'not entertaining me' in some way. She communicates a lot through song and in this session is able to let me know her fears that she will always be a soiled, abused child, the 'ugly duckling', and wish to be a 'pure swan', a girl to whom abuse has not happened. It is very hard for her to maintain a split between a desired state – e.g. ideal – that one might aim to be and the

chaos of feelings also inside. Here a coarse, 'farty' song blows out the light of the candle – hope.

The hopes for 'fulfilment/wholeness' are now experienced outside her – in the Holbein picture. It's as if a question has formed in her mind. What would it be like if she could have this ideal mother with her always? Experience has not been consistent enough for her to internalise an ideal reliable mother so she needs the concrete presence of someone with her. There is then a celebratory feast of materials laid out on this special cloth. The sense of safety and protection – of containment – allows something to take shape inside. The pinkish paper she chose reflected the soft hint of tints in the original. It felt like a child's fascination with mother's clothes,

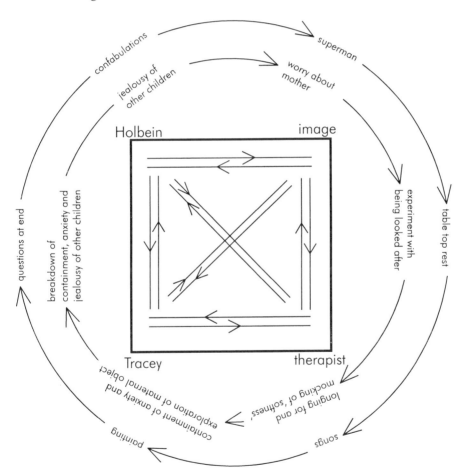

Figure 1.10 The roundabout – Session with Tracey

jewellery and personal items as she asked questions about the picture, and quite different from her intrusive personal questioning towards me in the past. In the 'all colours' there is a sense of celebration of fullness and health.

There is some understanding of how therapy might heal in the story that her mother is an 'art teacher' and a 'doctor'. She quite perceptively, in the idea of how 'the therapist might want to do both', has a sense of my conflict, in a way that children living a lot in projective identification can have an acute awareness of their therapist. She is also very in touch with her mother's needs.

Difficulty for her arises with the face of the picture. She is faced with her ambivalence towards her mother and the therapist in the transference: her mother, who loves her but has been unable to protect her, who mothers her and has enormous needs unmet of her own, which Tracey senses, and thoughts of the therapist, who offers her a space each week but does not see her any other time, and sees other children, all create a conflict expressed in the painting of the face. Mother/therapist are 'all colours' but mixed up feelings/colours produce sludge/black. She leaves out black the second time but paints the brown mixture over the face, obliterating the firm lines beneath, then hurls a term of racial abuse, 'She's a Paki!', at the picture with a shriek of laughter. As with the songs it is very hard to maintain a 'good object' inside. With the awareness of the end of the session she wavers between colouring in the surround of the portrait 'all colours' or brown, and brown/shitty feelings predominate. This could be described as racial abuse to part of the self/therapist. (For a discussion of these issues see Case 1999.)

Despite the emergence of worthless feelings and ambivalence, the portrait has a sense of dignity and composure – as if the structure of the pencil drawing underneath, taken from the Holbein, can withstand the 'abuse'. We end the session with the feelings that were encapsulated in the first lie/con-fabulation, of being the only child to come to school/therapy, coming full circle in her rush of questions about other pupils who come to see me.

As the picture can in its underneath drawing structure withstand the paint attack, so the therapist can withstand her chaotic mess and verbal attacks, and usually manage to maintain the boundaries of the session. This is beginning to give her some sense of consistency that has enabled the tentative exploring of what it might be like to be cared for.

Objects and painting in therapy

In therapy clients both bring things to the session but are also affected by the setting and its contents. In his discussion of 'the evocative object', Bollas describes this interplay rather well: ' … thinking ourselves out through the selection of objects that provide inner experience and being thought out, so to speak, by the environment which plays upon the self' (Bollas 1992, p.4).

He is interested in the objects we choose and how we 'constantly endow objects with psychic meaning'. This is very helpful both in thinking about how children use aspects of the setting and in thinking about what they sometimes bring with them to therapy. This chapter has focused on three children's relationship with a picture by Holbein, but as I write children arrive bringing things with them to a session, e.g. a boy arrived before a session with father and two brothers, unusually because it is in a holiday. He had in his pockets four cars and proceeded to play with them. They are all broken down and are stuck with plasticine in a 'train' and come to me – the garage – to be fixed. In this deep but simple way he is able to show me that other members of the family are also experiencing 'problems', and it is his feeling that they could also be helped by coming to see me. After I had talked of this he changed play and began to incorporate the holiday chart I had made, of when we are meeting and when we are away.

Introducing 'holiday charts' to different children in a set of separate sessions in a week can be a vivid example of how something new is absorbed into the psychic texture of life by each child. Practically identical charts can be experienced as: 'a random series of numbers evoking bingo, gambling and fate'; 'a booklet that tells one how to train a wild dog'; and 'a till in a holiday gift shop where I am the customer and the child the owner'– just to give three examples from one week.

Children's uses of aspects of the room are interesting in themselves, but also throw a slightly different light on the experiences of children while making. 'The objects of intermediate space are compromise formations be-tween the subject's state of mind and the thing's character' (Bollas 1992, p.18).

The above uses of 'holiday charts' illustrate well three different states of mind in relation to an approaching gap in therapy sessions. The interplay between what an object elicits and what we locate is very present when we paint or make, i.e. which medium we choose and how it acts on us as well as what we externalise. It is possible to see this more clearly with Tracey's change from pencil to paint. She chooses pencil and both 'copies' and 'uses' the compositional structure of the Holbein to have an experience of structure internally. She then wishes to 'colour it in', I think to give it life and mass, but

there is then a terrible struggle as this medium can elicit 'fullness' from her but also 'mess and chaos', and so the conflict between them is made very visible externally as she works.

Her use of the picture on the wall as an object and the picture she makes highlight some differences between projection, projective identification and the related but different psychic interplay that we have with mediums in art.

First, back to Bollas:

> These 'subjective' objects, to use and yet extend Winnicott's term, are a vital part of our investment in the world. Through this particular type of projective identification we psychically signify objects, but as they retain their intrinsic value they can be said to occupy an intermediate area between the conventional use or understanding and our private one. (Bollas 1992, p.20)

He goes on to discuss how projective identification usually results in the unfortunate loss of the parts of the self projected into an object, 'but the intriguing mental processes involved in subjectification of an object world invite us to emphasise its positive aspects' (p.22).

Take Tracey's use of the Holbein when she takes it off the wall and hugs it, saying, 'I want it with me always.' There is a wish for and splitting off of a good maternal object to protect it, but also possibly an experimentation with the idea of me – certainly this is present while she is watching me earlier.

When she paints, though, a different dynamic is present. This is her creation. She is playing seriously with the idea or concept of 'mothering', like a child fingering mother's clothes or jewellery – it is a journey around mother, related, I think, to Simon's 'point-to-point' journey around mother, and Wendy's exploration. She is allowing herself to explore some aspects she has noticed about me – that is, 'art teacher' and 'doctor'. Near the beginning of the drawing and painting there are possibilities of meaning, feeling or thoughts allowed to come together – painting is a quintessential mixing of feeling and thought – but this becomes too painful, so that 'mother' is attacked. She does have the opportunity through the painting both to integrate very different opposing feelings but also literally to fight it out – the two sides as she uses the different mediums. The pencil gave a structure that survives the more ambivalent feelings present in the use of paint. The pastel, used to enhance the figure at first, then becomes chaotic and scribbly but the change from paint may have been to protect the figure from further attacks. After the use of these facilitating mediums, she is able to verbalise her

anguish and what is evoked inside by the awareness of my seeing other clients.

Conclusion: Refractive transference

In this chapter there has been the intention to stimulate thinking about the form and process of child art therapy. It is hoped that art therapists who work with adults will also have found something of interest. Child examples can sometimes illuminate more coded presentation of similar psychic states in adults, and indeed every therapist will hopefully encounter the inner child in the adult. Through a chance misreading of 'strangulation around the potential space' instead of 'triangulation around the potential space' there has been opportunity to rethink the notion of a triangular relationship in art therapy. It can be a very useful way of conceptualising our work, but also limiting.

The term 'refractive transference' has been suggested as one way to conceptualise work with children in a 'paranoid/schizoid' position, who will be employing defences characterised by idealisation, splitting, omnipotent thinking, denial and manic activity. A 'refractive transference' would be the experience of being in a situation in the therapy room where the child has split transference to therapist, objects in the room and images made, and is also projecting parts of the self in order to manage psychic pain. The pain would be characterised by an underlying sense of depression and worthlessness and the great difficulty of managing loving and hating feelings towards the same person hidden and disguised by an omnipotent state of mind. The term 'refractive transference' has been used to reflect thinking in progress about the room as a container for the liquid psychic state of very disturbed children. It is an umbrella term to cover the oblique projections and transference that may be split to different aspects of the setting, including the therapist.

In this chapter the aesthetic moments have involved journeys around the maternal object, inevitably a mixture of an internally created object, the external mother and the therapist. For each child, some aesthetic quality of the Holbein picture, its clarity of line, empty spaces, rosy tint and composure, attracts the beholder, and some aspect of their inner experience is located there. Different frames can be put around such experiences with external objects. Bollas describes how we psychically signify objects and that this can be a positive aspect of projective identification. It can be seen either as a splitting and projection of an idealised internal mother experienced in the

picture, or as transference of a previous moment of illumination between mother and child – as an aesthetic moment of experiencing with a picture, or as transference of feelings from a past relationship to the therapist which feels too dangerous to experience person-to-person. What seems to be important is that with the safe location of experience in the Holbein (part of the setting) each child is able to 'journey around the maternal object' as they draw and paint. In all the pictures discussed the children's fluctuating states of mind and their relation both to aspects of inner life and to the therapist effect changes as they work.

For a child such as Wendy who is struggling with psychotic fears and terror of leaking away, or a child such as Tracey who is in flight from the experience of abuse, depression and pain, brief moments of experimentation and experiencing need to build up over months of work before a triangular relationship may develop. I have included in the chapter a more standard art therapy session where Simon comes in and sits down and engages with art materials directly. This has been partly to contrast this session with the other two examples, but also because of the interweaving flow of positive and negative transference and the opportunity to explore copying, imitation and identification in relation to the picture by Holbein.

Experience suggests that with more disturbed children a picture evolves out of fluctuating states of mind, and at some point in the session, amidst a welter of other activity. I have mapped the session with Wendy like a star con-stellation to demonstrate more effectively the splitting of parts of self and transference around setting, image and therapist. The session with Tracey has been mapped like a roundabout to suggest the eternal flight of manic defence that is very fast without actually getting to a new place. There is a flit from activity to activity in a sequence. I have in this chapter both attempted to map a whole session like this and also to map the moments of aesthetic interaction with the Holbein and image-making.

It is hoped that these kinds of sessions with Wendy, Simon and Tracey will be familiar to therapists working with disturbed children, and that the attempt to differentiate and name them will be useful in conceptualising process in art therapy. If the notion of a triangular relationship can be rethought then it may enable us to work more resiliently with the downward spiral of mess and chaos which these children frequently generate, a long stage on the way towards containment of feelings through image-making in a relationship. Therapy jargon and technical terms abound, but the idea of refraction – perhaps the meeting of the mediums, the child's inner world, the setting and all its contents – could be quite a helpful one; as if the child's pro-

jections/transference hit the surface of the room and shoot off to alight on images, mediums, furniture, spaces, toys and therapist, and out of this there arises a creative potential.

References

Balint, M. (1968) *The Basic Fault.* London: Tavistock.

Bollas, C. (1987) *The Shadow of the Object: Psychoanalysis of the Unthought Known,* London: FAB.

Bollas, C. (1992) *Being a Character,* London: Routledge.

Case, C. (1985) 'Superman, Smurfs and Cinderella.' Conference paper: Eleventh Congress of the International Society for the Study of Art and Pyschopathology.

Case, C. (1987) 'A search for meaning: Loss and transition in art therapy with children.' In *Images of Art Therapy,* T. Dalley, C. Case, J. Schaverien, F. Weir, D. Halliday, P. Nowell-Hall, D. Walter (eds) London and New York: Tavistock.

Case, C. (1990) 'The triangular relationship (3): The image as mediator.' *Inscape: Journal of Art Therapy,* Winter, 20–26.

Case, C. (1992) 'Superman, snakes and Snow White.' *Japanese Bulletin of Art Therapy 23,* 1, 134–147.

Case, C. (1994) 'In the belly of the spider.' *Inscape: Journal of Art Therapy,* 1, 3–10.

Case, C. (1995a) 'Silence in progress.' *Inscape: Journal of Art Therapy,* 1, 26–31.

Case, C. (1996) 'On the aesthetic moment in the transference.' *Inscape: Journal of Art Therapy, 1,* 2, 39–45.

Case, C. (1997a) 'Keeping mum.' Unpublished paper.

Case, C. (1997b) 'Silence in the session.' Unpublished paper.

Case, C. (1998) 'Brief encounters: Thinking about assessment.' *Inscape: Journal of Art Therapy, 3,* 1, 26–33.

Case, C. (1999) 'Foreign images.' In *Art Therapy, Race and Culture,* J. Campbell, M. Liebmann, F. Brooks, J. Jones and C. Ward (eds) London: Jessica Kingsley Publishers.

Damarell, B (1999) 'Just forging, or seeking love and approval?' *Inscape: Journal of Art Therapy, 4,* 2, 44–50.

Freud, S. (1921) *Group Psychology and the Analysis of the Ego.* Standard edition, 18, 69, 105. London and New York (1995). The Hogarth Press and the Institute of Pyscho-Analysis.

Houzel, D. (1996) 'Bisexual aspects of the countertransference in the therapy of psychotic children.' In *Countertransference in Psychotherapy with Children and Adolescents.* J. Tsiantis, A-M. Sandler, D. Anastasopoulos and B. Martindale. London: Karnac.

Klein, M. (1946) 'Notes on some schizoid mechanisms.' In *Envy and Gratitude, and Other Works 1946–63.* M. Masud and R. Khan (eds) London: The Hogarth Press and the Institute of Pyscho-Analysis.

Kuhns, R. (1983) *Psychoanalytic Theory of Art: A Philosophy of Art on Developmental Principles.* New York: Columbia University Press.

McNeilly, G. (1989) 'Group analytic art groups.' In *Pictures at an Exhibition,* ed. A. Gilroy and T. Dalley, London: Tavistock/Routledge.

Ogden, T. (1992) *The Primitive Edge of Experience.* London: Karnac.

Schaverien, J. (1990) 'The triangular relationship (2): Desire, alchemy and the picture.' *Inscape: Journal of Art Therapy,* Winter, 14–19.

Schaverien, J. (1992) *The Revealing Image,* London: Routledge.

Schaverien, J. (1994) 'Analytical art psychotherapy: Further reflections on theory and practice.' *Inscape: Journal of Art Therapy,* 2, 41–49.

Schaverien, J. (1995) *Desire and the Female Therapist*, London: Routledge.

Segal, H. (1957) 'Notes on symbol formation.' *International Journal of Psycho-Analysis*, 38, 391–397.

Skaife, S. (1995) 'The dialectics of art therapy.' *Inscape: Journal of Art Therapy, 1*, 2–7.

Winnicott, D.W. (1951) 'Transitional objects and transitional phenomena.' In *Through Paediatrics to Psychoanalysis*, London: Hogarth. (reprinted London: Karnac, 1992).

Wood, C. (1990) 'The triangular relationship (1): The beginnings and endings of art therapy.' *Inscape: Journal of Art Therapy*, Winter, 7–13.

Wood, M. (1984) 'The child and art therapy: A psychodynamic viewpoint.' In *Art as Therapy*, ed. T. Dalley. London: Tavistock.

The Triangular Relationship and the Aesthetic Countertransference in Analytical Art Psychotherapy

Joy Schaverien

This chapter is offered with the intention of attempting to illuminate the current state of the practice of art therapy. The aim is to find ways of understanding, as well as questioning some of the similarities and differences in existing practice and to distinguish some of the processes which are included in the overall heading of art therapy. The chapter is drawn mainly from my own experience, working as an art therapist in many different settings, as well as from my current position as a Jungian analyst in private practice. Thus, in many ways, the chapter traces my own development but it is intended to include a description of some of the approaches which are common within the profession.

The triangular relationship

The chapter centres on a deceptively simple question: What does it mean when art therapists describe an art therapy relationship as triangular? Is there really a simple triangle that is made up of a picture at the apex of the triangle: client–picture–therapist?

I propose that, in practice, this a highly complex set of processes which merits close attention. In different settings and with different client groups, this triangle constitutes in a variety of ways. Each profoundly affects the ways in which we can work with the transference and, as therapists, use our countertransference responses. Furthermore the picture evokes an aesthetic

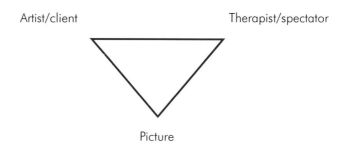

Figure 2.1 Simple triangle

countertransference from both the therapist, as spectator, and also from the client as viewer of her or his own picture. Attention to this reveals the meaning of the difference in emphasis in these triangles. This is a development of my discussion of these issues in *Desire and the Female Therapist* (1995).

In the triangular relationship to which I am referring there are two distinct stages and each involves the process of looking – a gaze. Elsewhere I have identified these stages as 'the life *in* the picture' and 'the life *of* the picture' (Schaverien 1991, 1994). The 'life *in* the picture' is the life, which fuels the process of making the picture, and 'the life *of* the picture' is the life *of* the picture, as an object, once it is made. These are respectively the transference embodied in the artwork and the countertransference to the picture as an object. I will argue that when both are fully activated a dynamic field is created which engages all the elements of the imaginary triangle with an equal balance between its three points of client–picture–therapist. However, the dynamic field is not always fully active and it is my hypothesis that with specific client groups and in particular settings, the elements of the triangle constellate in different ways. These differences centre on the primacy of the image which may alter, depending upon the depth of engagement in the art process and the therapeutic relationship respectively. The discussion needs to be contextualised and so I start from the debate about the name of the profession.

Art psychotherapy – Art therapy

The name has caused a good deal of political debate within the British Association of Art Therapists (BAAT). Whilst some practitioners are known as 'art

therapists', others prefer the title 'art psychotherapist'. By implication the chosen title seems to indicate some difference in practice; however, the precise nature of this difference is not always clear. Art therapists come from a variety of backgrounds and work with different client groups, and so have diverse experiences in the field. Some have undergone further training in psychotherapy or analysis or other specialist areas of practice which influence their practice. Perhaps these differences are reflected in a preference for one or the other title. It seems that this is a potentially very rich environment in which to explore differences as well as similarities.

In a profession such as art therapy developments evolve from practice; it is out of this that theory gradually emerges. The history of art therapy in Britain (Waller 1991) and the USA (Junge and Asawa 1994) has been documented and many aspects of developments in theory and practice, in Britain, have been traced by Waller and Gilroy (1992), Waller and Dalley (1992) and Case and Dalley (1992). Gilroy and Lee (1995) offer an overview of approaches to research within art and music therapy. Wood (1997) has traced the origins of art therapy in Britain with reference to therapists working with patients who had a history of psychosis. This theoretical background to the ideas I am discussing is very important but my intention is not to offer a historical overview. However, certain ideas directly relate to my topic.

McNeilly (1984) in a paper entitled 'Directive and non-directive approaches in art therapy' named his non-directive approach 'group analytic art therapy'. He observed a difference in the primacy of the image in directive and non-directive approaches, in group art therapy. Thus he began to focus debate regarding difference in art therapy practice. Case and Dalley (1992) introduced the notion of a '"standard" practice of art therapy'. This they describe as being 'based on the training and experience of art therapists – that is, a qualified professional who meets the required basic standards of acceptable practice as outlined by the British Association of Art Therapists (BAAT)'. They continue, 'the approaches and orientations of art therapists vary enormously, particularly in relation to the client group…' (Case and Dalley 1992, p.1). It is these variations and differences within art therapy that I am attempting to differentiate.

My intention is to offer some suggestions about how we may accommodate difference within the profession without total polarisation. This is reminiscent of the pluralist philosophy towards the various schools of depth psychology proposed by Samuels (1989, 1991). The idea is that personally,

and professionally, there are many voices which influence us simultaneously, and that this offers the potential for creative discord.

Analytical art psychotherapy

In *The Revealing Image*, which was completed in 1990 and published in 1991, I introduced the term 'analytical art psychotherapy'. My stated aim was

> to establish the central role of the picture as a vessel within which trans-formation may take place and this involves the picture as an object of transference... The term Analytical Art Psychotherapy is not intended to exclude either art therapy or art psychotherapy but rather to establish the power which both of these at times may generate. Thus it is intended to be inclusive rather than exclusive... The term Analytical Art Psycho-therapy is derived from two sources: Cassirer and Jung... (Schaverien 1991, p.7)

The intention was to find a way of acknowledging the power sometimes generated by the pictorial images made by clients and the ways in which these can, in themselves, be formative. This formative nature of the art object, in the case of analytical art psychotherapy, is mediated within the context of a boundaried, therapeutic relationship. This creates a dynamic field where transference interpretations may take place in relation to the picture as well as the person-to-person relationship. The term allies this mode of art therapy with analytical psychology and analytical forms of psychotherapy; thus I am proposing that certain forms of art therapy may also operate as depth psychology. My own thinking has developed since writing this and it is now possible to make some further distinctions, and so I will explore what is included within the wide spectrum of the term 'analytical art psychotherapy.' My premise is that differences in approach in art therapy tend to constellate around attitudes to the transference and countertransference.

The aesthetic transference and countertransference

The aesthetic effects of pictures made or viewed within the analytic frame form a central aspect of the work in analytical forms of art psychotherapy. It has often been claimed that the aesthetic quality of art created in psycho-therapy is of no interest to the therapist. In the past the therapist was expected to be interested in the process, the making of the art object, rather than the end product. The process was considered to be healing in itself and

the aesthetic quality of the art work was then regarded as close to irrelevant. For many years this view prevailed but recently the aesthetic has started to receive wider attention, from Maclagan (1989, 1994), Gilroy (1989), Simon (1991), Schaverien (1991, 1995) and Case (1996). This is significant because, in order to be conscious of our responses as therapists, we need to monitor all aspects of the countertransference, and the aesthetic appreciation of the picture, even when it is not good as art, is one aspect of this.

In an attempt to make a distinction between different types of aesthetic affects in pictures I have identified two distinct types of image or art object. These are the diagrammatic and the embodied image respectively (Schaverien 1987, 1991). The difference reflects the transference that is made to the art work in the process of its creation. This distinction is informed by aesthetic considerations. The diagrammatic image may be made to tell something to the therapist. Very often it is a conscious form of communication made with the therapist in mind – perhaps to help in recounting some feeling state, dream or memory. The picture itself may be of rather poor aesthetic quality; it may use only line or pin figures. It is like a map, an aid to telling the therapist about a dream or memory; it records the basic relationships but in itself it effects little change. Feeling may be evoked in relation to it but the picture itself does not transform the state of the artist. If we consider this in the light of the triangular relationship we might observe that the central focus is the person-to-person axis, whilst the picture forms an illustration usually demanding a spoken explanation of its meaning.

The embodied image is rather different; it is a picture or art object which conveys a feeling state for which no other mode of expression can be substituted. Such a picture engages the artist/client in its making; it is as if the picture seems to lead, becoming something rather different than originally intended. Often such a picture reveals some previously unconscious element in the psyche. This embodiment of a feeling state may be understood to be a form of 'scapegoat transference' (Schaverien 1987, 1991) – a transference embodied in the picture which may reflect or reveal the transference to the therapist. The point about the embodied image is that, in the process of its creation, feeling becomes live in the present and so the psychological state of the artist/client is transformed. Such a picture plays a significant part in the healing process. Here the picture is central and all the points of the triangle are activated, creating a dynamic field between them.

One way of assessing which type of image one is regarding is to pose the question: Could this be conveyed in any other way? With the diagrammatic image words are needed to explain what is shown in the picture. The

embodied image needs no words, there is no substitute for the image; it reveals but it tells nothing. The point in reiterating this is that the aesthetic countertransference is one means of distinguishing the difference. It is through the aesthetic appreciation of the art object, within the therapeutic relationship, that understanding emerges.

The investment made in a picture as it is created is evident in the finished work. Therefore in regarding an art object, whether or not we are conscious of it, we bring into play our aesthetic sensibilities. In regarding the embodied image it is evident that its aesthetic quality is more complex or visually engaging than is the merely diagrammatic image (Schaverien 1991, p.85). I emphasise that the work does not have to be great art; in fact, art works created within therapy rarely stand alone as art. Nonetheless, within the context of the therapeutic relationship they may have the effect of engaging the aesthetic sensibilities of both therapist and client and so influencing the countertransference. This 'aesthetic countertransference' (Schaverien 1991, p.117; 1995, p.141) is affected by all the subtleties of the colour, line, form figurations and tonal relationships. These elements of the 'life *in* the picture' subsequently contribute to the 'life *of* the picture'.

The primacy of the image

I propose that the different titles of art therapy which are evolving within the profession need to be given some distinctive notation. Therefore, based on existing practice, I have proposed three different categories (Schaverien 1994):

1. art therapy
2. art psychotherapy
3. analytical art psychotherapy.

In all these forms of art therapy, the innate healing potential of art is a common factor. I make the point because it is important for me to establish that this is not in dispute. I am assuming that, in all forms of art therapy, the power of the artist's relation to the art work is respected. The difference may centre on the priority of the image and whether or not the picture is treated as a central element within the transference.

It might be helpful to imagine each of these categories itself as a picture made up of figure and ground. The art process and the therapeutic relationship constitute the interrelating aspects of this figure and ground. The three categories might then be viewed in the following ways:

In **art therapy** the art process would be the figure, the focus of attention; the therapeutic relationship the necessary ground from which it emerges. The triangle is centred in the image and so the *client–picture–client* axis is activated. The therapist as a witness (Learmonth 1994) is a more peripheral figure than in the other two combinations.

In **art psychotherapy** (and some forms of psychotherapy) the therapeutic relationship would be the figure and the pictures the ground. Here the axis *client–therapist* is the main focus. The pictures illustrate the therapeutic relationship or recount some aspect of the history. They may even record the transference in some way but are essentially the backdrop for the more important person-to-person transference and countertransference relationship.

In **analytical art psychotherapy** the two are interchangeable. The dynamic field is fully activated. The pictures interrelate with the person-to-person transference and countertransference. Neither figure nor ground has priority; they are of equal status, creating an alternating focus which integrates the pictures fully within the transference. Thus the triangle would constellate equally as *client–picture–therapist*.

This is a linear description of processes which are far from linear in practice, and so I emphasise that these distinctions are made for the sake of attempting to differentiate these elements. This is not intended to be definitive, prescriptive, nor hierarchical. In examining my own work I realise that, as well as being the province of different people, these differences of approach may be evident in the work of the same practitioner. They may well be engendered by responding to the needs of a particular client, clinical situation or client group. They may also reflect the experience, interests and further training of the individual practitioner.

As the common feature in the forms of art therapy I am noting is the scapegoat transference in the picture, I will briefly recap this theory. In the past I have applied Greenson's (1967) division of the therapeutic relationship in order to clarify the transference in art therapy (Schaverien 1991, pp.15, 37). Thus we have:

- the real relationship.
- the therapeutic alliance.
- the transference.

And following this, I have added:

- the scapegoat transference.

The scapegoat transference is a transference to the picture which may, or may not, be linked to the traditional psychoanalytic transference. It is an engagement in the picture, by the client/artist, and psychological change or insight may be generated through the relation to the art object. The diagram (Figure 2.2) may help to clarify the distinction. I am suggesting that these aspects of the therapeutic relationship have different priority in the various forms of art therapy. As with all linear representations, the boundaries are not as clearly defined as a diagram might suggest, and in practice these different categories may blend into each other and overlap.

TRANSFERENCE IN DIFFERENT FORMS OF ART THERAPY

	Art therapy	Art psychotherapy	Analytical art psychotherapy
Real relationship	■	■	■
Therapeutic alliance	■	■	■
Transference		■	■
Scapegoat transference	■		■

Figure 2.2 The therapeutic relationship in different forms of art therapy

In Figure 2.2 we see that in art therapy (in the first column) and art psycho-therapy (in the second column) one of the categories is missing. in the third column, all the elements come together in analytical art psychotherapy. To further elaborate these distinctions, I offer an additional diagram (Figure 2.3):

THE SCAPEGOAT TRANSFERENCE

	Art therapy	Art psychotherapy	Analytical art psychotherapy
Identification (unconscious)	Non-verbal	Non-verbal	Non-verbal
Familiarisation (dawning consciousness)	Non-verbal	Non-verbal	Non-verbal
Acknowledgement (conscious)		Verbal	Verbal
Assimilation (conscious)			Non-verbal
Disposal (conscious or unconscious)	Action	Action	Action

Figure 2.3 The patient's relationship to the pictures in different forms of art therapy

Figure 2.3 is an attempt to analyse the 'life *of* the picture' (Schaverien 1991, p.106). In regarding the diagram, I would ask the reader to imagine that we are looking at the artist's relationship to her or his own pictures. The primacy of the image alters in each case. The stages of this process are:

Identification: there is an unconscious identification with the created image; there is no separation and the processes involved are non-verbal. This is an undifferentiated state and the gaze of the artist is held in the picture. If we invoke a mental image of the imaginary triangle, it would be as if the main axis of engagement was client–picture–client (Figure 2.4). The main engagement is between the client and the picture, and the therapist is a witness, offering containment. Words, at this stage, may be experienced as intrusive. The figure-ground constellates with the therapeutic relationship as the ground and the picture as the figure, the central focus.

Familiarisation is the dawning of consciousness – the beginning of differentiation. The client–picture–client axis of the triangle (Figure 2.4) is still primary, as the artist stands back and becomes a spectator of her or his own work. This too is a non-verbal relationship between the artist and picture; her/his gaze is held in the picture. The therapist, although

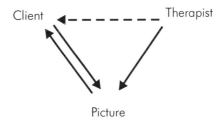

Figure 2.4 Identification / familiarisation

potentially a significant witness, is not called upon to intervene. This may be a normal stage in the development of a conscious attitude to the art work. However, there are times when the therapist is actively excluded and the engagement becomes a self-referential loop, which holds the 'client/picture–picture/client' axis as fixed beyond the point at which it is useful. (An example of this, with a patient suffering from psychosis, was given in Schaverien 1997.)

Acknowledgement is the stage when a conscious attitude to the image begins to consolidate. The artist/client may wish to engage the therapist as a second spectator at this point and to speak about the image. The triangle becomes fully activated. The therapist's role is acknowledged as central and the figure and ground may have equal intensity.

Assimilation is like the earlier stage of familiarisation in that the artist, as spectator, observes the picture. This is a return to the client–picture–client axis of the triangle but with a renewed understanding. The process

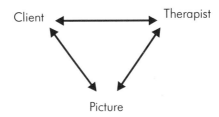

Figure 2.5 Acknowledgement and assimilation

follows acknowledgement and integrates the conscious understanding brought about by the previous stages. The therapist may be included, if not directly, in the conscious awareness of her presence. It is also a time for assimilation of interpretations which may have been offered by the therapist. The dynamic field may be active and the picture and therapeutic relationship interact equally. The figure and ground may alternate in priority.

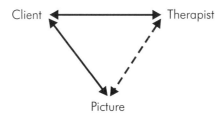

Figure 2.6 Disposal

Disposal is the final stage. If there is a concrete object, some form of disposal will occur. This may be a conscious and fully differentiated decision in which there is a transformation of the significance of the art work; it may be valued as a talisman. However, disposal may be an unconscious act – an attempt to be rid of some rejected element. The disposal of the art work is always meaningful, and the development of a conscious attitude to the disposal of the pictures is an important element in the resolution of transference in all forms of art therapy (Schaverien 1987, 1991 and 1995). At this stage, if the import of the picture has been assimilated, then it may be that the axis client–therapist takes on a more central role. The therapeutic relationship may then become the figure whilst the picture becomes the ground.

The categories that I will now discuss are based on these stages of the process.

Art therapy

In art therapy we might consider the picture as the figure and the therapeutic relationship as the necessary ground from which it emerges. The main factors operating are the real relationship, the therapeutic alliance and the scapegoat transference (Figure 2.2). In most cases there is a transference but it may be that it cannot be analysed for one reason or another. Perhaps the art therapist does not consider this to be a useful way of understanding the therapeutic relationship. There is a significant history to this approach.

Art therapists in Britain began as artists who worked in hospitals. The following give accounts of this history, and particularly the centrality of the artwork in this approach: Adamson (1985), Thomson (1989), Waller (1991), Simon (1991), Skailes (1997) and Henzell (1997). In addition Gilroy (1989), Maclagan (1989) and Lanham (1989) discuss various considerations in relation to the art in art therapy. Many of the early practitioners worked in a studio and considered that it was the healing potential of art itself that was the therapy (Lyddiatt 1971). Psychoanalytic theories such as transference and countertransference were considered to interfere with this process; they were the realm of the psychiatrist (Cunningham Dax 1953) or psychotherapist (Champernowne 1969, 1971).

Some art therapists work in a similar way today and, even when they observe the transference, interpretation may not be made. Of course, psychotherapists often refrain from interpretation when it is not appropriate for the client; this is a matter of timing in each case. However, I am suggesting that the main feature of art therapy is the client's non-verbal engagement with the picture. The picture offers a means through which the space between inner and outer worlds may be mediated. The effect of this is to alter the patient's relation to the self in some fundamental way. An analytical differentiation takes place, and unconscious elements may begin to become conscious, through the process of making and regarding the picture.

There may be technical reasons for not interpreting the transference directly. It may be inappropriate because the setting is contaminated by lack of a clear frame, as in some institutions. There may be a justified concern about unbalancing a fragile hold on reality with certain borderline or psychotic clients. With some child or adolescent clients there are times when it may be preferable not to interpret. The therapist may observe the transference but will refrain from interpreting it to the client. In this form of art therapy the stages (Figure 2.3) of identification and familiarisation are operating but the process does not significantly develop to the later stages. These demand a more complex ability to symbolise and so to use language.

For some clients, relating via the mediation of an art object permits the development of the ability to symbolise. Thus, eventually, the ability to relate as a separate person and even to use language in relationship may be developed. Several examples of this are shown in Killick and Schaverien (1997).

Elsewhere I have proposed that the picture may be related to as a transactional object and discussed how this offers a particular approach to working with clients suffering from anorexia (Schaverien 1995, p.121) or from a psychotic illness (Schaverien 1997, p.24). I will not repeat this but would make the point that in such cases the triangular relationship constellates as in art therapy. The scapegoat transference is central, with the real relationship and the therapeutic alliance as the often unacknowledged background.

Similarly, clients who lack the ability to verbalise or conceptualise, such as those with learning difficulties, have in the past been considered to benefit greatly from the art process, but often this was the limit of art therapy. Recently it has been shown that the therapist's understanding and interventions are informed by psychoanalytic theory (Goldsmith 1985; Hughes 1988). Cregeen (1992) demonstrates the use of the transference relationship with clients who have epilepsy, whilst Tipple (1993a) and Damarell (1998) both give examples of integrated applications of transference and counter-transference when working with clients with severe learning difficulties. Thus it is important to bear in mind these categories are not fixed but rather a means of focusing debate.

Many art therapists develop unconventional approaches to suit their client group. Some of these approaches could be recognised as theoretical developments. Thus there is a need to formulate these differences in order to understand more clearly the range of art therapy that already exists. To illustrate I cite two of the many art therapists who have developed innovative ways of working, adapted to specific client groups. I should add that this is not intended as a comprehensive list but merely to give examples of the type of approaches that I have in mind.

Gold (1994) works in a hospice with people living with terminal illnesses. Her aim is to enable her patients to come to terms with the remaining period of their lives and, when the time comes, their death. She does not work actively with transference interpretations, as this would be inappropriate, given the nature of this particular setting, as well as the state and wishes of many of her clients. (I am not suggesting that working with the transference is inappropriate with all who are dying. For discussion of approaches to physical illness see Scaife (1993). For an example of a case

where the transference/countertransference dynamic was central in analysis with a dying client, see Schaverien (1999).) Most of the clients in the setting where Gold works do not require psychotherapy; none the less, the therapeutic relationship and the art process are centrally linked in her practice and she adapts her working method to suit the needs of individual clients.

Gold has developed a method of working with those people who are too disabled to make their own paintings or drawings. She draws for such patients, using her own previous experience as a trained and experienced graphic artist, to visually interpret the mental images they describe to her. In this way the patients externalise their own internal images and engage in the therapeutic relationship. Such an approach, where the art therapist applies her or his skills as an artist, has not been generally discussed in the literature as far as I know. This is curious, as a number of art therapists do draw for their clients; Tipple (1993b) writes about this as an integrated part of the process in his work. This is a special contribution that artists/therapists have to offer.

Karban (1994) works in forensic psychiatry and she too has evolved a particular way of working to suit her client group. The work here is a meeting of the therapist and client through the pictures. The triangular *client–picture–therapist* relationship facilitates a way of being together and relating in the present. The clients with whom Karban works have committed acts of an unspeakable nature; those which are usually the substance of imagined fears. Unlike most other client groups these people are not dealing merely with murderous fantasies but with the terrible reality and consequences of past acts. For this reason insight is intolerably painful and, indeed, not in the best interest of the client. These clients need to be permitted to use art therapy in a very particular way in order to meet another human being and, to varying degrees, themselves.

These two examples are offered with the intention of giving a sense of the diverse approaches which are accommodated within the umbrella term 'art therapy'. I suggest that we need to recognise that these are significant forms of art therapy, where knowledge of transference and countertransference is essential, but interpretation to the client is inappropriate. Many art therapists work in settings which engender this type of approach to the transference. It seems that, if the art therapist truly follows the needs of the client, this may lead to creative solutions with specific clients or client groups. In these cases we might see the triangular relationship as constellating in the following way:

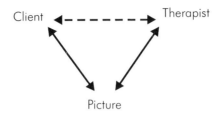

Figure 2.7 Art therapy – The scapegoat transference

The scapegoat transference is central and the real relationship and the therapeutic alliance may be the background. In art psychotherapy this priority is reversed.

Art psychotherapy

In art psychotherapy the real relationship, the therapeutic alliance and the transference are applied as in Figure 2.2, but the pictures are rarely an embodiment of the transference. They may illustrate it in a diagrammatic way, but this is different. I will discuss this with reference to my own experience.

In 1982, having worked as an art therapist in psychiatric settings, I was appointed to a psychotherapy training post in the British National Health Service. Although there was then, as now, no officially recognised statutory designation of art psychotherapist, this was how the post was described within the psychotherapy department. I changed from working as an art therapist in psychiatry to a training post in the psychotherapy department. I participated in seminars and was supervised by the consultant psychotherapist. In this way I began to acquire additional skills in the area of psychotherapy. This is important because it is not possible to merely change departments; I consider that additional training is necessary to equip the art therapist to offer psychotherapy.

It was in this setting that I began to sense a need to articulate the difference in what I was offering to clients then and what I had previously been able to offer. The distinction is that in art therapy, although the transference is always present, it is not always possible to analyse it. In art psycho-

therapy it is possible to work fully with the transference. This is due to the regularity of appointments and the fact that art psychotherapy is usually offered to outpatients. This means that, if the art psychotherapist is the only therapist involved with a patient, a boundaried approach can be maintained.

This has an effect on the role of the picture in therapy. In common with other colleagues, who have made such a change in their working setting, I found that it was not always possible to keep the art process central. If we regard the diagram Figure 2.2, I am suggesting that in art psychotherapy the real relationship, the therapeutic alliance and the transference operate very much as in other forms of psychotherapy. The scapegoat transference in the pictures is interpreted as part of the transference between patient and therapist. This means that art may come to be of secondary significance because it is a means to an end, i.e. an additional way of coming to understand the transference, so it may be that the patient does not fully engage with the art process.

There are many forms of art therapy which mix with other forms of psychotherapy and the art process then takes a less prominent position. For example, McNeilly's (1984) group analytic art therapy was criticised, when his paper was first published, on the grounds that he points out that the picture moves to the background when the group process is analysed. Donnelly (1989, 1992) and Deco (1990) discuss the role of the pictures in art therapy with families. Here the pictures are used as a means of communication, and of revealing the family dynamics, rather than being permitted their full power as means of personal exploration.

Moreover, the picture may be given scant attention by the patient who is eager to get to what s/he feels to be the 'real' business of talking. The transference to the therapist may come to dominate and the pictures then become more like illustrations. An example would be a diagram of a dream that is made to show the therapist how parts of the dream related. This is different from spending time painting a dream where the picture begins to develop a life of its own. In the triangular relationship in this case the axis client–therapist (Figure 2.8) is the central focus of attention, and the picture illuminates the therapeutic relationship but does not effect change in itself.

Here the therapeutic relationship is the figure and the picture is the ground. At times art psychotherapy is a psychoanalytically informed approach where the pictures are interpreted within the existing framework of psychoanalytic and object relations theories. The effect may be that the pictures are seen as expressing some element of regressed behavior and so they are interpreted as such. This reduces the impact of the imagery. The

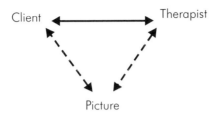

Figure 2.8 Art psychotherapy – Central axis the therapeutic relationship

picture becomes framed, as it were, within a deterministic philosophical attitude. Thus in Figure 2.3, the pictures are subject to all the stages I have outlined, but the non-verbal processes, in relation to the pictures, are not always given their full space. The stages of familiarisation and assimilation may be disturbed by interpretation. This is not necessarily negative; in fact, it may be helpful, and in the interest of the patient, because the unconscious material is more accessible to consciousness and to verbal acknowledgement.

In a culture where the spoken and written word is the dominant method of communication, I have found that it is not always possible, nor in the interest of the client, to insist that they participate in art psychotherapy from the beginning. If the person has been referred by their GP they have come expecting to talk to someone; often the patient is desperate to do so. It is then questionable if it is in their interest to insist on them painting from the start. Engaging with art materials can be a source of anxiety. Whilst, in some cases, it is justifiable to expect the patient to overcome such reticence, and even to treat it as resistance, there are other times when it may be necessary to permit time to elapse prior to the introduction of art materials. Thus the art process becomes secondary to the therapeutic relationship. Pictures may play a significant part, but only during certain periods in therapy; for example, during a particularly regressed phase when words become inadequate to express the current feelings.

Other reasons for the less potent role of the pictures may be that the production of artwork is limited by the 50-minute hour. With the more articulate patient, the pictures may be interpreted rather sooner than in other forms of art therapy. It is possible then that the patient's relationship to her or

his own picture is interrupted by the intervention of the therapist. An inter-
pretation may alter the process and change priorities. The power may be
held in the transference and countertransference between the people. Here
art psychotherapy and forms of psychotherapy where pictures are brought to
sessions may begin to merge. The triangular relationship may be fully
engaged but the picture does not engender a dynamic field.

Analytical art psychotherapy – The dynamic field

In analytical art psychotherapy, Figure 2.2, all the elements of the transfer-
ence in art therapy operate, and this creates a dynamic field where the tension
between all three points of the triangle are of similar significance. This
creates a tension, which may include the picture as a central element within
the transference/countertransference.

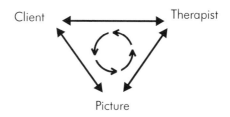

Client ⟷ Therapist

Picture

Figure 2.9 The dynamic field

In analytical art psychotherapy the term 'analytical' is key because it
emphasises the analytical differentiation which takes place through the
picture. It is an approach which is allied to both depth psychology and
analytical psychotherapy. The term 'analytical' is intended to indicate that
consciousness is attained through the client's relation to the art work, as well
as through the therapeutic relationship. In the third vertical column in the
diagram, Figure 2.2, there is the real relationship, the therapeutic alliance, the
transference and the scapegoat transference to the picture. These carry equal
weight in analytical art psychotherapy.

I would add that, although the engagement with the art process is central,
it is not idealised; nor is it separated from the impact of the therapeutic rela-

tionship. Engagement in analytical art psychotherapy is sometimes expressed, for example, by the patient forming a negative transference to the art therapist or to the process. This may manifest itself in the imagery produced in the pictures, or in not painting, or in numerous other ways. The point is that both the art process and the therapeutic relationship are held to be central in this form of analytical therapy.

Regarding Figure 2.3, all the categories of the life in the picture are activated. The patient may move through all the stages of identification, familiarisation, acknowledgement and assimilation, eventually to a conscious disposal of the art work. This takes place at the end of therapy or at some time during the process. Analytical art psychotherapy may take place in a psychiatric setting, but it is more likely to be possible in a more formal psychotherapy department or in an analytic practice where the appointments take place weekly or preferably more frequently. The application of all the categories I have outlined would depend on the level of disturbance of the individual patient and the ability of the setting to provide the holding needed for a depth process. This is the point: analytical art psychotherapy is a depth analytical process.

Case illustration

I will give an example of the way in which the dynamic field is created and the triangle fully activated. In this case art therapy and art psychotherapy were activated at different times within an analytical art psychotherapy encounter.

Figure 2.10 (see illustration below): in the centre of the picture, very faintly drawn in pencil, is a raised hand and forearm. A precise incision is drawn in red paint, and from the wound drips of paint appear like drops of blood. The lower half of the picture is divided from the top. Here, also faintly drawn, a figure lies on the ground in a pool of blood. This division of the picture seems to suggest a time lag and to show the result of the wound; the figure lies lifeless as the blood drains from her.

Lisa, a professional woman of 29, had been in psychotherapy for a few months when she made this picture. She was experiencing powerful suicidal impulses and we had an agreement that, when they became unbearable, she would telephone me rather than acting on the feelings. This picture, along with two others on a similar theme, was made one evening when she was feeling at the end of her resources and after she had phoned me. She did not think that she could continue living; she felt alone, isolated and abandoned. I

Figure 2.10

was fully convinced that there was a real suicide risk and the picture confirmed it.

'Is this a diagrammatic or an embodied image?' In order to assess this the additional question arises: Could this have been conveyed in any other way? If the answer is yes, then it is likely to be a diagrammatic image; if on the other hand it is no, then it is likely to be an embodied image. I suggest that this picture carries elements of both; it does certainly tell the therapist how Lisa was feeling and that was one aspect of its purpose. However, it is also an embodiment; it conveys the state in a vivid manner which no other mode of expression could have so graphically revealed. It enabled Lisa to bring the desperate feelings of the previous night into the present of the therapeutic relationship. It reveals, rather than describes, a feeling state for which there was no other adequate mode of expression.

Although this picture is rudimentarily drawn it conveys its message unambiguously. Feeling was live in relation to the picture, when it was made, and I consider that in some ways it was a rehearsal; an enactment of the suicidal act. The picture is not altogether symbolic; it was close to a concrete enactment of the state which might otherwise have been acted out. An enactment such as this does not symbolise the act but it is at one remove from it. The picture creates a space between the impulse and the act and this is the import of such an image; it holds the feeling state 'out there', separate from the artist, until the feelings can be integrated. Thus the picture may be understood to embody a form of 'scapegoat transference'; it holds the feeling state from last night, live within the frame of the picture, and brings it into the therapeutic setting.

How do we assess the authenticity of such a feeling in the present? There are several points I wish to draw out in connection with my theme. The first is the effects of such a picture on the therapist.

The aesthetic countertransference – the therapist

The aesthetic countertransference is activated as the therapist gazes on the picture. Here the immediate response was a certain revulsion at the technical precision of the wound. Thus, although this picture would in no way stand alone as art in the world, its effect was profound and immediate. This was a result of its unambiguous message; the picture and its creator demanded immediate attention. Is this an aesthetic judgement? I suggest that the aesthetic quality of the picture is secondary to its message, which overrides any sense of the picture not being 'very good' art. Within the therapeutic frame it clearly conveys its message.

This image holds its place at the centre of the therapeutic triangle by the impact of its content and thus it evokes a countertransference. Of course the aesthetic elements of line, form, figuration and colour contribute to its impact, but this is secondary to the evident distress of the artist as she brought the image out into the light. The triangular relationship is fully activated, but this is an art psychotherapy interaction. The person-to-person dynamic is central and the picture tells of the feeling. This is a necessary and significant development in the therapy but the picture itself does not significantly transform the state of the artist.

The picture combined with my knowledge of Lisa to convince me of the seriousness of her suicidal intentions. It seemed that Lisa had made the picture instead of committing the act portrayed.

The aesthetic countertransference – the artist.

Embodiment affects the countertransference. When Lisa made her picture it seemed that she was probably totally engaged in it. At that time there would have been no separation between herself and the created image. This is the stage of *identification* (Figure 2.3). The picture became a scapegoat in that it embodied the current feeling state. The transition to the next stage of *familiarisation* may have taken place directly after making the picture when she stood back and regarded it. It seemed that there was some release of the intensity of the feelings as she became familiar with it. Graphically conveyed, she was now able to view both the act and its potential consequence. This could be understood as a rehearsal of the act she was considering. I suggest that, despite the urgency and despair of her situation at the time, the impact of the imagery was such that she was able to refrain from cutting herself. The impulse was now held outside of herself within the picture. The image was sufficient to contain the situation until her session the next day.

Of course, because the picture was not made in the presence of the therapist, it could be thought that this was a hysterical gesture without emotional content. The only way that this can be assessed is in the feeling tone of the session in which it is presented, but also in the knowledge of the client, derived over time. If it develops in a meaningful manner the therapy deepens. This can be gauged as in any other analytic encounter through attention to the countertransference.

In the stage of *acknowledgement* the artist consciously begins to acknowledge the implications of the picture and to talk to the therapist about it. Bringing the picture to therapy evokes many additional concerns, some of which include anxiety about the aesthetic quality of the work. Lisa was worried about how the picture would be received – was it good enough? An additional concern was, would I believe and take her seriously? This was a manifestation of the transference; she would often stand outside of herself and view her emotions in a critical and disbelieving manner. Thus her concern about whether the work was 'good enough' was also a concern about whether she would be acceptable when she revealed the extent of her distress.

Figure 2.10 was not pleasing to Lisa but it did impress on her the reality of the potential outcome of the impulse; she could stand outside and view herself lying on the floor bleeding. This was the beginning of the process of differentiation. Gradually a transformation in her state began to take place and this is revealed through the following pictures made at disparate intervals during the process of therapy.

Figure 2.11

Made a year later, Figure 2.11, entitled 'ANGER', was one of five made during the same week. In assessing the impact and aesthetic effects of pictures in art therapy or analysis it is important to analyse exactly what we see. Therefore I will describe the visual elements of this embodied image. The picture is quite small and square and at the centre is a red circle, surrounded by a ring of orange and then one of a dark purple. The gaze of the viewer is taken immediately to the centre and then leads outward to a jagged rim made up of orange triangles surrounded by a purple/blue and then an outer edge of the same red as that at the centre. The whole is held in a ground of blue and framed in the same red. From the tip of alternate triangles a line of red joins up with the outer frame.

Regarding its aesthetic quality this picture is a whole; all the elements are integrated. I do not suggest that this is a conscious and considered design, but rather a response to the engagement of the artist in the process. She was feeling angry when she made it. Lisa had learned not to express her anger, and so we begin to understand that Figure 2.10 was an expression of anger turned inward. In comparison, Figure 2.11 shows anger which is owned and expressed visually. Furthermore, in the year since the first picture was made

we see that the artist has become more confident with her use of the art materials. The picture appears to have been painted without much hesitation; visually there is a coherence.

Thus, whilst Figure 2.10 was a combination of both the diagrammatic and the embodied image, I would suggest that this is an embodiment of the feeling state. This was live at the time it was made and is carried through into the aesthetic quality of the picture as a whole. Lisa entitled it 'ANGER', and told me that this was an explosion of her feeling state. The picture confirms this but its coherence suggests an additional meaning to me. The embodied image could be understood, in this case, also as a self-image. This echoes the transference where Lisa was beginning to challenge the taboo on expression of her emotions. She was now able to let me know directly when she was angry with me. The picture reveals the explosive and fearful nature of her anger. She was previously unconscious of the connection between her anger and her suicidal feelings. However, through the manifestation of it in such pictures and through interpretations this gradually began to become conscious.

Figure 2.12

Further significance can be given to the red, if we compare this picture to Figure 2.10, where the only colour was red. The red forms the central element and is contained at the centre of the circle. This might be understood as reflecting the containment provided by the therapeutic setting. A year later a series of serpents begins to symbolise the power of the anger and her fear of it. Words combine with the imagery to reveal a more conscious attitude.

Lisa began to describe her anger as like a bag of serpents (Figure 2.12), which she had to keep tied up. If they escaped she was afraid of what else would emerge with them. This figure reveals the bag's contents. On the left side of the figure are the words GUILT, DESPAIR and SADNESS. Each is attributed a colour associated with one of the serpents within the bag. On the right side, attributed to the largest red snake, is ANGER. Below this are HOPELESSNESS and ENVY and then, in small pencil marks as a kind of afterthought, 'frustration' and 'disappointment'. Sometimes when emotions

Figure 2.13

begin to differentiate words are needed to emphasise them. They tell the artist what she is experiencing (Schaverien 1997). This seems to be an embodied image, but it also has vestiges of the diagrammatic because it seems to illustrate a state which could be explained, although less graphically, in words. This picture was followed by Figure 2.13, a full year later. This was four years after the first suicidal picture and shows the serpents again, but this time out of their bag.

The serpents are wound together as two aspects of a whole and the words attributed to each convey her feelings in an articulate manner. The red one, the head of which has now changed sides and is on the left of the picture, has the unambiguous words I AM ANGRY attributed to it. The blue serpent, which was previously on the left of the picture, is associated with the words I FEEL HURT and, in tiny writing at the bottom right-hand corner, the words 'I can't' are written, along with the date. Thus Lisa now has words to express what previously could only be acted out. Wound centrally in with these two serpents is a purple shape which emerges above them and contains a green figure which might be understood to be an emergent aspect of her 'self'. Here the words unambiguously state her feelings and convey them first to herself, and secondly to me.

My intention in showing this series of pictures has been to illustrate how, in the work of one person, art therapy and art psychotherapy might be activated at different times within a framed and boundaried, analytical art psychotherapy encounter. The full triangle of client–picture–therapist is evoked and a dynamic field created. The figure/ground relationship alters in priority during this process, so that there are times when the picture was the figure and the therapeutic relationship the ground, and others when this was reversed. The point is that this was interchangeable and flexible during the course of treatment. Lisa valued her pictures and took them with her when she concluded her treatment. This was fully discussed, and thus it seemed that the elements which were initially held in the pictures had become integrated. Lisa could recognise her anger and no longer had the impulse to cut herself when she experienced painful feelings. This series reveals the dynamic field of the triangular relationship and shows how the aspects of it change during the course of the work with one person.

The aesthetic countertransference plays a central role and is activated in the client, as viewer of her or his own work, as well as the therapist. When the gaze of the client meets that of the therapist in the picture, the unconscious elements in the psyche may be illuminated. Thus the imaginal world is brought into the realms of the visible. In response to the question with which

this chapter began – What does it mean when art therapists describe an art therapy relationship as triangular?– I hope to have shown that this is a more complex area for investigation than might at first glance appear.

Conclusion

In conclusion I would once again emphasise that the categories of art therapy, art psychotherapy and analytical art psychotherapy which I have outlined are not intended as a prescription for practice. Nor are they hierarchical or fixed; in practice they overlap and interweave. These are different approaches, which are often arrived at as a response to the needs of the client and the therapeutic setting. The way of working is also based on the original background and further training of the art therapist. As I have indicated, these are all approaches I use or have applied at different times, in my own clinical practice. Over the years I have come to understand that it is relatively easy to elicit depth material through art. However, it is not enough to elicit such material; it must also be integrated within the personality. This demands some clarity of purpose as well as a boundaried setting.

In institutional settings a boundaried psychotherapeutic frame can not always be provided, thus there are times when the therapist has to adapt to the setting as well as to the needs of the client. In private practice a boundaried setting can usually be achieved, but it can be a challenging endeavour to work with the extreme states that the psyche sometimes presents. Thus the categories I am proposing may help to identify the limits and extent of what can realistically be offered in any particular clinical setting. It is my view that analytical art psychotherapy is particularly applicable in private practice, as it is analytical in relation to the art works. This is included within a psychoanalytical or depth psychological attitude to the therapeutic relationship as a whole.

References

Adamson, E. (1985) *Art as Healing*. Boston and London: Coventure.
Case, C. and Dalley, T. (eds.) (1990) *Working with Children in Art Therapy*. London and New York: Routledge.
Case, C. and Dalley, T. (1992) *The Handbook of Art Therapy*. London and New York: Routledge.
Case, C. (1996) 'On the aesthetic moment in the transference.' *Inscape* 1, 2, 39–45.
Champernowne, I. (1969) 'Art as an adjunct to psychotherapy'. *Inscape 1*, Autumn, 1–10.
Champernowne, I. (1971) 'Art and therapy an uneasy partnership'. *Inscape 3*, 1–14.
Cregeen, S. (1992) 'Seizure as symbol'. *Inscape*, Spring, 17–26.
Cunningham Dax, E. (1953) *Psychiatric Art*. London: Faber and Faber.

Dalley, T., Case, C., Schaverien, J., Weir, F., Halliday, D., Nowell-Hall, P. and Waller, D. (eds) (1987) *Images of Art Therapy*. London: Tavistock.

Damarell, B. (1998) 'Grandma, what a big beard you have! An exploration of the client's reaction to a change in the art therapist's appearance'. *Inscape* 3, 63–72.

Deco, S. (1990) 'A family centre: A structural family therapy approach.' In C. Case and T. Dalley (eds) (1990) *Working with Children in Art Therapy*. London and New York: Routledge.

Donnelly, M. (1989) 'Simultaneous and consecutive art expression in family therapy'. In A. Gilroy and T. Dalley (eds.) *Pictures at an Exhibition*. London and New York: Routledge.

Donnelly, M. (1992) 'Art therapy with families'. In D. Waller and A. Gilroy (eds.) *Art Therapy: A Handbook*. Oxford: Oxford University Press.

Gilroy, A. (1989) 'On occasionally being able to paint'. *Inscape*, Spring, 2–9.

Gilroy, A (1992) 'Research in art therapy'. In Waller, D. and Gilroy, A. (eds.) *Art Therapy: A Handbook*. Oxford: Oxford University Press.

Gilroy, A. and Lee C. (eds.) (1995) *AND MUSIC: THERAPY AND RESEARCH*. London and New York: Routledge.

Gold, M. (1994) Master's thesis, University of Hertfordshire.

Goldsmith, A. (1985) 'Substance and structure in the art therapeutic process working with mental handicap.' *Inscape*, Summer, 18–22.

Greenson, R. (1967) *The Technique and Practice of Psychoanalysis*. London: Hogarth.

Henzell, J. (1997) 'Art, madness and anti-psychiatry, a memoir'. In K. Killick and J. Schaverien (eds.) *Art, Psychotherapy and Psychosis*. London and New York: Routledge.

Hughes, R. (1988) 'Transitional phenomena and the potential space in art therapy with mentally handicapped people'. *Inscape*, Summer, 4–8.

Junge, M. and Asawa (1994) *A History of Art Therapy in the United States*. Published by the American Art Therapy Association.

Karban, B. (1994) 'Art therapy in a forensic psychiatric unit'. In M. Leibmann (ed) *Art Therapy with Offenders*. London: Jessica Kingsley Publishers.

Killick, K. and Schaverien, J. (eds.) (1997) *Art, Psychotherapy and Psychosis*. London and New York: Routledge.

Lanham, R. (1989) 'Is it art or art therapy?' *Inscape*, Summer, 18–22.

Learmonth, M. (1994) 'Witness and witnessing in art therapy'. *Inscape, 1*, 19–22.

Lyddiatt, E.M. (1971) *Spontaneous Painting and Modelling: A Practical Approach to Art in Therapy*. New York: St Martin's Press.

Maclagan, D. (1989) 'The aesthetic dimension in art: Luxury or necessity?' *Inscape*, Spring, 10–13.

Maclagan, D. (1994) 'Between the aesthetic and the psychological'. *Inscape 2*.

McNeilly, G. (1984) 'Directive and non-directive approaches in art therapy'. *Inscape*, Winter, 7–12.

Samuels, A. (1989) *The Plural Psyche*. London and New York: Routledge.

Samuels, A. (1991) 'Pluralism and training'. *Journal of British Association of Psychotherapists*

Schaverien, J. (1987) 'The scapegoat and the talisman: Transference in art therapy'. In T. Dalley, C. Case, J. Schaverien, F. Weir, D. Halliday, P. Nowell-Hall and D. Waller (eds) *Images of Art Therapy*. London: Tavistock.

Schaverien, J. (1991) *The Revealing Image: Analytical Art Psychotherapy in Theory and Practice*. London: Jessica Kingsley Publishers.

Schaverien, J. (1994) 'Analytical art psychotherapy: Further reflections on theory and practice'. *Inscape, 2*, 41–49.

Schaverien, J. (1995) *Desire and the Female Therapist: Engendered Gazes in Psychotherapy and Art Therapy*. London and New York: Routledge.

Schaverien, J. (1997) 'Transference and transactional objects in the treatment of psycho-sis'. In Killick, K and Schaverien, J (eds.) *Art, Psychotherapy and Psychosis*. London and New York: Routledge.

Schaverien, J. (1999) 'The death of the analysand: Transference, countertransference and desire'. *Journal of Analytical Psychology 44*, 1, 1–28.

Simon, R. (1991) *The Symbolism of Style*. London and New York: Routledge.

Skaife, S. (1993) 'Sickness, health and the therapeutic relationship: Thoughts arising from the literature on art therapy and physical illness.' *Inscape*, Summer, 24–29.

Skailes, C. (1997) 'The forgotten people'. In Killick, K. and Schaverien, J. (eds.) *Art, Psychotherapy and Psychosis*. London and New York: Routledge.

Thomson, M. (1989) *On Art and Therapy*. London: Virago.

Tipple, R. (1993a) 'Communication and interpretation in art therapy with people who have a learning disability'. *Inscape 2*, 31–35.

Tipple, R. (1993b) 'Challenging assumptions'. *Inscape*, Summer, 2–9.

Waller, D. (1991) *Becoming a Profession: The History of Art Therapy in Britain 1940–82*. London and New York: Tavistock/Routledge.

Waller, D. and Gilroy, A. (1992) *Art Therapy: A Handbook*. Oxford: Oxford University Press.

Waller, D. and Dalley, T. (1992) 'Art therapy: A theoretical perspective.' In D. Waller and A. Gilroy *Art Therapy: A Handbook*. Oxford: Oxford University Press.

Wood, C. (1997) 'The history of art therapy and psychosis 1938–95'. In Killick, K. and Schaverien, J. (eds.) *Art, Psychotherapy and Psychosis*. London and New York: Routledge.

Back to the Future
Thinking about Theoretical Developments in Art Therapy

Tessa Dalley

This chapter explores the concept of going back in time in order to think about the future. The title is related to the film which introduces the notion of 'critical moments' when an important decision is made or an event happens and how this affects the future. In this chapter I explore some of these critical moments in art therapy, both in clinical practice and in theoretical developments. This includes some examination of the loss incurred when choices are made, progress is underway and things move forward.

Particular attention is paid to the idea of the image as a container. The central thesis develops thinking about images as containers based on Bion's ideas of containment (Bion 1962). The formulation of the container/contained model helps to understand further the function of the image within the art therapeutic relationship. The image holds the transference and countertransference responses – the idea that within this the image can act as a container of intolerable and unbearable feelings that can be held, processed and thought about which leads to the experience of being contained and understood. Case material illustrates some critical moments in the therapuetic process of a twelve-year-old boy. The chapter ends with further thoughts about some pieces from an exhibition at the Tate Gallery, 'The Rites of Passage', and how these art objects can express such critical moments. The need to think about our own rites of passage is emphasised – marking time in our own history, which is essentially different from being in a time warp.

This chapter was adapted from an original paper written for the opening address of the Theoretical Advances of Art Therapy Conference, Warwick University, 1995.

'Back to the future'. This title seems to create an idea in my mind that unless we take full consideration of the past and think about what has

happened and learn from the experience, then it is difficult to contemplate a future. I have always wondered about the concept, or the sense that if we go back in time and think about critical moments when an important decision was made or some event happened, this begs the question, what if a different decision had been made or something different had happened, how would things have been affected? How would the future have turned out?

Birth, in a sense, is one of the first critical moments. The very first experience of the newborn baby may be containing or it may be frightening, and the infant's continuing experiences will be profoundly affected by this. The baby has lost the state of being in the womb and is now faced with the many challenges of the various stages and milestones of development in his life. In the psychoanalytic tradition, going back to our roots in the sense of regression or becoming in touch with early infantile experience is something which occurs in order to go forward as a healthy adult. Revisiting moments of early trauma in order to re-experience and work through it forms the essence of psychoanalytic thinking.

The same model can be applied to art therapy and art therapists – as a profession we need to go back to consider how we go forward. As individuals working in the therapy room we continually need to analyse what has just happened in the session, in the moment, in the countertransference and in the image in order to process, digest and enable the work to go forward. These are specific critical moments that happen in our work, but there are also more general moments that have occurred within the profession. Whether these can be identified easily or whether they blend into a general evolution of our thinking is an important question which needs thinking about. Probably everyone has their own views about these critical moments – the 1982 NHS Directive, the establishment of art therapy training in the 1970s, some might include the election of Mrs Thatcher in 1979; a recent critical moment of state registration. Both in personal and professional lives, we are constantly faced with the question, how would things be different if something different had happened?

There is a kind of momentum that takes things forward and moves our thinking on which has a different quality to the swinging backwards and forwards of a pendulum. What do we mean by thinking? I am reminded of Bion's theory of thinking when Edna O'Shaughnessy asks the question, what does he mean by this? 'He does not mean some abstract mental process. His concern is with thinking as a human link – the endeavour to understand, comprehend the reality of, get insight into the nature of...oneself and

another. Thinking is an emotional experience of trying to know one's self and someone else' (O'Shaughnessy 1981, p.181).

Thinking involves reflection, time, space, a container for those thoughts. This is a difficult task. Thinking together and working through can be one way. With any individual or group, when faced with anxiety and conflict, early defence mechanisms come into play. Using the Kleinian model of early development, the baby moves from the paranoid-schizoid position to the depressive position by working through the split, and only then can both good and bad be tolerated. This leads to further development, weaning and independence from mother, which enables the ability to move away from the parent. The early split in art therapy between education and psychiatry, which formed the roots or 'parental figures' of our profession, became integrated and resolved only to throw up other ones around directive and non-directive ways of working. To some extent the 'art' versus 'therapy' debate continues to be alive in our minds but we are now moving on to accommodate this split so that we can work together, respect difference and stay within the tension. It is interesting that the debate continues to centre around professional names, but the significance permeates deeply into the core of our identity.

However, within this overall situation there has been sufficient solidity built into the profession to enable individuals to move out on their own in their thinking and initiatives. In a sense we are talking about 'theoretical mother' and in our development we have been able to develop the capacity for independent thinking, having internalised something and gained knowledge from the 'maternal' relationship. The theoretical debate in art therapy is open, challenged, and continues to be well documented, which keeps the questioning in mind. For example, Joy Schaverien (1995) develops further ideas on gender, desire and sexuality and makes a most welcome contribution to the literature for art therapists and also for the psychotherapy profession as a whole. As a predominantly female profession, this whole subject requires considerable examination if we are to sufficiently inform ourselves as to the real implications of working with male and female clients. Levens's (1995) book on eating disorders draws upon anthropological and psychological theories to develop her ideas about primitive functioning. The author explores the idea of cannibalism as a primary defence in order to understand and inform her work and the significance of the images and symbolism used by her clients.

There are also some notable initiatives that have taken place with developing practice with different client groups. With quite extraordinary

bravery and initiative, there has been work with displaced women and children in the refugee camps in Bosnia and Croatia (Lloyd and Kalamanowitz 1997). It was necessary to think carefully about this work. By offering time and space through consultation and planning, a peaceful container for thinking was provided within a shattering war environment. It seemed that working with images was found to be an extremely helpful medium for people to process and make sense of their experience. This may have been the only way to speak about or find a voice for the tragedies. Closer to home, with the closure of the large institutions, art therapists need to rise to the challenge of responding to the demands of community care planning. This certainly does seem to be a critical moment in our history and it involves the loss of a tradition, a way of life, a home or sanctuary for many, and, for those living in institutions since birth, the splitting up and loss of their emotional container. The question is then raised, does this mean the loss of our professional container? Many art therapists have been working within these hospitals and these changes may shake some foundations of our professional identity. Indeed, it was in the open studios that the practice of art therapy started through the work of Adrian Hill and Edward Adamson. How are we to adjust to this loss? Does it take away the essence of the art base of our profession? If so, this suggests that we do need to continue to think about what we call ourselves.

Whatever is decided about our professional title, it is my view that it is the art work and images with which we work and the understanding of transference and countertransference processes within the clear boundaries of the sessions that form the foundations of art therapy identity and practice. We have had to go back to fundamental principles of this early practice and theories to establish these foundations and continue to think further about them in the context of the here and now. Whether this is in Bosnia or in closing institutions, the same questions still have to be asked – What is happening now? What am I doing at this moment? What if…?

This is how ongoing practice continues to inform theory, and this is one of the most important aspects of the work. In clinical sessions, in therapy, in supervision and in private thoughts we continue to give space and time to thinking about the application of theoretical ideas in the daily practice of what we do. The practitioners are in many ways the pathfinders – this is the where the future lies – with well-qualified, experienced professionals working alongside other colleagues with consideration, acceptance of difference, but within a tradition of firm boundaries, code of ethics and conviction about what we do.

It is at this point that I would like to return to our theoretical future, and specifically to two aspects of the work of Case (1994). Before writing this, I re-read her paper. Going back, before thinking about going forward. The first is the idea that she develops of a 'standard art therapy practice'. The point she made was that there is a desire to be told how to do art therapy, this is what you do as an art therapist, and at the outset of training maybe there is an expectation that cannot be realised. The child in us would like this, like learning to read, but even in the teaching of reading there are different views about the actual methods. However, there are standards which can be worked towards – particularly with monitoring of ethical codes of practice and training which we have fully in place as a profession. But is it right to have one way of doing things? More and more there is a sense that there is a continuous development along more traditional psychoanalytic lines – or is there? To what extent do the majority of art therapists work with boundaries, containment, transference and countertransference?

Recently, when struggling to write *The Three Voices of Art Therapy* (Dalley, Rifkind and Terry 1993), the more I sat down with my colleagues to write, the more that difference emerged. This was a fascinating process, as on the surface it seemed a fairly straightforward piece of work involving a certain level of agreement. But the more we entered into the process, the more the deeper issues emerged, and there were some important areas of difference that came to the surface. For example, the idea that pictures can go on the wall in the therapy room. What messages does this give the client, and the other users of the room? What are the transference and countertransference implications and the overall impact of the projective processes that these images stir up? Another question fundamental to our practice that arose was the extent to which the art therapist should enable work to be done outside of the actual session itself, so that a more considered image or completed piece of work is brought for consideration between therapist and client. When we think about the image as the transitional space in the therapeutic relationship, what are the issues that are brought into the space when a client brings a completed piece of work? Is it necessary to actually be there while the image-making is happening for the therapist to fully understand the essence of the communication? Case (1994) talks of a clay piece that would probably not last over the holiday break if it continued to be constructed by the child in a particular way. This engendered anxiety in the therapist. Is it therefore the very nature of making, the actual process of the construction of the image that holds together all the threads of the therapeutic picture for the therapist and client? But maybe this process is too full of conflict and tension for some

clients who choose not to make any images. Is it preferable to allow this to happen outside of the art therapy room, outside of the container? And what about the fact that many clients will not make any images at all – how do we as art therapists view this? The sense of not 'producing the goods' is an anxiety expressed by many who may find this an attack on the very identity of the art therapy, of the art therapist and of the artist in the therapist. To go back, how does this connect to a notion of standard art therapy if there are no images? It seems just as interesting to ask the question, if there are images, many of them, in fact floods of them, which many of us have experienced, is this not the same – a defence or resistance against thinking about what is really going on? If the art therapist is happy to accept images for the sake of it without understanding fully the impact on the session and how these many images might be stopping some thinking – is this a spilling out or blocking out, covering over, flooding?

To return to the writing of *Three Voices*, these were some initial issues that quickly emerged but took hours of thinking about as we pulled apart and thought about every aspect of the work. What came out of these discussions were some lingering thoughts about containers, containment and the dynamic of intrusion, intrusiveness. In the relationship between Gabrielle, the therapist, and Kim, the client, the anxiety about intrusion surfaced early and was an essential part of the process in the work. Indeed, it felt so critical that there were moments of doubt about the continuation of the therapy. The dilemma was how to enable Kim to allow these brittle defences to be dropped without feeling intruded upon, vulnerable and exposed. Equally, how could this be worked with by the therapist, who had the experience of being very intrusive into the client's private process? The idea of drawing and painting in the client's own space and time was one way to work with this as it held the therapeutic alliance, but it is interesting to think about how this affected the dynamic between client and therapist and the ongoing process of the work. It seems that both the fear of and the experience of intrusion became intolerable, and the projective processes were working in such a way as to be a necessary part of the process. Identification can be important in helping to understand exactly what it is that is the primary defence and the therapist can be identified with this as well. We can only speculate – that is, what if the notion of a standard art therapy had come into the work as to what is the 'right' thing to do? The fact that there is no right or wrong way makes it complex and difficult. The therapist used her own sense of intrusion/intrusiveness in the countertransference response to enable the process to proceed, and Kim to continue in treatment. There was a

developing fear of the container which needed some understanding. What would have happened without this understanding – would the room have become overwhelmingly claustrophobic, enough to suffocate or stop the work and thinking going forward?

This brings me to the second point, also mentioned in Case's paper. It is a question that I often find myself thinking about in my work and this question centres around the experience of the therapy room. Is this experience essentially a 'claustrum', a container, or is it actually claustrophobic?

Let me describe two situations – probably familiar to many art therapists. Having run groups at the Leeds Art Therapy Spring School, a five-day residential school in Leeds, for fifteen years now, every year, without fail, in the first session that runs for two-and-a-half hours there is apparent dismay that there will not be a coffee-break, and concern is expressed about those people who might want a cigarette. The anxiety of being shut in is usually overtly expressed in this way. As the group proceeds, trust develops and the understanding of containment by the strong boundaries is experienced. In the subsequent sessions, there is often hostility expressed towards anyone who might be wanting to leave the room or break the container for any reason. This is a most fascinating process, as what was initially experienced as claustrophobic becomes containing.

The second situation is when a disturbed child is out of control and wants to escape from the therapy room: there is what appears to be a claustrophobic need to get out, escape and run away. The therapist, however, attempts to enable the child to stay in the room. The thinking adult can contain the needs of the child who wants to violently break out, but whose ultimate need is to be contained, held emotionally, so that some rational thinking can take place. The therapist is there to provide containment in these anxious moments. But what if the anxiety is too great, claustrophobic feelings are overwhelming, and it may be impossible to provide containment? The child may get out of the therapy room.

Claustrophobia is the abnormal dread of being in closed or confined spaces. The concept of a claustrum that has been developed by Donald Meltzer (1975) is of an unconscious fantasy of an experience of being inside mother's body. From this claustrum, there is a need to provide a safe place, like that for a newborn baby. It is the task of the therapist to provide this, but it may be that the baby has had a claustrophic experience in the womb in the desparation to get out, in the struggle to birth. It feels important to think about these very early experiences in the therapy room and about the need to return to the womb – a safe place. These experiences both involve the sense

of being enclosed, but one is safe and the other is terrifying. They may be returned to on a fantasy level, but the container needs to be there for these experiences to be processed and understood. The sense of containment can be constructed through the understanding of this process if we, as therapists, fully understand the idea of containment. Case (1994) describes how she manages to work with this, both with the child's art work and in working towards an understanding in her own art work outside of the sessions. I would like to suggest that much of this understanding of the experience of containment can be achieved by using the image as a focus or container for thinking.

I would suggest that art forms can simultaneously express these claustro-phobic anxieties, this need to escape and need for containment, and can therefore be understood within the art therapy context when thought about in this way. An example of this can be seen in the image in Plate 3. Where is the child in this picture? What is he trying to say? Many things about con-tainment, violence, needing to devour or be devoured, incorporation, the experience of wanting to be inside mother's body, the experience of wanting to be inside the therapist's body – who are the lions and tigers and the family at play? This image seems to say it all at once, but each aspect is said separately. Made over several weeks, it seemed important to wait until the image was complete – the gas chamber was added at the last moment for anyone who may escape. It was made by a thirteen-year-old boy who has been in therapy for over two years. The image was consciously made to create somewhere he would like his friend to go; this was a much older boy, someone living in the same children's home who had led him into trouble. This older child had been the cause for my patient to move yet again to another care situation, as it was felt an inappropriate place for him with these influences from these older children. This led him to feel yet more uncer-tainty and anxiety and feelings of insecurity. But as we considered the image and thought together, it was clear that a person could not survive in there as there was no space. We came to understand that he also wanted to be in there, safe, locked up, guarded against intruders, but acknowledged that it was easier for him to express this in terms of someone else getting locked up than face the overwhelming anxiety about his need for the same safety and con-tainment. We thus explored his dilemmas and anxieties about intrusion into his own space and how he might also break out of this. There was also an issue about not being able to tolerate being contained, as this led to feelings of claustrophobia which we linked to his enmeshed but antagonistic relation-ship to mother (Plate 4).

Plate 5 embodies the same idea with a prison van with the prisoners sellotaped in – probably suffocating, but needing to be kept safely just in case they escape. This expresses a need to return to the womb where it is warm, safe and cosy, some expression of 'claustrum'. These images seem to hold both meanings simultaneously, and if some exploration is possible, understanding of this confusion can take place. Equally, Plate 6 is a more ambivalent statement of being trapped, but this also states a need for containment, safety and enclosure. From *Three Voices*, Kim is letting us know about his need to escape, and desperately wanting to be held in.

It is here that Bion's ideas of the container/contained informs us the most (Bion 1964). The therapist's situation endeavours to provide both these – a bounded world within the container where meaning can be found and contained. Based on the idea of projective identification, Bion brought the object, the mother or the therapist into the conception of the process more than Klein had done. Bion thinks that when the infant feels assaulted by feelings he cannot manage he has fantasies of evacuating them into his primary object, his mother. If she is capable of understanding and accepting these feelings without her own balance being too disturbed, she can 'contain' the feelings and behave in a way towards her infant that makes the difficult feelings more acceptable to him. Mother/therapist can process and digest unacceptable, intolerable feelings and these can then be introjected in a manageable, acceptable form. He can then take them back into himself in a form that he can manage better.

I would suggest that making an image and understanding its meaning within the safety of a therapeutic relationship can have the same containing function. Unacceptable feelings/anxieties/fantasies can be expressed into an image and these can be held in this image over time or until the client is ready to take them back in an acceptable form. A client spontaneously creates an image or object, and at the time it is not possible to understand or make sense of it. The meaning is held by and therefore contained in the image in the sense that those unacceptabe, intolerable feelings can be taken in at a later stage when the client is ready. This certainly occurred in the case described – the child first expresses violent, aggressive feelings aimed at someone else, but in fact the expression of his own aggressive impulses was too hard to bear at that moment. All the outer containers in his life, his mother and several foster homes, were experienced as not able to bear his violent projections. After some while it was possible to explore this as the image contained all the aspects at once and so over time it was possible to make sense of many layers of feelings of deep anxieties, primitive fears and persecutory thoughts. Also

the ambivalences about wanting to be safe and secure, or break out and escape, are able to be put together and understood. By providing a container that helps the client make sense of his experience, these are put into words through the associations to the image; this creates meaning, and there is an experience of being contained.

This formulation of the container/contained model helps us to develop our thinking and enables us to understand further about the function of the image within the art therapeutic relationship. We have already come to understand how the image can hold transference and countertransference responses – the idea that the image can act as a container of intolerable and unbearable feelings that can be held, processed and thought about, which leads to the experience of being contained.

However, what if the process goes wrong – either because the infant/client projects overwhelmingly and continuously or because the mother/therapist cannot stand very much distress? The infant resorts to increasingly intense projective identification and eventually may virtually empty out his mind so as not to have to know how unbearable his thoughts and feelings are. By this time he is out of control and on the road to madness. This leads to the next question of creativity and destruction, and the times that we have all experienced in sessions when making images and using art becomes destructive and persecutory. These are times when patients cannot symbolise. A deep enough disturbance will prevent symbolic thinking, and therefore pretend blood made by the child in the battle becomes blood, playfighting becomes fighting. There is no distinction between fantasy and reality and this becomes dangerous both for client and therapist. It is the task of the therapist to hold the thinking and contain the feelings. This is not the same as keeping things neat and tidy in the sessions which must be cleared up. Many times symbolic acting out can be expressed through the art materials and this must be contained, not controlled, through understanding and interpretation. When the use of art materials becomes out of control, in my view, it is essential to set limits in order to contain the anxiety so that thinking can take place, and not a continual splurging out which is in essence an attack of thinking. We are now more prepared to understand how patients attempt to arouse in the therapist feelings that they cannot tolerate in themselves but which they unconsciously wish to express. These can be expressed through the image or object made, which can be then understood by the therapist as a communication.

I find that another way of thinking about this concept of the container/contained is the idea of the search for meaning, or a way to find

sanctuary, inner peace. The distress of many of our clients is tangible – once contained and meaning is found, this can change. Sanctuary suggests a sense of being in a safe place, which itself expresses an idea of being inside something good. Winnicott called this 'a sense of being held' (Winnicott 1960). Esther Bick (1968) equated it with having a sense of envelopment like a skin around oneself which protects and enfolds (Bick 1968). Bick has suggested that a focus of perceptual experience may provide cohesion for the infant, whether it be a nipple in the mouth or an object of the eye. As I have suggested, maybe the images can be focused on in this way, as a means of defending against very early primitive defence mechanisms for an experience of early contact and against the threat of annihilation. That is, to prevent the threat of this bursting of the skin that psychically holds the infant together. If the sense of sanctuary – that is, a sense of being inside something secure – is lost, the individual feels as if they are 'falling forever or that there is no floor to the world. If the inner meaning is lost, a sense of internal incoherence and fragmentation is felt'. Bion says the sanctuary is provided by a container, and 'a sense of coherence crystallised by an organising central idea or selected fact' he described as the 'contained' (Bion 1962, pp.102–105).

We should think long and hard about these ideas. For me it informs many aspects of the work I do with some very troubled children, their parents and families. For some of these families, there is sometimes a problem with engagement – they feel worried about coming to the clinic, feeling perhaps that they have failed in some way or are struggling with overwhelming needs which feel hard to describe. With some of the more aggressive children, these ideas of containment have been vital in my understanding and processing of the at times extremely stressful situations that are encountered in the therapy room. I have had to think about how to manage with some of these children who do seem to suffer from very low self-esteem, and the dynamic this sets up is often a difficult barrier with which to work.

Sometimes it becomes clear that in the session there is an experience of exclusion, even of persecution, which carries with it a sense of inferiority. If the child believes that the therapist is an impermeable object – as if coated with an impregnable sense of superiority – this can cause quite aggressive responses. It seems to underlie some of the situations of spiralling violence which occur in the therapy sessions. If patients feels that they cannot 'get through', that they are making no impression or impact on the person whom they are addressing, then an intensification may occur in their efforts to project and force feelings into the therapist. This often produces a vicious circle, since one way for the therapist to respond to this is by hardening

inside. This may be communicated by choice of words, in the expression, or in the tone of voice. This in turn provides more sense of being faced with an impervious object, which can induce quite a desperate response. It is as if two people are knocking against each other and the lack of understanding creates a lack of absorption and sensitivity to feelings. Fear of the containing object does not only take the form of a fear of being denied access or acceptance – another fear results from a fantasy of the projected self being taken and then destroyed, a fear that one's nature is taken by the other's devouring curiosity. The child is somehow left in the feeling that he is comprehended but nullified by the process.

This was clearly described, in *The Three Voices of Art Therapy*, by Kim, in the early experience of therapy with Gabrielle. The images enabled him to hold on to this anxiety and gradually verbalise it when he felt safe enough. I would like to show you another example of how it was possible for the image to mediate in this persecutory sense, and how the process of making enabled the child to shift from feeling excluded, persecuted, angry and defiant to a stage of acceptance, tolerance and some degree of understanding. A child enters a group late, angry and silent. He makes his image on his own, unable to join in any discussion in the group or participate. His other main communication, apart from his mood, was to sit very close to the male therapist as he began, at first with the face, painting it black, and then creating his stand-up man, which he then placed in the box (Plate 7). This enabled him to join into the group, at the end, and it emerged that he had been badly let down yet again by the adults in his life; he experienced no containment or thinking about as once again he was struggling with an abusive situation at home. As he spoke he was able to make the model/man stand up on its own and we all helped him think about how he had to do that in his life, and how it is easier for a model to do that than for a vulnerable child like himself. This helped him to symbolise his experience at so many different levels without too many words. He was speechless with rage, hurt and disappointment, but the process of making this model enabled a thinking through, a container for his feelings, which could then be safely expressed and understood.

Bion applied this basic relationship of the container to the contained in a very general way. He saw it as a predetermined form, a preconception which would seek its first expression in the mother–infant relationship. Whatever fantasies it engendered in that early encounter would shape for the individual fundamentally his experiences in all subsequent situations and also in this relationship with himself – inside himself. I find these ideas important. As art therapists, there is a need to think how the art work or image is used centrally

within this process. It is important to think about the maker of the art objects in therapy – the client and also the observer/receiver/viewer/therapist. How are the images perceived, what is the aesthetic response of the therapist observer? If the art objects can contain these intolerable anxieties, then, if they are processed, meaning takes place and the experience of their understanding is a containing one. This understanding seems to be crucial if the image is to hold the containing function that has been described.

We as artists and art therapists continue to give close consideration to all images – those made both inside and outside of the therapy room. This leads us to ask what is the function of these images, what is the nature of this function, how do we respond to them? Generally the images we might see in everyday life can be understood within the model of container/contained. Many of the images I see and look at can be understood in this way, particularly in some contemporary art. An exhibition at the Tate in 1996, called 'Rites of Passage', consisted of images, objects and installations which marked passages of time and made statements about the future. 'Rites of passage', an anthropological term, describes the ceremonies which mark significant changes in life in a ritualised way. This exhibition proposed that contemporary art, by responding to key experiences of life, can be analogous to such ceremonies. The art is preoccupied with states of change and with related states of identity, much of it absorbed with the greatest change of all – death. There is the use of the art objects as containers to express these ideas. I was struck by how much these images were expressive of the essence of our work as therapists, in the sense that the feelings/anxieties/preoccupations were so clearly given meaning in these pieces.

Two main pieces spring to mind. Louise Bourgois, now well into her eighties, made two linked installations, 'the Red Rooms' that correspond to spaces from her childhood – her own room and that of her parents. They have been described as explorations of 'the psychosexual drama of her home' and engender old ideas of childhood as a state of innocence. The spaces are psychological as well as actual, with the sheer proximity of the two kinds of intimacy that bedrooms imply – carnal and innocent. The child's space is full of objects – spooled thread still to be unravelled and spun. Glass jars stand enclosing nothing. In this room either things are empty or it feels as though they are waiting to acquire significance – this is different to the parents' room, which is orderly, resolved, with secrets well hidden. Everything is separate, part objects, which contrasts with the warmth and safety of the parental bed – a sense of 'wholeness'.

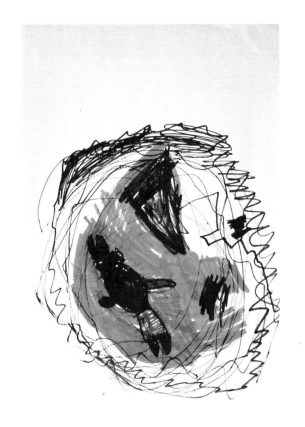

Plate 1

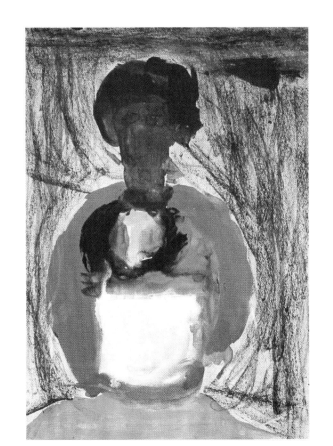

Plate 2

Plate 3

Plate 4

Plate 5

Plate 6

Plate 7

Plate 8

Plate 9

Plate 10

Plate 11

Plate 12

Plate 13

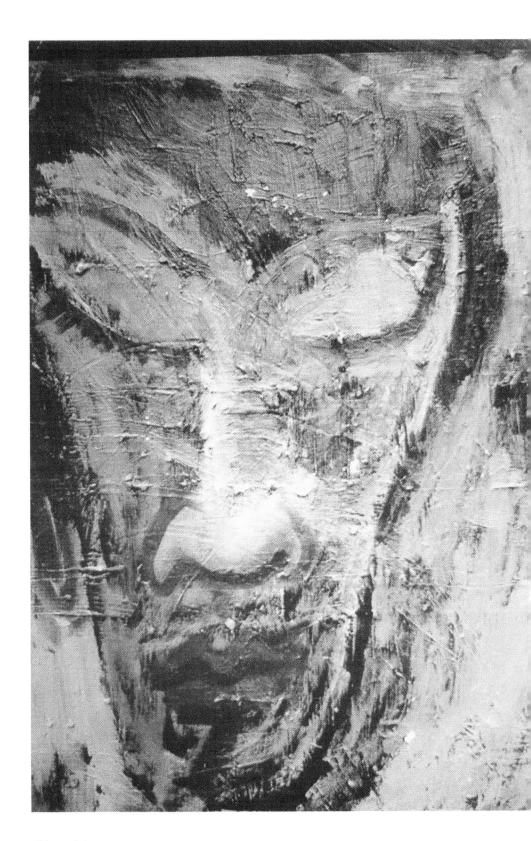

Plate 14

Another piece also expressing ideas of childhood and adulthood, 'Remembrance of the First Holy Communion', is the work that Marislow Balka made for his graduation show in 1985. It is a self-portrait and signals the strongly autobiographical element in his work. First Communion, the spiritual step from childhood to adolescence, is an important Christian rite of passage, but took on specific significance in the context of the Catholic Church in Poland under Communism. Balka later opposed the regime and the Church.

I want to describe this image in detail as it moved me a great deal. A small figure stands beside an occasional table covered with a tablecloth with some exquisite detail of lace. He is tidily dressed, with a shirt buttoned neatly at the neck, and the suit of a boy, with short rather than long trousers; on his lower legs he wears long white socks, pulled up but nevertheless a little wrinkled. One of his knees is bloody, and on closer examination there is a mark of lipstick/blood – carnal and innocent. The boy is seemingly in command of himself, standing poised, but with a slightly shambolic air, one hand resting on the table. His head is turned in expectation. His shoelaces are undone. Two things disturb the image. On the table, embedded, hidden, but on the surface, as if in a gravestone, is a photograph of a child: First Communion, which after all witnesses the birth of the adult, equally signifies the death of the child. Above the boy's left breast, like a pocket handkerchief, is an opening with soft red fabric – a pincushion, an open wound, a heart. The boy is standing on a bed of sharp nails, holding the table. On further inspection there is a mutilated finger on his shoulder, which gives the impression of a shell within a soft body. At the back there is an open space leading down to his bottom – an open chasm of emptiness or nothing inside. The simultaneous expression of complex and difficult feelings into an object: a contained space, the image provides the container, thinking can be done and meaning can be found. The image is poignant and seems to encapsulate the very ideas I have been attempting to discuss here.

The more you look, the more you see, and it is difficult to stop looking. This exhibition enables art to push forward ways of seeing that we see everyday in our therapeutic work – painful, inexpressible thoughts expressed in forms and objects. Loss can be managed through expression in contained ways which create meaning. Art can speak about the future as well as the past. The dilemmas of life can be contained in one object, these awful, difficult, painful things put in a form that can then be understood. There were a number of critical moments in the life of the first patient described here – he must be constantly wondering, what if? The child in therapy is in the

moment – the therapist in the here and now. What if Kim had not met Gabrielle? What if the child in the group had not been able to make that figure that day? One thing is certain: that without a container, a containing space, then things would probably have been different. The therapy space provides a sp ace for this – art can mediate as a container for feelings.

Seeing and looking back can be containing or frightening. Looking back raises the question 'what if?' and identifies critical moments in history and in the history of the sessions that might have made significant difference.

Do we learn anything from our experience? It does seem important to look back. Things have changed a lot since the pioneering work of Adrian Hill and Edward Adamson and their valuable contribution to the future of our profession. Ways of working in art therapy are developing and in a sense there is a loss of this tradition as we go forward into the future. What seems to be important is managing this change. Going forward in life involves loss and letting go. We can look back and mourn the loss of childhood, but maturation proceeds. Is this such a tragedy? Perhaps, when it seems that adulthood involves responsibility and decision-making, when childhood was blissful and innocent and non-thinking. But we all know that childhood is not really like that – being an adult we can take hold of our own destiny. For our learning we can look back to think about future. We can can mark points of time in our history which may or may not be critical moments and may also represent our own 'Rites of Passage'.

References

Bick, E. (1968) 'The experience of skin in early object relations.' *International Journal of Psychoanalysis 49*, 484–486.

Bion, W.R. (1962) *Learning from Experience*. London: Heinemann.

Bion, W.R. (1964) 'Container and contained.' In *Elements of Psychoanalysis*. London: Heinemann.

Case, C. (1994) 'Art therapy in analysis: Advance/retreat in the belly of the spider.' *Inscape 1*, 1, 3–10.

Dalley, T., Rifkind, G. and Terry, K. (1993) *The Three Voices of Art Therapy*. London: Routledge.

Levens, M. (1995) *Eating Disorders and Magical Control of the Body*. London: Routledge.

Lloyd, B. and Kalmanowitz, D. (1997) *The Portable Studio: Art Therapy and Political Conflict*. London: Health Education Authority.

Meltzer, D. (1975) *Explorations in Autism, a Psychoanalytical Study*. Strath Tay: Clunie.

O'Shaughnessy, E. (1981) 'A commemorative essay on W. R. Bion's theory of thinking.' *Journal of Child Psychotherapy, 7*, 181–186.

Samuels, A. (1991) 'Pluralism in training.' *Journal of the British Association of Psychotherapists* 3–17.

Schaverien, J. (1995) *Desire and the Female Therapist: Engendered Gazes*. In *Psychotherapy and Art Therapy*. London and New York: Routledge.

Winnicott, D.W. (1960) 'The theory of parent–infant relations.' In *The Maturational Process and the Facilitating Environment*. London: Hogarth Press (1965).

The Art Room as Container in Analytical Art Psychotherapy with Patients in Psychotic States

Katherine Killick

Introduction

In this chapter I outline the principles of an approach to severely disturbed patients which evolved in my work as an art therapist in adult psychiatry, with particular reference to the potentials for containment offered by the concrete setting of an art room in a psychiatric hospital. As I have shown elsewhere (Killick 1993, 1996; Killick and Greenwood 1995), the concreteness of the analytical art psychotherapy setting and of the transactions which take place within it can absorb the impact of primitive affective states and, over time, can facilitate the evolution of symbolisation. These potentials are significant in enabling those ego functions which are weakened by psychotic processes to strengthen, in particular fostering the emergence of a sense of self.

I will begin with a brief introduction to some ideas which inform my thinking about the approach, most importantly Bick's (1968) concept of the 'containing object', and go on to describe the setting in which I practised, using case material to show how different patients used the setting, with particular emphasis on their use of the art room itself. I conclude by wondering whether changes of the kind I describe can take place within art psychotherapy relationships when the therapeutic setting cannot include a concrete space of this kind.

Theoretical elements

Esther Bick, in her paper 'The experience of the skin in early object relations' (1968), wrote about early infantile states of mind in which parts of the personality, as yet undifferentiated from parts of the body, are felt to have no binding force amongst themselves. An external object, optimally the nipple in the mouth, is experienced as being capable of holding the parts of the personality together. Repeated experiences of being held together by the object over time are introjected by the infant, forming an internal object which Bick describes as a 'skin container'. When the 'skin' is reliably established, a sense of a space inside the self can arise, in which experiences can be held and digested. Bick describes instances of disturbed 'skin-formation', linking this with states of 'unintegration' which are encountered by clinicians, and stresses the necessity for regression to dependence in the analytic setting if the disturbance is to be worked through. She writes: '…the containing aspect of the analytic situation resides especially in the setting…' (p.486). This is the idea which I now propose to employ in my discussion of the potentials of the analytical art psychotherapy setting.

Psychotic states are states of unintegration, in which the containing object has failed catastrophically. I do not intend to engage in a discussion of the possible causes for this failure here. One patient who had recovered from an acute psychotic episode described this state as 'a body without skin'. In this state of mind, the absent container is experienced as the presence of an internal object threatening annihilation of the personality. Bion (1967a) has described this as the 'no-breast', a breast which 'refused to introject, harbour and so modify the baneful force of emotion' (p.108). Without a space inside the self in which experiences can be held, and potentially digested, the experience of emotion threatens the sense of self with annihilation. This profound anxiety is defended by 'attacks on linking'. 'Linking' is a phrase which Bion uses to encompass thinking processes in all their richness and diversity, and which are inevitably accompanied by some degree of psychic pain. In order to protect the sense of self from the annihilation threatened both by emotional experiences and by linking itself, the emotional experience and the part of the mind which experiences are both evacuated through projective identification, leaving the ego fragmented and the sense of self depleted. The world outside the depleted, experienced self is felt to be full of potential destructiveness attempting to force itself into the self.

Writing on the subject of working with these states of mind, Meltzer *et al.* (1986) distinguish between projective identification and intrusive identification. Projective identification is characterised by a need to communicate and

a wish to be contained by the object, whereas intrusive identification is characterised by invasion and control of the object for the purpose of evacuation of anxiety. In my experience the early stages of therapy with patients in psychotic states almost always necessitate a period of working with the latter in order that the former might become a possibility. The presence of an object felt to be capable of containing the patient has to be established in the patient's mind before it can be used as an object to be projected into for the purpose of containment. It follows from Bion's description of the breast which repudiates emotional experience that the experience of containment which might enable a 'skin container' to form would be provided by an object felt to be able to 'introject, harbour and so modify the baneful force of emotion'.

In the setting which I will describe, the art room played a crucial part in mediating the experience of a containing object for patients in unintegrated states of mind. The substances available within the room, many of the transactions occurring between therapist and patient, and the art work made, all had a concrete, physical existence. As I have described elsewhere (Killick 1996), the original emotional experience which has not been contained together with repeated experiences of the trauma of non-recognition are often experienced in the transference and countertransference through what Bion (1967b, pp.51–52) has described as 'projective identification in reverse'. At times this has the physical and emotional impact of an assault. The concreteness of the setting in itself offers a medium which can absorb the impact of primitive affective experiences emerging in the transference and countertransference when unintegrated states are engaged without the risk of damage to patient or therapist, and which can persist over time.

The art room could accommodate a wide range of 'intrusive' activity, which frequently, but not always, involved the use of art materials. The objects made could be held in the room over time, and acquire the possibility of meaning something within the analytical art psychotherapy relationship as the patient's capacity to communicate with the therapist increased. Even when it is being used as a means of evacuation, the patient's material can often seem rich in symbolic meaning to the therapist, and particularly to the art therapist, trained to perceive and relate to symbolism. However, as I have stressed elsewhere (Killick 1991, 1993), the patient's relation to his productions in acute psychotic states is evacuative, and the art produced is what Eigen (1985) describes as signs of meaninglessness. As he says in his paper discussing the work of Bion, 'What passes for symbol may be an elemental sign of distress and horror. The psychotic patient signals rather than

symbolises his ongoing sense of catastrophe. The materials he uses may resemble symbols but they are used to point to an unnameable psychic reality' (p.323).

When developing a relationship with an acutely psychotic patient in which the art can begin to have meaning in therapeutic terms the therapist needs to pay persistent attention to the containing potential of any and every situation in which she meets the patient. The art room can be thought of as a matrix with the potential to contain what Jung (1946), in his alchemical metaphor for the analytical relationship, describes as *prima materia*, 'the substances to be transformed'. These 'substances', raw affective experiences, correspond to what Bion (1967c) has described as 'beta elements'. The matrix offers the potential for transformation by what Bion describes as 'alpha function' to occur, and this function can come into play in the patient's art-making and in the relationship with the therapist. The analytical art psychotherapy with a therapist employing the art room as a container enables 'beta elements' to become increasingly 'thinkable thoughts'. In time, as the experience of emotion becomes more bearable, the art can acquire symbolic meaning for the patient, and can be used to communicate with the therapist.

The art room

I worked in one particular art room from 1979 until 1988, when I moved to an out-patient setting within the same psychiatric service. This art room has been described elsewhere (Goldsmith in Case and Dalley 1992; Killick 1993, 1996). It was a converted ward in a medical-model psychiatric hospital, offering a large studio space with tables, chairs, art materials, facilities for tea- and coffee-making, music playing, and access to extensive grounds. There were also two individual therapy rooms, an office, and toilets. The main studio space had an atmosphere which was almost always remarked on by people coming into it for the first time. This is hard to describe, but the words 'church-like' and 'sanctuary' were often used. People often said that they felt 'safe' in the room. I remember one male patient who never attended art therapy running into the room through the French doors which opened into the grounds, holding a large green pine-cone. He was very excited, and said: 'This is beautiful. I've brought it here, there isn't anywhere else where it can go!' He placed it on a small, round table which stood in the centre of the room, which held our collection of plants and other *objets trouvés* which had accumulated over the many years during which the room had been used for making art. I believe this had amounted to a period of at least 20 years by the time I arrived.

The floor was made of pine, and all the tables and chairs which stood in the room were also made of wood. The many large sash windows, the French doors and a big bay window at one end let in a lot of light and views of the lawns, trees and flowerbeds of the grounds. Squirrels and birds were usually to be seen out there, and patients could easily walk out and sit outside the room. Within the room there was an area where patients could sit and read or talk or simply take a break. There was an extensive collection of art and poetry books within the room. The walls, window ledges and mantelpieces held many years' worth of objects and images. Within this environment each patient had his or her own allocated space at one of the tables. There might be up to twelve patients using the studio at any given time, forming a group. This group was an essential element of the setting, and patients would support one another in unexpected and surprising ways, revealing immense sensitivity to the states of others and a capacity to contain these. New arrivals would be tolerated and helped to learn the ways of the setting by those who could best empathise with them.

Patients were initially referred to the art therapy department for assessment, and treatment could be conducted while their status fluctuated from in- to day- or out-patient in relation to the hospital. Most acute psychotic in-patients would attend sessions in the art room for at least five two-hour sessions per week, many attending for ten sessions. Out of these, one hour would be allocated to an individual interview with a therapist in an individual therapy room. The rest would be spent within the main studio. Some patients produced large quantities of art, and others none at all. Their engagement in art therapy did not rely on the production of art. The patient's involvement with his or her art was treated as a private affair, and often a long period of testing out was needed by the patient in order to establish that the production of art was not required by the therapist. The table formed his or her inviolable territory within the relationship with the therapist, corresponding to the privacy of the core of the self from which new material might emerge in its own time. Plate 8 shows how one patient used this space.

As I have said elsewhere (Killick and Greenwood 1995) I met considerable ambiguity in colleagues' attitudes toward the purpose of acute psychotic in-patients' involvement in art therapy. These patients were frequently referred for art therapy by psychiatrists, yet the same doctors often stated that psychotherapeutic work with psychotic patients was at best ineffective, and at worst dangerous, although the nature of the 'danger' was never articulated. When I started work at the hospital, these patients were not selected for individual work by art therapist colleagues. They attended unstructured open

sessions and were sent back to the ward if their behaviour was in any way bizarre. This seems to express the ambiguous nature of the patients' referral to art therapy, and the anxiety generated in staff by the fact that adverse changes in patients' mental states were often attributed to art therapy. Improvements tended to be attributed to medication. At the same time, I noticed that patients in acute psychotic states seemed to engage particularly well with the setting. With support and supervision, from my consultant psychotherapist colleague Dr Heiner Schuff, who had worked with Dr Murray Jackson at the Maudsley Hospital and had a particular interest in working with psychosis, I began to work with individual in-patients. By the time I took over the management of the art therapy department in 1986, we had developed a co-operative approach to psychotic illnesses within the setting. Wherever possible, when appropriate, I would work with the identified patient in individual therapy, and Heiner Schuff would simultaneously engage the family as a whole in systemic family therapy. Often, particularly when patients' anxieties diminished, they would attend groups offered by the occupational therapy service, developing their life skills and social skills.

Once a patient had started individual analytical art psychotherapy, he or she would meet his or her therapist every week in a setting structured along analytic lines, and the therapist would also be in relation to the patient throughout his or her attendance in the art room. Each patient was given a folder to hold two-dimensional images. The therapist would ask the patient to bring this folder to the weekly individual session. The patient was aware that placing material in the folder would bring it into a potential relation with the therapist. Many patients placed their art outside the folder, and the therapist would make clear to the patient that this would be respected. The art might be placed out of the therapist's sight, on walls, window sills or in other spaces which enabled it and its potential meaning to remain in the setting until the patient was ready to bring it into a more direct relation to the mind of the therapist. Once the patient and the folder were in the individual therapy room for the weekly session, the therapist communicated as simply and as clearly as possible that this was the time and space in which the possibility existed of sharing and trying to understand experiences together. What was shared, when, and how, was the choice of the patient, including the contents of the folder. All that the therapist asked of the patient was that he or she attend the session with the folder for one hour per week.

The experience mediated by a therapist/breast/containing object using this persistently interested and at the same time unintrusive approach was potentially containing for the patient. It seemed to me that the growth of

symbolic meaning in the patient's use of visual imagery depended upon the quality of this experience. Initially the therapist's task was to establish a boundaried space which could be experienced as a safe place for the patient to *be*. Because of the degree of anxiety experienced by patients, necessary boundaries within the relationship could often take some time and effort to establish. For example, patients might not attend their sessions, or attend at different times, leave after a few minutes, try to stay after time was up, and so on. Many would invite the therapist and others into their personal space in the room, foreclosing on the possibility of the space being experienced as a potential space for thinking. Frequently attempts would be made to evacuate the art and what it held from the setting by throwing it away. Negotiations about the patient's use of space, time, equipment and materials offered many opportunities for establishing relatedness, as the following case material will show.

Case examples

Case example 1

Mr A, aged 21, was referred to art therapy in an acute psychotic state on the day of his first admission to hospital. He was diagnosed schizophrenic on the basis of many first-rank symptoms, and his consultant psychiatrist remarked to a clinical conference at which Mr A was presented that his was the most serious case of schizophrenia that he had encountered. Mr A was dishevelled in appearance, and moved quickly around the art therapy room, appearing to try and make sense of what he encountered. He spoke in a language which I could not comprehend, and seemed to understand my efforts to introduce him to the setting as a series of demands, seductions or attacks. It took me some years to understand better his experience at that time. In condensed form, this was that he was dead, and had been ever since he became aware of the 'out of focus', an invisible civilisation which has qualities of permanence and is inhabited by gods and spirits. This civilisation uses the mortal world in which his body exists to manifest itself, and he had been taken hostage by it. The out of focus was controlling his thoughts and demanding that he perform the acts they dictated in the mortal world. He existed between the threat of sadistic vengeance if he failed to perform the required acts to perfection, and the promise of glory and immortality if he succeeded. In order to be a 'good model' his 'cybernetics' had to be perfectly 'tuned' with the 'focus' that would allow him to balance the demands of the mortal and immortal worlds. However, the out of focus had designed his body in such a way that its workings created interference in his 'cybernetics'. He was

troubled by 'aliens in the system', 'voodoo', and other disruptive experiences which constituted the workings of his embodied self. He experienced himself as being in an impossible position, and his behaviour revolved around attempts to find a 'balancing angle' which would allow him to 'advance focus' and 'override the interference'. This project was a matter of life and death. He felt himself to be failing, starving, and at risk of annihilation.

This experience, which he later described in these terms which made it communicable, could be understood as the results of a loss, or absence, of what Bion (1967c) describes as 'alpha function', the capacity to differentiate raw experience and transform it into thinkable thoughts, and consequent reliance on projective identification as a means of evacuating beta elements. He seemed to have been unable to contain the experience of separation from a girlfriend, which precipitated his psychotic breakdown. This seemed to have opened early and severe wounds or gaps in those ego functions which might enable him to process the experience. When I met him his world was split into good and bad. Both good and bad were projected into hallucinatory space, and consequently his sense of himself as an embodied being was impoverished. Mr A's therapeutic need as I understood them were to consistently, over time, experience containing elements which might gradually restore his sense of self and enable him to learn from his experience.

To begin with, Mr A experienced the rules and boundaries of the setting as persecutory demands. His omnipotent project demanded limitless feeding. Any and every limit on space, time, materials or my availability was reacted to with rage and threats, and powerfully overruled. He took three tables for himself, enormous quantities of paper, broke into the art therapy room out of hours, walked out of his individual therapy sessions, and so on. There was a mismatch between what he demanded and the 'mortal structure' of our relationship. Each occasion of discrepancy between his demands and what I could give offered an experience of contact between us. If possible, I would try to explain why the structure was the way it was, and suggest alternative possibilities which were available within the structure for the enactment of his project. Initially whatever I said was drowned out by contemptuous attacks, and attempts to cajole me into accepting his point of view. He would issue threats when this did not work, projecting into me his experience of being threatened. I persisted in my efforts to consistently communicate the fact of containment to him via the rules and boundaries structuring the concrete aspects of the setting.

In the third week of his attendance, Mr A began to show signs of relating differently to the containing elements, and to myself as a representative of the mortality he mistrusted so deeply. He began to ask me where various lost possessions of his were, as if I might be able to find the things he had lost. One day he added a reflective comment, which seemed to come from a more integrated sense of himself, 'I keep losing things.' This was intensely moving. The fact that he was talking about himself as an embodied being in relation to me allowed a connection between us to be experienced. His statement, although it related to concrete objects, could also be understood metaphorically as a description of the plight of his sense of self fragmented by projective identification, that he kept losing himself. He was implying a wish to find and keep things, to experience links. I was able to empathise with the pain of losing so much, and to comment that this was why I felt it was useful to keep things in one place, it seemed to reduce the risk of losing them.

Over a period of weeks in which many similar encounters which differentiated inner from outer realities took place, the structure of the setting became less persecutory and more containing for Mr A. I have described this elsewhere (Killick 1996), and proposed that a significant shift in his use of the setting as a container occurred when he built himself a 'nest' out of cardboard boxes and overalls in a corner of the studio, to which he retired when overwhelmed by 'beta elements'. Previously he had left the room to lie on his bed in the ward at these times. The nature of the room could accommodate his nest-building which enabled him to stay in the room for the whole of the session. This concrete experience, over time, was crucial in enabling him to experience the setting as a container.

Case example 2

Mr B's personal history included repeated exposure to physical cruelty at the hands of his mother and sexual abuse by his older brother, who was diagnosed schizophrenic. At the time of his referral to art therapy he was being held in the locked ward of the hospital under a compulsory order of the Mental Health Act and had been diagnosed as suffering from paranoid schizophrenia. As with Mr A, the meaning of his speech and actions was hard for me to understand and became apparent only after a relationship within which his experience could be communicated had developed. Later I understood that he believed that his testicles had been irreparably damaged when he was 11 years old, and that, shortly before admission, he had begun to believe that his body was changing into a female body. He also believed that everyone knew about the condition of his body, and that he was a subject

of ridicule by the media. He heard daily derogatory reports on the state of his body on radio and television and read similar accounts in the newspapers.

Every interaction he had with me was perceived and understood in terms of these beliefs. He presented me with a demand that I share his reality, in which I was either on his side or on the side of the persecutors, and he further demanded that I give him evidence of my allegiance. There were fleeting moments when he voiced a need for 'help'. I tried to avoid either colluding with his demands that I accept his reality or persecuting him with my demands that he accept mine, by simply saying again and again that I needed to keep an open mind about what kind of help would be truly helpful for him until we had understood his situation. I hoped he would help me to do this. He would repeatedly invite me over to his table to engage in this conversation, often with a space of only a few minutes between encounters. He seemed to be inviting me to invade his space, repeating an abusive pattern to which he was addictively connected, and in order to set limits to this, I would add that this time and space was his to use privately for himself, and that we would meet together at the time of our next session. I felt it would be best if he waited until then to speak to me because I could give him my full attention. I suggested that he could write down his thoughts in between in a private notebook.

I have described elsewhere (Killick 1993) how, once Mr B had begun to accept the existence of his space and had learned by repetition that I was related to this space in a particular way, and that this relationship included my separateness from it, he arrived one day with two bulging carrier bags. He placed these on his table, and laughingly asked me for four coffee tins. I felt very curious, and at the same time I recognised that he was testing out the validity of what we had established in our conversation. His laugh seemed to express his sense of imminent betrayal. I gave him the coffee tins and as unobtrusively as possible continued to go about my business. He filled the coffee tins with water, and placed the legs of his table in them. He then unpacked his bags on to the table, placing a selection of fruits, vegetables and a small collection of objects in a careful arrangement. Plate 8 shows his table at a later stage. He kept this arrangement for some time, changing it gradually as the fruit decayed. He later told me that he had to ensure that the space would be safe from invasion of ants before he could place valuable objects within it. Having established a space, he went on to paint a series of images of the objects. Plates 9 and 10 are examples of the dozens of very different paintings he produced.

I think these had the meaning of what Eigen (1985) calls 'signals of disso-
lution in progress' (p.326), the painting of the pictures being concrete
attempts by Mr B to keep alive the parts of himself which he had invested in
the objects. It took some time, and different kinds of interventions, before the
repetition of this motif of despair shifted to a creative involvement with
visual imagery.

Mr B used his individual sessions to deliver 'lectures' to me concerning
the formal aesthetic qualities of his paintings. He asked me to write down
what he said and to read it back to him in order that he could check that I had
understood it correctly. This activity became a ritual which established a tran-
sitional area of relatedness between us. Although I was in this one area
complying with his omnipotent demands, the concreteness of the activity
offered many opportunities for contact. It introduced an element of conver-
sation, in that he would speak, and then I would speak, sometimes discussing
my 'mistakes' and how to rectify them. When the writing was completed, I
raised the question of what *we* should do with it, again using the concreteness
of the situation to increase contact. We agreed that the notes I had written be
attached to Mr B's paintings with paper clips. In this way we were able to be
together in relation to a concrete endeavour.

Case example 3

The approach which had emerged spontaneously between Mr B and myself
proved useful in my work with Mr C, whose withdrawal from the world of
human contact was more extreme, and more established. Mr C was a young
man who had a ten-year history of admissions to a succession of hospitals, as
his family system became increasingly fragmented and moved location
regularly. He was catatonic on admission and was eventually sent to art
therapy. In his first session he showed me a drawing and proceeded to talk in
a monotone for a solid hour, regaling me with details of British Rail
timetables, descriptions of train machinery, and vivid enactments of station
announcements in English, Italian and German, punctuated by operatic arias.
I sat with this succession of 'signals of dissolution' and tried to bear the
intrusive identification of an absence of connection which they conveyed.
We agreed to meet at the same time the following week.

In the second session Mr C laid a second image on the table and began to
speak about the intricacies of trains and the British Rail system in a similar
way to the previous session. I interrupted him and told him that what he said
was of interest to me, but that I was finding it hard to follow what he was
saying. Would he mind if I wrote down his words and checked with him that

I had got them correctly? They could then be attached to his work if he had no objection, as in a sense what he said about his work was part of it. I would like to carry on doing this until he told me to stop, which he could do at any time. He laughed and concurred with this request. In the following session he brought in his folder, which he had drawn and written for the intervening week (Plate 11). I think this image and what he said about it usefully demonstrates the fact that, although the material is of symbolic interest to the therapist, the patient cannot at this stage relate to it symbolically within the relationship. The following are excerpts from what I wrote down in that third session.

> This is the by-pass round Canterbury Cathedral because there should be a path round Canterbury Cathedral. That 13 inches is actually 18 inches, and it's the width of the head code from Victoria to Ramsgate. This train is number 7119. The correct number is really prescribed 7150. Must be, because that's the same as 50. Maybe 7150 is the train and 74 is the head code. The driver comes from the right. I think on the ones from Dover they drive from there as well. Probably best to say that because I don't know. They've changed Canterbury station. The station at Canterbury East is the smallest station in Canterbury, including the bus station. That's Canterbury West station. Sixty-four foot six-and-a-half inches long, definitely, and the distance between the wheels has got to be eight foot. Actually it's twelve foot on the Southern Region at the moment. The traffic lights are just to stop and start it, and they just have to be the way they are.
>
> This is supposed to be a map of London as I think it should be in the year 19 million. And maybe there's got to be a bus station here. It's just by Trafalgar Square. Maybe it's best to destroy that bus shelter. The bus shelters are in German in Berlin. London should be rearranged only to a certain extent. Hitler said they should rearrange Germany. He was wrong, but the Labour Prime Ministers reckon he was right and the Conservative Prime Ministers reckon he was wrong, if you ask me...
>
> This has got to be Trafalgar Square in the middle of Canterbury Cathedral, so they've got to knock it down. It's falling down anyway. No, don't knock it down. I believe in God the Father Almighty...

I read this back to him, and asked him if I'd got it right, and if he would like me to change anything. He said it was all right as it was, and I attached the paper with the words on to the folder. He quickly began to play with this experience of another, and to experiment with different ways of speaking in relation to me. He began to differentiate between statements that he wanted

to go in 'his book' and those which were addressed directly to me. The meanings which had initially been encoded within a language of machines, were gradually translated into a language of body parts, body sensations, emotional experience, and relatedness between himself and myself, in his visual imagery and in the way he spoke about the imagery in our individual sessions. A drawing (Plate 12), and his words, from a session which took place two years later, clearly show this change:

> I have vomited. It's gone on the floor. It will sink in and bows and arrows will come out of it and go in your eyes. The Victorians used to spear it and eat it – sperm after sperm. They carried on eating until they were exhausted. They carried on eating until they were exhausted. Until they were exhausted and exhausted. Then they dived into the sea off a high cliff, and then they decided that they should swallow the water and it came out of their backsides as sick. The sick came out of his backside and spread all about the water.
>
> This is the Kitchen of Spain, and that is the menu. Roast mutton and double joints and little boys' penises. With standard engine names on their buttocks. With letters hanging from their noses…
>
> That's quite a good painting, isn't it?…Perhaps I could go to the Printing department and print the writing. Make babies out of it. I think you've been doing funny things with yourself because you're not in the mood for sex. You're a Victorian. You can talk about terrible death. We can talk about our children's death. Perhaps they'll fall over a stumbling block in front of a penis. Will you draw on my picture? Keep me alive…
>
> I keep thinking you're the Queen … I think you'd be good at school, learning about vaginas and switch points. You could understand the points and change lines. You could drive to Glasgow. I could just sit in the cab… I hope that psychiatrist doesn't find out what we're doing. He'll have it off with you … Are we on television? I think that fire is a trick recorder … You are a severe schizophrenic. You must see a doctor. You're very white, aren't you …Your eyes frighten me. You look English, Japanese and Chinese, with a bit of German mixed in. They're closed. They scare me … I've been leading·you on. Shall I turn the fire off? Not very cosy, is it? … You've gone too far. Now I can't shut up.

In this session, Mr C was animated and lively in distinction to his earlier monotone. His ambivalence in relation to the experience of my existence as a significant other was held within the pattern of our concrete interaction. In time, each of the three patients I have introduced were more able to tolerate emotional experience to the point where the art work and associated

activities were used predominantly for what Meltzer *et al.* describe as projective identification, employed for the purposes of communication, rather than evacuation. Mr C began to invent fantasy stories in the sessions, which were clearly metaphorical accounts of his experience, and asked me to stop writing so that we could talk to each other.

As I have described elsewhere (Killick 1993), Mr B began to work in plasticine and clay, risking the increasing links to body experience which these media foster, and he too spoke spontaneously in his individual sessions, inventing a series of fantasy characters, which clearly held aspects of his personality (Plate 13). In the early stages of Mr A's therapy, Mr A worked on a plasticine model called 'Sleeping Muse'. To begin with, this was experienced as an alien object made by the 'out of focus' using his body. After several years he painted a Muse which he called a 'self portrait' (Plate 14), and linked this to his earlier experience. He said, 'I don't know whether to put it sideways or upwards – lying down muse or standing. It's just the head, no neck or anything… I felt it was me as a kind of monster, dying in my sleep. It wrecked my life…This picture sums it up…They're just about a crisis in my life and how I coped with it at the time.'

Concluding thoughts

Each of the three patients whose material I have shared was able to engage with the setting as a container enabling raw affective states to become increasingly 'thinkable' in the medium of art, and gradually communicable to the therapist. The analytical art psychotherapy setting as a whole, including the therapist, was used as a primitive containing object of the kind I outlined earlier, which in Bion's (1967a) terms could 'introject, harbour and so modify the baneful force of emotion'. As primitive anxiety diminished, the possibility of symbolisation increased, and at the point where I have left them here, each of the three was well on his way to developing a personal metaphorical language for his experience. It is hard to imagine how the process of 'harbouring' the patients' material would have been possible without the art room. The room provided a concrete space in which ritual transactions between therapist and patient could be repeated for as long as necessary, and in which material could be concretely held over indefinite periods of time. The room accordingly constituted a womb which could hold the patient's embryonic sense of self over time until the patient was ready to leave. In two of the three cases I have cited, this process occurred.

I have described the early stages of therapy with three patients. In the beginning the therapist works to establish the containing object as a

potential in the mind of a patient. The patient's embryonic sense of self often expresses itself only in the person's continued physical presence in the setting, and gradually by fleeting moments of contact such as the one described earlier with Mr A, and the laughter of Mr B. The approach I have described continuously invites the patient into relationship, enabling him to experiment with the experiences of linking available within the setting and to learn from them at his own pace. I think that the core anxieties evoked in this journey towards relatedness require many experiences of containment before change is possible.

One patient with whom I started to work when he was an in-patient continued in once-weekly therapy with me as an out-patient. He had a long history of psychotic episodes accompanied by destructive acting out which had included suicide attempts and attacks on staff. One day, speaking of his first admission to the hospital, he commented: 'People like me need places like that art room. Places which allow the mind to heal.' This statement made me consider the part the art room had played in his recovery, and I began to wonder whether I could have worked with him as effectively during his acute psychotic phase without a place of the kind I have described. This is still an open question, and one which in my experience is shared by many art therapists. Although I was able to research the theoretical underpinning of this question (Killick and Greenwood 1995), I was not able to research the claims which I make about the effectiveness of this approach during my time in the hospital. I regret this, because without research establishing the effectiveness of this treatment method in terms which are convincing to NHS managers, it would be very difficult for an art therapist to make a case for a treatment setting of the kind which I have described within the form which psychiatric services take at present. I was part of a generation of art therapists for whom the principle of 'asylum' was an implicit component in the treatment of patients in psychotic states, and as far as I know there is no evidence-based research establishing this principle as vital and necessary. Without it, it is hard to make a case for the investment of time needed for the effective treatment of psychosis, and time played an essential part in the changes I have described here.

References

Bick, E. (1968) 'The experience of the skin in early object relations'. *International Journal of Psycho-Analysis 49*, 484.
Bion, W.R. (1967a) 'Attacks on linking'. In *Second Thoughts*. London: Heinemann.
Bion, W.R. (1967b) 'Differentiation of the psychotic from the non-psychotic personalities'. In *Second Thoughts*. London: Heinemann.

Bion, W.R. (1967c) 'A theory of thinking'. In *Second Thoughts*. London: Heinemann.

Case, C. and Dalley T. (1992) *The Handbook of Art Therapy*. London: Routledge.

Eigen, M. (1985) 'Towards Bion's starting point: Between catastrophe and faith'. *International Journal of Psycho-Analysis 66*, 321–330.

Jung, C.G. (1946) 'The psychology of the transference.' In M. Fordham and G. Adler (eds) *The Practice of Psychotherapy* Collected Works, Vol. 16, Second Edition. London: Routledge and Kegan Paul.

Killick, K. (1991) 'The practice of art therapy with patients in acute psychotic states'. *Inscape*, Winter, 2–6.

Killick, K. (1993) 'Working with psychotic processes in art therapy'. *Psychoanalytic Psychotherapy 7*, 1, 25–38.

Killick, K. (1996) 'Unintegration and containment in acute psychosis'. *British Journal of Psychotherapy 13*, 2, 232–242.

Killick, K. and Greenwood, H. (1995) 'Research in art therapy with people who have psychotic illnesses'. In Gilroy, A, and Lee, C. (eds.) *Art and Music: Therapy and Research*. London: Routledge.

Killick, K. and Schaverien, J. (1997) *Art, Psychotherapy and Psychosis*. London: Routledge.

Meltzer, D., Milana, G., Maiello, S. and Petrelli, D. (1986) 'The conceptual distinction between projective identification (Klein) and container-contained (Bion)'. In *Studies in Extended Metapsychology: Clinical Applications of Bion's Ideas*. Perthshire, Scotland: Clunie Press.

Keeping the Balance
Further Thoughts on the
Dialectics of Art Therapy

Sally Skaife

Introduction

This chapter develops ideas discussed in two previous papers (Skaife 1995 and Skaife and Huet 1998) about the relationship of the image-making process in art therapy to the verbal interaction that surrounds it. It was suggested that an inevitable tension arises between the art-making process and the verbal therapeutic relationship, but if space is given to both therapeutic tools regardless of the client group, this tension may allow for radical, therapeutic possibilities. In this chapter, the idea that these two processes have a dialectical relationship will be discussed in relation to the psychoanalytic literature that draws on dialectical theory to explain change (Blackwell 1994; Nitsun 1996; Ogden 1988, 1992a and 1992b).

My own interest in art therapy came from finding that art-making as a focused creative activity is like a microcosm of living creatively itself. The process of deciding whether to put red there or not in a picture, of taking the risk of losing the picture by restructuring the whole piece, creating a dull piece of work because of avoiding feeling, giving up on something because of feeling no good at it, all these things can be experienced and mastered with the aim of making an exciting piece of art work. Development of an aesthetic sense is part of the endeavour, without this there are no boundaries and so no precision. The finished piece represents the best one can do at the time, and acts as a new starting point. It seemed to me that involvement in this process, in a circumscribed way such as in visual art-making, could act as

a metaphor for consideration of the issues involved in being an active agent in one's own life script.

Many years later, I often find myself thinking that the art therapy work that I do with clients seems a far cry from my initial ideas of what I believed art therapy to be. It seems hard to find a space for these ideas about art therapy and for working in a psychodynamic way with verbal language, with clients. This chapter, then, explores my thoughts around this area.

I have chosen to look at dialectical theory because it is a theory which involves conflict and its resolution, and it seems to me that there is a conflict involved in the combining of verbal psychotherapy and art-making. However, the theory of dialectics involves polarities and it is questionable whether we are talking about polarities here, or about two different processes which might be combined in a new theory altogether or in a partnership or duality of theories.

The chapter is divided into three parts. In the first part I will describe the tension for dominance between art-making and verbal interaction in art therapy groups and explore the art therapy literature relating to this issue. In the second part I will look at dialectical theory and in particular how this has been used in psychoanalytic theory and group analytic theory. In the last section I will explore the relevance of a theory of dialectics to the two processes referred to in art therapy groups, relating this to my own practice.

1. Art therapy
Tensions in art psychotherapy groups

I have discussed tensions arising from the use of verbal interaction and art-making in art psychotherapy groups previously (Skaife and Huet 1998). These centred around the teacher/therapist role of the conductor, the difficulty of too much material coming into the group for members to process, and the fact that the role of the art work tended to be subordinated to group verbal interaction. It is this last phenomenon which will be examined in this chapter in relation to dialectical theory. In art therapy groups run along group analytic lines there is a tendency for the art work to be regarded by the group as primarily a reflection of group processes. Although art used in this way is helpful in expanding the material in the group and in holding and containing strong feelings in symbol and metaphor, it can leave other aspects of art-making unexploited for their therapeutic potential. These are essentially about the aesthetic aspects of making art which have a parallel in fundamental interactions between self and world. For example, the fear of

taking risks, essential to creating an exciting piece of art work; the paradox that in order to change/to create a satisfying piece of art work, you have to accept yourself as you are/what you make now. Gilroy, in an account of her research into art therapists' experience of making art, describes how those that kept in touch with their art found 'refreshment, self affirmation, self discovery and insight'; she adds: 'But there is something which goes beyond pleasure and therapy to a more profound sense of "being" in the world. It is extraordinary how clearly this comes across in the questionnaires. As one art therapist said: "I have to paint to be alive"' (Gilroy 1989, p.8).

It is this existentialist aspect of making art, equally of value to patients, that I fear may come second place in art therapy groups because, as an individual experience, it may be in conflict with the use of verbal interaction as a therapeutic tool in the group. In my experience, when the therapist places a different emphasis on the art work, encourages an exploration of the meaning of the art-making process to the artists/patients, it seems that the group itself loses its potential as a vehicle for the expression and resolution of conflict, as the focus of conflict becomes the art-making process. What role does group interaction have then?

An awareness of a tension around art and verbal interaction appears in groups even when a shared understanding has developed, perhaps not articulated, that the purpose of the art work is as an illumination of the group interaction. This is particularly apparent when the group change from talking together to going off to do their own art work, and when they return from working alone to look together at what they have made. This can be described in a literal way as an 'eyes up and an eyes down' change. Members are at one moment reaching out for contact and meaning through words, and at an another, entering into an activity where direct communication is not the primary aim, and meaning is always elusive. The use of words is an attempt at precise communication, whilst art is the attempt to communicate something indescribable in words.

To explore this conflict further some important questions need to be addressed. Is the tension intrinsic to the practice of art therapy or is it particular to group art therapy? Is it only of relevance when the art therapy group is the primary therapy for the participants, or, when the clients are verbally articulate people, capable of insight?

To address the first question, I will look at how theoreticians have understood the role of art in individual art therapy, and will in particular explore the concept of the triangular relationship. I will then look at the literature on group art therapy, and examine the concept of resonance. The

underlying question here is: do the concepts of the 'triangular relationship', and of resonance of the art work in group art therapy, allow enough prominence for the therapeutic potential in art-making? There will only be space to address the second two questions briefly.

The triangular relationship

The triangular or three-way relationship is a key concept in art therapy. It refers to the 'three voices of art therapy' (Dalley, Rifkind and Terry 1993) – that is, the art work, the patient and the therapist – and the relationships between them. Art therapists have used psychoanalytic theory to consider the relationship of the different parts of the triangular relationship. Waller and Dalley (1992), drawing on object relations theorists, in particular Klein and Winnicott, discuss art-making as a reflection of the transference, which may or may not need to be verbalised for resolution to take place. Using Winnicott's concepts of transitional phenomena and potential space they describe art in therapy as an adult form of play. Schaverien introduces a new concept, that of a transference to the art work, and coins a new name, 'analytical art psychotherapy', for the type of therapy based on this idea (Schaverien 1992, p.6). The concept of a transference to the art work is the cornerstone of her theory and is highly significant to an understanding of how the potential conflict between art-making and verbal interaction, described above, is considered. First, it is important to look at what is meant by a transference to the art work, as this is quite a complex concept, transference usually referring to feelings, originally towards a primary care-giver, that are inappropriately felt towards other people in the present.

Schaverien refers to Greenson (1967, p.154), a Freudian, as making the point that transference can be made towards inanimate objects. She writes:

> ...transference reactions may occur towards 'people who perform a special function which originally was carried out by the parents. Thus, lovers, leaders, authorities, physicians, teachers, performers and celebrities are particularly prone to activate transference responses. Furthermore transference reactions can also occur to animals, to *inanimate objects*, and to institutions, but here too, analysis will demonstrate that they are derived from the important people of early childhood.' (Schaverien 1992, p.16, quoting Greenson 1967)

Schaverien uses Greenson's idea of a split in the therapeutic relationship between the transference and the therapeutic alliance to understand the process in individual analytical art psychotherapy whereby the artist both

has a transference to their picture and can also stand back and observe it as the viewer. She also draws on Jungian ideas about the art work being the place in which a transformation of the transference takes place, through archetypal imagery. Transference to the art work is the key to how Schaverien understands the relationship of the three parts of the triangular relationship in individual art therapy. Using Winnicott's concept of 'object usage', she describes a difference between art psychotherapy and psychoanalysis or verbal psychotherapy in the use of the therapeutic relationship. Winnicott's term 'object usage' refers to the way in which the infant differentiates itself from the mother by a discovery of her separateness, through establishing that destructive attacks made on her do not in fact harm her. Winnicott says that if destructive attacks do not take place against the analyst then the therapist is merely a companion to self-analysis. Schaverien says that in art therapy the art therapist is often the companion on a journey of self-analysis rather than a recipient, but the destructive attacks are made in the art. This may 'incorporate vivid pictured attacks on the art therapist. Like the mother, or the psychoanalyst, who survives the destructive attacks of the infant or analysand, the therapist and patient survive the witnessing of these attacks in the pictures' (Schaverien 1992, p.34).

Having established a central role for art within a psychoanalytic model through the concept of a transference to the art work, Schaverien examines the process through which art becomes therapeutic in individual art therapy. Key to this is her feeling that the process of art-making in art therapy has been given prominence over the product made. She describes the stages of familiarisation and assimilation and eventually disposal that accompany the finished art object and involve both the patient and the therapist. Her concept of the scapegoat transference, in which the art work containing the transference is integrated or not by the client, is central to her ideas about the art psychotherapeutic process. The idea is that there are a series of frames, the picture within a frame in which the transference is held, the frame of the therapeutic relationship, and the frame of the context of the art, its meaning or reference to its culture in its relation to the art gallery or theatre. Interestingly her case study (Schaverien 1992) which illustrates these ideas is a retrospective study of art work made in art therapy. As such, the product of the therapy rather than the process is what receives attention.

Dalley, et al. (1993), in an art therapy case study of one-to-one work in which the voice of the client is represented, as well as the therapist and the supervisor, describe the triangular relationship of picture, client and art therapist. Similarly to Schaverien, they describe the therapeutic relationship

as the frame for the therapy, and the art work as the central means through which destructive and painful feelings are expressed and worked through by the client:

> As Kim describes, he did not experience Gabrielle directly 'as if' she was his mother. The transference to mother was contained in the image. The therapist was perceived more as someone he trusted while his feelings about mother were expressed through the images and could thus be worked through in this way. (Dalley *et al.* 1993, p.158)

Interestingly, though they sometimes talk about a transference *to* the image – for example, when they describe Kim's oedipal issues as worked out through Gabrielle as mother, and the art work as father – they more often refer to the transference as being *expressed in* the image. It may be of importance that Kim, the client, mostly did his art work at home and brought it to the session. In this way he enacted a split between art-making and verbal psychodynamic therapy. Kim himself gives the reason for this as there not being enough time in the session for painting and talking.

Schaverien feels that not enough attention is paid to the end product in art therapy. Interestingly she links this to the tendency of art therapists to lose touch with themselves as artists, a discussion explored in some depth also by Gilroy (1989). Schaverien feels that because of the need to reassure those clients who are anxious about their artistic ability, art therapists have neglected the role of aesthetics. I think that these same arguments could be applied to support an idea that the art *process* is neglected for the same reasons; that is, that we are afraid of embracing aesthetics and aesthetic judgements that are intrinsic to making art.

Clients are often told that it is not important to be good at art to do art therapy. This is usually said because an invitation to do art therapy often meets with the reply, 'I am no good at art.' It is important to consider what a person is really saying when they say this. They are responding to an idea of what art is, and to some mythical idea that some people can do it and others cannot do it, as if it didn't involve a process of *becoming* good at art. It is their first comment or attitude to aesthetics. But if we say 'Oh, don't worry, art therapy is not about aesthetics', what are we saying? In a sense this admonition tells them that art-making is not what is important, but 'telling something' through using art – in other words, a conceptual idea – or finding something out that is hidden in the art work. We are certainly not inviting them to use a therapeutic tool in which it is possible to really *engage* with their feelings. It may be that it is more productive to actually address this attitude

of the client towards aesthetics as the first therapeutic step, rather than trying to push it out of the way. The art therapist might reassure them that they make aesthetic decisions all the time, by deciding about the colour of their clothes, or how they arrange the fruit in the fruit bowl, for example. Wood (1986) discusses the fear people often experience when invited to make art, and suggests means of trying to engage clients such as asking them about their own histories as artists (a change from their psychiatric histories, as she points out) to help them get in touch with their childhood selves who were less concerned about 'not being good enough at art'.

I have been questioning whether a conflict between art-making and verbal interaction may exist in individual art therapy by examining the concept of the triangular relationship. The literature suggests that there is an uncertainty as to whether the art work is an expression of the transference or the transference itself, which raises questions as to whether a phenomenon is being moulded to fit a theory in which it does not rest comfortably. The concept brings together the two different languages in art therapy, art and talking, under one unified theoretical umbrella. This idea potentially leads to less attention being paid to the therapeutic possibilities in the client's experience of making art. Schaverien herself points to the need for other the-oretical models besides a psychoanalytic one in art therapy (Schaverien 1997).

The problem of there being enough time for both talking and painting, which Kim refers to (Dalley *et al.* 1993), seems to be a crucial one in art therapy groups too (Skaife and Huet 1998). Similarly, Schaverien's (1992) idea of the therapist becoming a companion on a journey of self-analysis in individual analytical art therapy fits with my own experience in group art therapy of the therapist relationship and the group relationships, when art-making is given prominence. In the group, the members relate to each other as companions in the pursuit of art, and/or in the stories that have brought them to therapy (see Liebmann (1997) for an example of the latter), and the interactions between them are not made use of as therapeutic material. I will now go on to look at the literature on group art therapy in an attempt to explore how the conflict I describe has been understood.

Resonance

McNeilly (1984 and 1987), acknowledging that there are many trans-ferences in the group, not just one towards the therapist, develops the concept of visual resonance, 'the language of the dynamic silence', which is expressed through the collective but unconscious use of themes and styles in

the image-making. Closely following the ideas of Foulkes, he regards these as reflecting the individual resonance to an unconscious group dynamic. In his earlier paper (1984) McNeilly appears to find conflicts with art-making in a group setting and describes three unsatisfactory ways in which discussion of the images made in a group can proceed: the group goes round in a circle talking about their work, with the result that the underlying dynamics are missed; one picture takes the focus of the group at the expense of an examination of the material in the other pictures; the group avoids talking about the images altogether. His later paper (McNeilly 1987), though, resolves these through developing therapist techniques for working with the phenomenon of resonance, moving between visual and verbal imagery in an attempt to make therapeutic use of unconscious material.

It is interesting that McNeilly refers to resonance as 'the language of the dynamic silence'. This term could well describe the taboo in the group on any mention of aesthetics, of an image being attractive, about some people having more of a facility with using the medium for self-expression than others. Indeed, when this is on occasion mentioned, someone will hurriedly say that the point of the group is not to make 'good pictures'. I wonder, though, if the result of this taboo is that the feelings involved with the presentation of art work made to a group of people go underground, and that these feelings have, in fact, a profound influence on the process on the group, in terms of competition, of showing off, of copying, of influence and self-worth, but that they are largely unspoken. In the time for talking, the content of the images is what is spoken about and frequently it is something that has come from an image, not the image itself, as McNeilly describes in his third unsatisfactory group mode. It seems almost inevitable that the linking McNeilly describes of verbal and visual imagery promotes the use of self-expression through verbal language, and that the therapist, in confining their role to comments of this kind, directs the group more and more away from emotional engagement with the art materials. Time constraints, however, may have a part to play. When experiential art therapy groups have been given longer time spaces in which to work, more time has been spent on the process as well as the product and the group interaction (see Dudley, Gilroy and Skaife, Chapter 7 of this book).

McNeilly's idea of group analytic art therapy adheres closely to psychoanalytic thinking, the uncovering of unconscious material being the key factor. Waller (1993), like more recent theorists on group analysis (Brown and Zinkin 1994), draws on other theoretical models including existentialism and systems theory. She coins the term 'interactive art therapy

groups', and tends towards a model where group members take responsi-bility as to how the group is structured in terms of art-making and verbal interaction. She does not comment on experiencing any conflict with this, though she says: 'There is a high degree of "drama" in an interactive art therapy group and the conductor may need to be particularly vigilant in rein-forcing boundaries and encouraging members to move into a different mode of enactment, to slow the process down' (Waller 1993, p.49). Waller's case examples are from short-term groups which are mostly teaching groups. In discussing 'practical matters', Waller recommends that clients would benefit from an introduction to art materials from someone other than the art therapy group conductor, and advocates more co-operative work between artists in hospitals and art therapists. The implication of this is that an engagement with the difficulties of visual creativity is seen to be outside of the therapeutic process. However, conflicts with getting the materials 'to do what one wants' are ongoing to anyone engaged with art.

In this section I have been exploring the art therapy literature in an attempt to understand how art-making and verbal interaction are seen to relate, and to see if my own experience of there being a conflict between the two in art therapy groups is reflected in it. The main theoretical literature on art therapy, both individual and group, is heavily based in psychoanalytic theory, with a focus on the unconscious and transference as paramount. It seems that this may not be enough, as evidenced by some of the discussion in Schaverien's work (1992). Waller's (1993) account of 'interactive art therapy groups', though drawing on a more eclectic theoretical base, does not address difficulties in moving between one form of expression and another. The fact that her examples are in the main from short-term experiential groups, where different time constraints, boundaries and group-member expectations alter the process of groups, could explain this difference in experience.

This leads into the next question, which is whether the tension described in art therapy groups between art-making and verbal interaction is present in a similar way in all settings, with all client groups. Here I will briefly present some of the issues, as space prohibits greater exploration.

Generability

Where the art therapy group is the primary therapy for the participants, there seems a real need for space for clients to be able to speak about their problems. If the group is to function interactively this means that verbal inter-action becomes an important aspect of the art therapy group process. When

the art therapy group is part of a larger therapeutic programme involving verbal therapy groups, such as in a day hospital or therapy centre, there may not be as much need for clients to talk about personal issues within the art therapy group. Another consideration is that there may be pressure from the institutional setting in which art therapy is practised for an emphasis to be placed on one or other aspect of the process. This might be for pragmatic reasons such as their being in an unsuitable studio space, or because of cultural assumptions about art, or about psychotherapy.

My hypothesis is that when the art therapy group is not the primary therapy, the conflict is less apparent, but it nevertheless is present in that it affects the therapist's internal model of the therapeutic process. It is possible that it has received so little attention in the literature because art therapists do primarily work in teams. As yet, the extent to which changes in mental health provision have affected the primacy of the art therapy group in therapeutic provision is unknown.

Chapters in an edited book on art psychotherapy groups focusing on different client groups (Skaife and Huet 1998) reveal that the conflict described is not so apparent with some client groups: for example, those who would not usually be suitable for verbal psychotherapy groups but who could participate in a psychodynamic group process in an art therapy group; children; those with chronic psychosis or cognitive impairment. With these clients enactment of feelings through the use of art materials within the wider boundary of the physical space was the chief therapeutic tool. If this finding is relevant beyond the parameters of the experiences related in the groups in the book, does this have implications for who should receive group art therapy? Is it best, for example, to avoid a therapy which has such a basic conflict in it in favour of one which does not, like verbal group therapy for the articulate, and group art therapy for those who are not? Schaverien (1994) proposes a consideration of different types of art therapy for different client groups. My own view is that there is a danger of reductionism in this, and that a possible alternative should be considered, one which makes a virtue out of conflict by harnessing its creative or therapeutic potential (Skaife 1995).

I will now go on to look at dialectical theory, and at whether as a theory it has any relevance to conflicts between verbal interaction and art-making in art psychotherapy.

2. Dialectical theory

What is dialectical theory?

The theory of dialectics posits that everything only exists in terms of its opposite, so that, for instance, we cannot know altruism without knowing selfishness, hate without love, etc. The tension that is created between these two opposites brings about a synthesis which in turn sets up its own antithesis. Thus there is the thesis, the antithesis, and a synthesis which becomes a new thesis. Ogden describes dialectics thus:

> Dialectic is a process in which opposing elements each create, preserve and negate the other; each stands in a dynamic, ever-changing relationship to the other. Dialectical movement tends towards integrations that are never achieved. Each potential integration creates a new form of opposition characterized by its own distinct form of dialectical tension. (Ogden 1992a, p.517)

The theory originates with Plato, who used the word 'dialectic' in the *Republic*. For him dialectical thought was philosophical thought and the aim was to understand everything. Hegel developed the idea to mean proceeding by contradictions, still with the aim of understanding everything and thence becoming like God (Warnock 1965). Marxists, in particular Engels, adopted dialectical theory to describe processes relating to material nature, and used it as a means to understand history, and to support a view of history as progressing towards positive change. Marx postulated that central to all things was matter – that is, that all social relationships are formed around the provision of our basic material needs: food, water, shelter. He believed that all other aspects of living were a superstructure whose nature was determined by the power relations set up around property. He saw that throughout history there was a dialectical relationship between what he called the property-owning classes and the propertyless. An increase in knowledge about methods of production inevitably brought about conflict between the propertied and those without property, resulting in class struggle, which resulted in a new type of relationship between the propertied and the working classes (Eddy 1979). There is a deterministic aspect to this theory in that Marx postulated that social revolution was inevitable. To my mind this stands in some contradiction to the idea of the individual's experience of empowerment through choice, though these two different strands of thought form yet a further dialectic.

The Marxist theory of dialectics has some relevance to this discussion in terms of a consideration of power relations and art therapy groups, and also

in relation to determinist theories, or monist theories, of which Freudian theory is also one. In this the concept of the unconscious, central to psycho-analysis, is seen to be the foundation on which all other factors become a superstructure.

Psychoanalysis and dialectical theory

Several theorists have used dialectical theory as a means of understanding processes of change (Blackwell 1994; Brown and Zinkin 1994; Nitsun 1996; Ogden 1988, 1992a and 1992b; Schlapobersky 1994;).

Blackwell (1994) describes how Freud, influenced by German phil-osophy, adopted concepts which could be considered as dialectical. For example, his ideas about instinctual drives being in conflict with societal demands, and the ego synthesising information from both, could be seen as a dialectical process. However, Freud tried to distance himself from this, as it was all-important to him to create a universal biological theory, which was ahistorical and acultural. Foulkes, too, was influenced by German philosoph-ical ideas. He had close links with the Frankfurt Institute for Social Research, which was a major exponent of the dialectical tradition; it sought to integrate a psychoanalytical understanding of the individual with a Marxist under-standing of political history. However, Foulkes, like Freud, turned to biology and psychoanalysis, despite his view of social process as the cause and remedy of psychological problems (Blackwell 1994).

Ogden (1992a and 1992b) explores the dialectics of the development of psychoanalytic theory from Freud, Klein and through to Winnicott. He puts forward a notion of a self that is never stable as it always consists of dialecti-cally opposed opposites moving towards an integration. He calls this the 'dialectically constituted/decentred subject' (1992a, p.517). He describes how Freud decentred the subject by his concept of 'the unconscious', suggesting that the 'self' only existed consciously, in the presence of the unconscious, and vice versa. 'The subject for Freud is to be sought in the phe-nomenology corresponding to that which lies in the relations *between* con-sciousness and unconsciousness' (Ogden 1992a, p.519).

Ogden continues with his discussion of the dialectics of psychoanalytic theory by pointing out that Klein came to see her concept of the 'positions', 'paranoid-schizoid' and 'depressive', not so much as developmental stages but rather as positions that exist alongside one another. 'I chose the term "position"…because these groupings of anxieties and defences, although arising first during the earliest stages [of life], are not restricted to them…' (Klein 1952, p.93 in Ogden 1992b, p.613). Ogden describes how the forms

of experience associated with the 'paranoid-schizoid' and 'depressive' positions 'can only be named by referring to the ways in which each represents a pole of the dialectical process in which each creates, negates and preserves the other' (Ogden 1992b, p.613). Each of the positions is characterised by a quality of anxiety, form of defence and object-relatedness, and type of symbolisation. In an earlier paper (Ogden 1988) he introduces a third position, the autistic-contiguous position, and describes how these three positions exist in a dialectical relationship with one another. Thus pathology is seen as a collapse into one singular mode, leading either to the tyranny of a reliance on autistic defences, a paralysis of fear in an unpredictable world which cannot be thought about, or a stagnant state devoid of spontaneity and aliveness. Conversely the energy generated between these poles leads to a richness of experience. Ogden also describes a dialectical process existing in two other of Klein's concepts, the splitting of the ego, and projective identification, but there is not space here to go into those.

Ogden then moves on to describe dialectical tension in Winnicott's theories. Winnicott proposes that the subject never resides entirely in the psyche of the individual, but between the mother and the infant. This creates several forms of dialectical tension, that between at-one-ness and separation, the dialectic of recognition/negation of the infant in the mirroring role of the mother, the dialectic of creation/discovery of the object in transitional-object relatedness, and the dialectic of the creative destruction of the mother in 'object usage'.

Thus Ogden's premise is that there is no such thing as a stable subject, the subject is always in a state of becoming through dialectical processes. I will now move on to discuss how dialectical theory has been used to describe processes in group psychotherapy.

Nitsun (1996) takes up Ogden's notion of a state of pathology as a collapse into one position or another, in his discussion of the dialectical relationship of constructive group forces and destructive ones. He describes the group as in a pathological state if it remains in either an anti-group mode or in a positive group mode. Nitsun's argument is that the healthy group is in a constantly moving place between these two positions, and that the dialectical movement is part of the transformational process. He uses various theories, including Winnicott's transitional space and Foulkes's concept of the matrix, to describe the space in which the dialectical process of conflicting opposites has a transforming potential for the group and individuals in it.

Brown and Zinkin (1994) say that group analytic theory may represent the synthesis in a dialectic between the individual and the social world. In an

edited book of chapters which explore the relationship of group analytic therapy to psychoanalysis, social science, systems theory and philosophical theories, they point out a number of theoretical conflicts that arise from and between the theories that are described. However, the central issue in the book seems to be that group analytic theory raises the question as to whether we should look to the individual as the primary object of study, or whether to the social context.

In this same book, Blackwell (1994), in his exploration of systems theory and what it has to say about the relationship of group analysis to its wider social context, takes a Marxist view of social power relations. He believes that there is no position that is not political, no theory without political implications. He describes systems theory as a 'sprawling field of ideas' (p.30) which attempts to be devoid of history and politics, another universal theory, which of course it cannot be. Blackwell discusses how systems theory has the idea of an outside observer of systems, as if it was possible for anyone to be outside of something they observed. He describes how, although it may initially have been important for systems theoreticians to distance themselves from an historical and political context, it is now necessary for them to incorporate a postmodernist political perspective.

Blackwell concludes: that psychoanalysis provides a way of thinking about and articulating individuals' subjective experience, but systems theory is a way of observing that process, and the two can be combined in a dialectical relationship towards progress. He describes this as the projection of the past into the dialectic of becoming. In the therapy group each individual is both an observer of others and a subject of their own experience, and this creates a dialectical process towards change.

The questions to be addressed now are: what can be understood from the use of dialectical theory in psychoanalytic thinking, and its application to group analytic theory, that is relevant to art therapy? Can dialectical theory also be of use in understanding processes in art therapy? And finally, does this theory have more to contribute to processes in group art therapy than individual art therapy?

Ogden's ideas of a self that is never static but always moving through conflict, and its resolution in a process of becoming, lend themselves to the idea of the process of becoming through the creative process involved in art-making. It brings to mind the interplay between conscious and unconscious factors in making a piece of art work. The dialectic he describes in Winnicott's theories of oneness and separation can be related to the paradoxical experience in art therapy of being alone with the art work but also in the

presence of other people. Thus in art therapy the art work is simultaneously about the other people in the room with the artist/patient, and about what is other than in these relationships. Perhaps this has a different character depending on whether the therapy is individual or group. Levine (1997) explores this dialectical process in art in art therapy, drawing on the philosophical ideas of Heidegger.

Ogden's ideas about 'the positions' as conflicting states, which, to be healthy, must be kept dialectically active, may have something to say about the dangers of adopting one type of therapy for one client group and another for another. Schaverien (1994) observes that art therapists tend to adopt different approaches for different client groups, and that these differ in the role given in the therapy to transference. If these types of art therapy were to become fixed, following Ogden's analysis, the therapy would be in danger of becoming rather sterile. For the argument in this chapter, the importance of an awareness of the dialectic between the different aspects of art therapy groups, with all client groups, is supported by Ogden's ideas.

Apart from Ogden the other theoreticians discussed above incorporate a plurality of theories for an understanding of the individual, their relationship to society, and the process of therapeutic change. Blackwell (1994), in his discussion of the use of psychoanalytic theory and systems theory, describes how the dialectical relationship between these two can explain how a process of change works. He appears to be describing something about creativity, though here in the relationship between different processes in a verbal group, which is of significance to this discussion.

3. Art therapy groups and dialectics

In this section I will be looking critically at how a theory of dialectics may be used to understand the tension between art and verbal interaction in an art psychotherapy group. The focus will be around three issues. The first is the private/public aspect of art-making in therapy, the second the dialectical relationship between work and relationships, and the third will be an exploration of the effects of contradictions involved in psychoanalytic theory and art, on this tension in art therapy groups. Finally I will explore implications for therapist technique with examples from my own practice.

The private/public nature of making art work

Is art activity in the group about a personal communication between artist and their art work, or is it between artist and group or therapist? This is the

age-old paradox in art: do we make art to communicate to others, or for ourselves? The answer, I think, is that both are true simultaneously. They exist paradoxically, or dialectically. In practice it is very difficult to follow one's own aesthetic direction and also be in communication with other people. However, part of making a successful piece of art work is that it does communicate to other people. Perhaps these are different stages in the art-making process. In the first stage one tries to find the idea for oneself, and in the second, one attempts to make it communicate. This is the process I think that Schaverien (1992) is referring to in her description of the split therapeutic relationship; the communicating with self being the transference to the art work, and the part of the client that is in a therapeutic alliance with the therapist being the 'other' to whom the art communicates. Perhaps, though, these two are better understood as existing in a dialectical relationship rather than sequentially, as one cannot act and review simultaneously. Deco (1998) also talks about not really being alone when doing art work because of one's inner objects, both of earlier relationships and of one's companions in the group. The other side of this, though, is that, in order to engage with what one is making at a deep level, it is necessary to follow a lead from oneself, and to experience a sense of allowing others to recede. What has been described so far is a dialectic of private/public in the art-making section of the group, which is being considered as a whole to be in dialectical relationship with the public space; that is, where the art work is shared with others. So, in the art therapy group there are two processes involved, one private and one public, and they exist in dialectical relationship to one another.

It is now useful to consider Ogden's idea of a collapse into one or other side of a dialectic as pathological. In the art-making it could be that if a client did not bear others in mind his art work would fail to interest the therapist or the group members. On the other hand, if it failed to involve a dialogue with self, then it would probably be of little therapeutic value. Thus these two processes are necessary for the art in therapy to be therapeutic. In the group as a whole, if the art-making has as its main purpose communication to the other group members, the therapeutic potential in art-making is lost; conversely, if art-making is entirely predominant and communication between group members neglected, the importance of what is going on between people is ignored. This will also impact on the value of the art that is made. You cannot have one without the other, as they both exist.

Bearing this concept in mind – that is, the importance of considering these two processes as having a dialectical relationship – there are serious

implications for the dynamic administration of art therapy groups. There is actually a tension in a quite literal sense between these two bits, as they suggest quite different practical aspects. The balance given to either one in the therapy determines many things about how the therapy takes place and, vice versa, the practical arrangement of the room, the type of materials, etc., affects what become the tools of therapy. So, for instance, if the therapist or group have in mind the idea of the artist and their relationship to their art work as the key therapeutic medium, they will create suitable, may be private, spaces for their clients to work. If, on the other hand, they are concerned with the group interrelationships first and foremost, group members may be encouraged by the way the tables are laid out to sit around a central table. If the emphasis is on exploring the meaning of imagery, then the quality of the art materials is less important. Conversely, if art-making is seen as the central process, quality materials become very important. These two things seem to stand in opposition to one another in a very immediate way. In a chapter about experiential art therapy groups (see Dudley, Gilroy and Skaife, Chapter 7 of this book) we explore these practical aspects in how the three of us ran our experiential art therapy groups. We look at the difficulties we had in facing up to the fact that we ran the groups differently and the importance of us being able to accept our differences, for the students to accept theirs and their difference from us, in order to separate from us as they graduated to become qualified art therapists. We discovered that we all sat differently in the room, one remaining in her seat throughout, another sitting on a raised bench and another moving around the room during the art-making. These different actions of the art therapist certainly give out different messages in that they convey something to the group members about the therapists' feelings and attitudes to the conflict involved in the private/public tension in the group.

Similarly, the type of intervention the art therapist makes regarding the art work and its making will reflect one or other side of the dialectic. If she only makes comments about the content of the work, i.e. the communicative bit, then this may encourage the artist/patient to focus only on this in their art-making. If, however, her comments only allude to the process with which the client is engaged when making art, then this will ignore aspects of the content that the client may wish the therapist to see. On the whole-group scale, if the therapist confines her comments to group process and members' verbal interaction, placing the art work in this context, the group will involve themselves less and less in their art-making.

Nowhere is the tension between public and private more acted out than in the situation of the therapist watching the clients making art. You could say that something private is being watched. This situation has few parallels in other areas of artistic activity. It brings to mind the tutor standing behind one whilst doing a life-drawing, as you carry on with the drawing, tense and waiting for him/her to interrupt. Or Rolf Harris using art as a performance on television. When watching this there was a sort of tension about what would happen if he went wrong, as you or I would do, and was thus exposed. Of course he never did, and knowing this, that he actually had a sort of formula, was an immense relief. There is the principle on the one hand that it is important that the therapist is present for the execution of the work, as the art-making process is just as important as the end product, but also an uncomfortable tension about the therapist being a voyeur. How far can clients really involve themselves in a dialogue with themselves whilst they are being watched? Was this an influence on 'Kim's' choice to work at home? (Dalley, *et al.* 1993.)

I think there might be quite a big difference between group art therapy and individual art therapy in relation to the public/private dialectic. In my experience in art therapy groups there is often a largely unspoken tension around finding a place, either away from the therapist's eye, or close to her where she can see. As Schaverien points out (1992), angry attacks can be made towards the therapist in the art work; these of course need to be seen. However, in the group the watching of the art-making process is more diluted than in individual therapy. It is not possible for the client to know exactly when, and by whom, she is being watched.

The difference between individual and group art therapy in this respect could be examined much further, but at this point I shall move on to the discussion of another dialectic, that of 'work' and relationships.

To love and to work

Freud said that mental health was about being able to love and being able to work (Freud 1930). It is interesting that these are two separate things, and it seems to me that though they are linked it is important also to think of them separately. Ogden's comment on the dialectic in Winnicott's theory in transitional phenomena is relevant here. That is, transitional phenomena are at the same time part of the child and also other than the child. It seems to me that art-making in the group opens up the possibility for exploration of the idea of a dialectic between work and relationships. In the category of work, I am not just thinking of paid employment, which may or may not be creative, but

I would include anything that one does, all activity and creative striving that does not have as its goal the achievement of intimacy with another. This would include decorating one's house, doing the gardening, choosing clothes: all these things give pleasure, are about aesthetics and are about creating meaning in life. Work is about one's interaction with the world, about one's contribution to society, which by definition is inextricably linked to relationships, with others, the 'society' in which the act of work interacts, as well as, in an immediate sense, with those one works with.

Much has been written about the psychological effects of unemployment, and it is interesting that several lottery winners, according to the papers, have chosen to go back to their jobs or have sought new enterprises even though they need never work again. It seems that without meaningful endeavour, our lives feel meaningless. Hence much of the depression that women who stay at home looking after children feel when their work is not framed by society as work. They become invisible and invalidated, only recognised by their children's interaction in society. The point I am making here, though, is that, if we do not separate out the act of work from the making of relationships in psychotherapy, and consider them in their dialectical relationship, we may miss an important side of the dialectic. Again considering Ogden's collapse into one side of the dialectical relationship as a collapse into pathology, we could say that if we consider difficulties at work only as difficulties in relationships and not as a fundamental difficulty with coming to grips with a creative, aesthetic process, we miss half of the process. Art therapy seems to offer a perfect form in which we can work with this dialectic; parallels can be made about the client's attitude and experience of art-making in the group and the material brought about work.

Before going on to look at examples of art therapy groups, I will now look at the extent to which the conflict between art and verbal interaction in art therapy groups is affected by complexities and confusions in theory.

Psychoanalysis and art

Several art therapists, Maclagan (1989), McNiff (1992) and Lanham (1989), have explored conflicts in the language of psychoanalysis and of art and have voiced reservations about too heavy a reliance in art therapy on psychoanalytic thinking. Maclagan in particular has drawn attention to the secondary role that a consideration of 'facture' (the way an image is made) is given in an understanding of the meaning of art work (Maclagan 1989). It seems to me that as art therapists we hold several different models of purpose in our groups, as do our clients, but that some of these may in fact be in conflict with

one another. It is not possible really to consider the tension in art therapy groups between talking and art-making without considering the role ascribed to the unconscious in our understanding of the purpose of art therapy groups.

Cohn (1997) points out that all psychodynamic theories adopt the idea that the uncovering of unconscious material is part of the process of therapy. He describes how modifications in theory have been made in response to discoveries such as the significance of the effect of real-life experiences on a person's thoughts and feelings, as exemplified in the work of Winnicott and Bowlby, for example, but only a few psychoanalysts (Binswanger and Boss) have attempted to refer their experience to a new theoretical framework, which he feels would make more sense. Cohn (1997) discusses the evolution of Freud's concept of the unconscious, and states that acknowledging awareness and lack of awareness of phenomena is not the same as believing there to be a state or place which is 'the unconscious'. This is too great a leap.

Diamond (1996) points out other confusions in psychoanalytic theory. She declares: 'Any understanding that starts with the primacy of the individual cannot be combined with an approach which begins with an interpersonal account of human development and experience' (Diamond 1996, p.305). She believes that an intersubjective approach starts with a different philosophical premise. 'Any differentiation between inner and outer world from an intersubjective perpective is an experiential division not to be confused with a metaphysical reality' (1996, p.311). In other words, she goes on to say, Winnicott's idea of a third space – that is, a cultural space other than the baby or the mother – is in fact the primary space. It is in this space that there might be an *experience* of inner and outer.

Looking at this idea in relation to the art therapy group, I take what Diamond is saying to suggest that the process of becoming within the art therapy group happens through enactment in the space of the relationships between people. Cohn's discussion suggests that there is nothing hidden to be discovered, only what is there about to happen. What is new in what they say, as far as I understand it, is that this idea of therapy cannot co-exist with an idea of revealing what is in the individual unconscious.

The concept of the 'inner world' is something held to be quite 'dear' in art therapy, as an individual inner world, or as a collective one. There is sometimes the idea in art therapy that a person in painting depicts or expresses their inner world, or their unconscious slips out through lack of control of the medium of expression. Interestingly, Chagall said,

For me a picture is a plane surface covered with representations of objects
– beasts, birds, or humans – in a certain order in which anecdotal illustra-
tional logic has no importance. The visual effectiveness of the painted
composition comes first. Every extra-structural consideration is
secondary. I am against the terms 'fantasy' and 'symbolism' in them-
selves. All our interior world is reality – and that perhaps more so than
our apparent world. To call everything that appears illogical 'fantasy',
fairy tale, or chimera would be practically to admit not understanding
nature. (Chagall 1944 in Goldwater and Trevees 1976, p.433).

In other words, he is saying there is no difference in the way one perceives
things to the way they are. Reality is one's perception. This idea seems in
keeping with the ideas of the philosopher Merleau-Ponty, for whom individ-
uality does not begin inside itself but rather outside itself, located within a
world and in others (Diamond 1996).

There is not space in this chapter to do justice to the relevance to art
therapy of these ideas. However, it seems likely that incompatible ideas about
purpose in art therapy groups have relevance in considering the conflict
experienced between art-making and verbal communication in art therapy
groups. These confusions are as much part of our culture as they are in art
therapists' thinking, and thus are very much part of the art therapy group
material, as is shown in the case examples.

In this discussion I have been attempting to see how 'dialectical theory'
might help in understanding the experience of a conflict between art-making
and talking in an art therapy group. Inevitably this sort of a discussion brings
up much bigger questions such as the nature of 'self' and thus the purpose of
therapy, and the nature of creativity. These questions need much deeper
discussion. At this point it seems as though dialectical theory may be
something to play with in thinking about how to run art therapy groups and
manage the conflicts.

I will now go on to illustrate some of the above ideas by a description of
the ways in which I think about the conflicts in art therapy groups.

Implications for technique

How does one work with this dialectic? What are the implications for
therapist technique? I think, first, it is about keeping in mind at all times the
process that one is not using. In groups I find that during the talking time it is
very important to be aware of the 'language of the dynamic silence'
(McNeilly 1984), of what is not being expressed in the words – to stay with

the aesthetic in the group. In a society which favours words over other forms of communication one is compensating all the time for this tendency towards words to give meaning. Because of this it is in fact less important to keep aware of words in the art-making time. There is the problem that re-entering the self to make art often entails letting go of a compelling verbal process, involving intense feelings and intimate exchanges between people. The direction is, I think, to bring the art-making, the aesthetic, the unknown, the unfathomable into centre-stage in the group. This will make the dialectic. The therapist needs to have a clear idea about this in order to be able to give direction to the group.

What is the art therapist doing when the group are painting? I have recently come to realise that her role here is to follow the aesthetic activity of the members and free-associate to it – to enter into the painter's experience of making the painting as though one were making it oneself. Then I have found that one finds out a lot about what is going on.

The following vignette illustrates some of the discussion so far and suggests a different way of dealing with the material in the group.

> I began enthusiastically following the art-making of the group one day
> and the start of their work was exciting. One member, Karen, found some
> bright yellow tissue paper and I could see how much she was responding
> to its colour, which incidentally was the same colour as another group
> member's tee shirt. She stuck this down on some cartridge paper, then
> she thumbed through some magazines for some images. I lost interest in
> following the work and began to watch another member, Bridie, who
> was also looking through a magazine for images. At first this was rather
> boring and my attention flitted to other members, but as she began to
> arrange her images and stick them down, she seemed to become enliv-
> ened and find some coherence in her work. All the other members had
> finished and I could see she was feeling rushed because she was the only
> one really involved emotionally with what she was doing.
>
> We began to look at the work. The woman who had made her yellow
> collage said that hers was not a therapy picture but one of her 'arty' ones.
> She said this in a self-deprecatory way. What I knew she meant was that
> recently she had begun doing rather minimalist collages in which she
> would choose only a few images and arrange them on the page with
> often only a few marks to accompany them. I found these pieces rather
> enigmatic and powerful and they always seemed to attract the attention
> of the group. But now she said, honestly (and this is a summary), 'This
> picture has no meaning, I am just pretending to be an artist. So you may
> as well ignore it. I know I should be doing work that reveals something

about me, but I don't want to today.' Another member said: 'Well isn't that what you should be doing, just not trying to say something, but something will come out anyway outside of your control. That's how art therapy works isn't it?'

This was interesting as at the same time I was thinking of art therapy as something quite different. I wanted to know what had made her decide that her picture was finished, because I realised that it was when she would have had to take her own aesthetic appreciation of the image seriously, that she stopped. In this sense it will be when she does believe she can be an artist that she will be able to move forward, because it will be then that she will realise, in a living way, that she can make something, control something. The truth is she is stuck because of a difficulty in giving up the idea that she cannot be in charge of her life, because with that, she fears she will have to give up the hope of ever being cared for.

The following week, an opportunity arose to go back to this image and I asked what had made her decide it was finished. She said that she could not think of any more to do to it. Bridie, the person who had got emotionally engaged with her work, then talked about pushing things further, experimenting and taking risks.

Karen then began to take risks in a big way in the things she said to others in the group, though not with her art work. Recently, however, she said that she found that making art in the group helped her get in touch with her feelings. Previously she had only ever said that as a naturally silent member, the art helped her to speak in the group. It seems she has begun to take her art work seriously.

The following is another extract from two sessions of the same group about three months later, which illustrates being on a pivot between meaning and aesthetics.

> The first session had been entirely talking and the members had all been energetically engaged. It was the second week for a new member, and it seemed allegiances were being redefined and individual change in the group evaluated. At the end I said, 'I want to make a suggestion, and that is that next week we start making art at the beginning of the group, as it seems that it is really difficult for the group to break away from the intensity of the talking once we have got going.'
>
> There were some interesting responses to this. Sophie said that there was so much art work that was stacked away in the drawers and much of it we hadn't actually talked about. Paul said, 'I never seem to get the opportunity to talk about things important to me', to which Karen

replied: 'But your art work is about them isn't it?' Karen said doing the art work helped her talk in the group. Sheila said, 'Well Sally [the therapist] seems to think that the art is important.' Christopher said, 'Do we need to do art work?' These last two comments could have been seen as part of an anti-group (Nitsun 1996) that I was aware was developing, with the group split between positive and negative members. I said that maybe each person needed to find out for themselves whether the art work was important for them.

The following week, Karen reminded everyone of the decision of last week. I said, 'There is some nice fresh white cartridge paper and a new bag of clay', to which Paul replied: 'Are you trying to tempt us?' I felt I had put aesthetics firmly on the agenda with this comment.

Interestingly, two members did unashamedly beautiful images, and though unmissable as attractive things to look at, no comments were made about them throughout the session.

The first image discussed was Karen's, and again this had a few enigmatic pieces from magazines, but also some clay smeared on the paper. This image was discussed in terms of its process, the clay referring to the invitation to use it made by me, and Karen's dislike of it. Again she dismissed any search for meaning in the enigmatic images, but this time the whole image, its making (involving her declaring that she deliberately returned dirty paper to the clean paper drawer), the images depicted in it, and her response to others talking about it, seemed to be an angry assertion saying, 'This is who I am, accept me as I am, shit and all.'

The second image discussed was the new member's. This was a tissue-paper collage with three circular areas worked on, and the spaces in between developed. She immediately began to describe the image as having an illustrative meaning, each bit representing the members of her family. She went on to describing her worries about neglecting her daughter and was in tears, highly anxious. The group made kindly comments and asked helpful questions.

At a certain point she said she'd had enough space, and, as there was only 10 minutes left, there was some tension over what we would look at next. There were the two beautiful images and another clay piece. In discussing Susie's work we had gone miles away from aesthetics. At this point we seemed perched between her picture, the discussion of which had been all about content, and the uncommented on beautiful images. We settled on the third, a clay piece which looked rather like a cactus. Paul said, 'I don't know what mine means and I doubt you'll help me find out.' People made comments on its physical character, it looked delicate, it looked organic, how many pieces was it made of? Paul became increas-

ingly prickly and rude to people. (At the time I didn't make the connection between being prickly and the cactus.) I pointed out that he seemed very frustrated that the meaning of the image was not obvious. He said that he was frustrated at the moment because the arrival of visitors brought back memories of his childhood sexual abuse.

Now I kept seeing the clay object as lots of abusing hands. We all sort of fell into silence. Then Paul looked at it and said 'pretty isn't it?' as if resigned to us not having found a meaning for it. I felt loaded with my own thoughts on the content of both his and Susie's images, but also with the aesthetic in the group that was not being mentioned, i.e. the beauty of the two other images. I said, 'A moment ago you seemed to feel very frustrated with it, now you think it could be pretty.' He seemed to feel happy with this comment, as if I had said 'maybe you are pretty after all', and it seemed to be enough.

This extract illustrates moving between a dialectic in the group between aesthetics and meaning, between the ugliness of the content and the beauty of the art, perhaps. At one level Paul's cactus was his abused self, was it acceptable to the group? Similarly so was Karen's shit image. But the content also demands attention, but if this had come out during this session, the value of the aesthetic dimension in the group would have been dropped. In this session there was very little group interactive material. The group spent longer making the art work than usual, and a longer time looking at each piece of work. This session was thus completely different from the one that had taken place the previous week, where verbal interaction and inter-member conflict had been primary.

I find that I have to go 'against the grain' quite often to keep the group in touch with art and the aesthetic. As soon as there is any threat to the group, such as someone leaving, an impending break, a dramatic happening in someone's life outside the group, the energy is back in the words, and although art happens, the emotional investment in it is not so strong. It seems to me that this conflict is particular to a group with verbally articulate people who are used to using language to reflect, and who do not have a particular investment in using art in the group other than for therapy. (Artists or art therapy students have an additional interest.) In an article written ten years ago (Skaife 1990), I suggested that art therapists leave the group members to structure the time in the group. I hoped that in time the group would find out themselves that they were not allowing themselves enough time for art. Having tried this, and it not really working, I now conclude that the therapist needs to be very active in relation to art in the group!

Conclusion

In this chapter I have attempted to explore a conflict I experience in art therapy groups between the two processes of art-making and verbal interaction. I have asked whether the conflict is present in all types of art therapy groups for all client groups, and whether it is intrinsic to art therapy itself, and thus present in individual art therapy too. To explore these questions I have looked at the art therapy theoretical literature. In individual art therapy the term 'analytical art psychotherapy' coined by Schaverien (1992) seems an attempt to ensure that the fullest use of art-making can be made in art therapy. However, I am left wondering whether the concept of a 'transference to the art work' does not in some way limit the potentiality of art-making. It seems that the conflict described is not universally experienced by practitioners of art therapy groups, which leads me to conclude that it is when the client group has art therapy as their primary therapy, and are used to verbal reflection as a means to deal with their problems, that the conflict is most obvious. However, I think the conflict may be of significance to a theory of how art therapy groups work, and thus universally relevant.

I have then looked at the 'theory of dialectics' and its application in psychoanalysis and group therapy theory, to see what can be learnt here about the therapeutic use of conflict and its resolution. I have gone on to see if dialectical theory may be of use as a possible means of harnessing two distinct processes in the art therapy group. Although this theory is of help in considering the private and public nature of art therapy, and the danger of not keeping both of these in mind, and although it may also provide an alternative way of considering creative activity as separate from personal relationships, as a theory, I think it only has limited value. For one thing, art and words are not really opposites, and for another, it doesn't really help in considering how the conflict can be helpful or therapeutic. I think it can only be attached to art therapy in a playful way.

My conclusion is that a theoretical framework is required in which art-making is given predominance in the group, but that this can only be of therapeutic significance if its context, i.e. the group dynamics, is fully taken into account. For a starting point this model might take Winnicott's third cultural space as its primary space. Perhaps the tension would look different within this model.

References

Blackwell, D. (1994) 'The psyche and the system'. In D. Brown and L. Zinkin (eds) (1994) *The Psyche and the Social World: Developments in Group Analytic Therapy*. London: Routledge.

Brown, D. and Zinkin, L. (eds) (1994) *The Psyche and the Social World: Developments in Group Analytic Therapy*. London: Routledge.

Case, C. and Dalley, T. (1992) *The Handbook of Art Therapy*. London and New York: Routledge.

Chagall, M. (1944) 'Marc Chagall: An interview.' *Partisan Review, 40,* 1, 88–93. R. Goldwater, and M. Trevees, (eds) (1976) *Artists on Art from the 14th–20th Centuries*. London: John, Murray.

Cohn, H. (1997) *Existential Thought and Therapeutic Practice: An Introduction to Existential Psychotherapy*. London: Sage Publications.

Dalley, T., Rifkind, G. and Terry K. (1993) *The Three Voices of Art Therapy*. London: Routledge.

Deco, S. (1998) 'Return to the open studio'. In S. Skaife and V. Huet (eds.) (1998) *Art Psychotherapy Groups: Between Pictures and Words*. London: Routledge.

Diamond, N. (1996) 'Can we speak of internal and external reality?' *Group Analysis 29,* 3, 303–317.

Dudley, J. Gilroy, A. and Skaife S. (1997) 'Teachers, students, clients, therapists, researchers. Changing gear in experiential art therapy groups.' Unpublished paper.

Eddy, W.H.C. (1979) *Understanding Marxism: An Approach Through Dialogue*. Oxford: Basil Blackwell.

Freud, S. (1930) 'Civilizations amd its discontents.' *Civilization, Society and Religion*. Pelican Freud Library, 12, 1985 ed.

Gilroy, A. (1989) 'On occasionally being able to paint'. *Inscape,* Spring, 2–9.

Goldwater, R, and Trevees, M, (eds) (1976) *Artists on Art from the 14th–20th Centuries*. London: John Murray.

Greenson, R.R. (1967) *The Technique and Practice of Psychoanalysis* 1. London: Hogarth Press (reprinted 1974).

Klein, M. (1952) 'Mutual influences in the development of ego and id.' In *Envy and Gratitude and Other Works 1946–1963*. New York: Delacorte, (1975).

Lanham, R. (1989) 'Is it art or art therapy?' *Inscape,* Spring, 18–22.

Levine, S.K. (1997) *Poiesis: The Language of Psychology and the Speech of the Soul*. London: Jessica Kingsley Publishers.

Liebmann, M. (1997) 'Art therapy and empowerment in a woman's self-help project.' In S. Hogan (ed) *Feminist Approaches to Art Therapy*. London and New York: Routledge.

Maclagan, D (1989) 'The aesthetic dimension in art: Luxury or necessity?' *Inscape,* Spring, 10–13.

McNeilly, G. (1984) 'Directive and non-directive approaches in art therapy'. *Inscape,* December, 7–12.

McNeilly, G. (1987) 'Further contributions to group analytic art therapy'. *Inscape,* Summer, 8–11.

McNiff, S. (1992) *Art as Medicine: Creating a Therapy of the Imagination*. London : Piatkus.

Merleau-Ponty, M. (1962) *Phenomenology of Perception*. London and New York: Routledge and Kegan Paul.

Nitsun, M. (1996) *The Anti-Group: Destructive Forces in the Group and Their Creative Potential*. London and New York: Routledge.

Ogden, T. H. (1988) 'On the dialectical structure of experience: Some clinical and theoretical implications'. *Contemporary Psychoanalysis, 24,* 17–45.

Ogden, T. H. (1992a) 'The dialectically constituted/decentred subject of psychoanalysis: 1, the Freudian subject'. *International Journal of Psychoanalysis 75,* 517–526.

Ogden, T. H. (1992b) 'The dialectically constituted/decentred subject of psychoanalysis: 2, the contributions of Klein and Winnicott'. *International Journal of Psychoanalysis 73*, 613–626.

Schaverien, J. (1992) *The Revealing Image: Analytical Art Psychotherapy in Theory and Practice.* London and New York: Tavistock and Routledge.

Schaverien, J. (1994) 'Analytical art psychotherapy: Further reflections on theory and practice'. *Inscape 2*, 41–49.

Schaverien, J. (1997) 'Transference and transactional objects in the treatment of psychosis.' In K. Killick and J. Schaverien (eds) *Art, Psychotherapy and Psychosis.* London and New York: Routledge.

Schlapobersky, J. (1994) 'The language of the group: Monologue, dialogue and discourse in group analysis'. D. Brown and L. Zinkin (eds) (1994) *The Psyche and the Social World: Developments in Group Analytic Therapy.* London: Routledge.

Skaife, S. (1990) 'Self determination in group analytic art therapy'. In Waller D. (ed.) 'Special section group analysis and the arts therapies.' *Group Analysis, 23*, 3, 237–244.

Skaife, S. (1995) 'The dialectics of art therapy'. *Inscape*, Summer, 2–7.

Skaife, S. and Huet, V. (eds.) (1998) *Art Psychotherapy Groups: Between Pictures and Words.* London: Routledge.

Waller, D. (1993) *Group Interactive Art Therapy.* London: Routledge.

Waller, D. and Dalley T. (1992) 'Art therapy: A theoretical perspective.' In D. Waller and A. Gilroy *Art Therapy: A Handbook.* Oxford: Oxford University Press.

Warnock, M. (1965) *The Philosophy of Sartre.* London: Hutchinson and Co.

Wood, C. (1986) 'Milk white panic.' *Inscape*, winter, 2–7.

Failure in Group
Analytic Art Therapy

Gerry McNeilly

Approximately three years ago I had feelings of failure while facing a professional crisis. I had seen a client for assessment. The outcome of this was that I placed her on the waiting list for focal psychotherapy. Two days later her consultant psychiatrist phoned to say that the client had been found dead. I did not know the cause of death at the time but I found out later that it was suicide. My immediate thoughts on hearing the news were: 'What went wrong? What did I miss in the assessment? Was it something that I said? Should I have put her on the waiting list?' – to name but a few. This event put me directly in touch with feelings of helplessness and guilt, along with primitive feelings of omniscience, i.e. 'I should have seen or known that she might kill herself.' These feelings had little to do with the facts. Dealing with suicide is often seen as one of the pinnacles of therapeutic failure – which is hard to argue against. Even knowing that suicide is a therapeutic hazard is no reassuring balm to the sting of failure which I was left with at the time. Also, knowing that the warning signs are hard to see when people are determined to kill themselves did not help.

Although I shall primarily be addressing failure in the group analytic art group I shall be speaking about a broad section of failure situations and potential meanings. I shall also consider an aesthetic point of view; that is, is failure seen as an ugly outcome to particular situations, with success being seen as a statement of beauty? I believe there is a dynamic basis to the beauty that is perceived in aesthetic imagery. At the root of this complex structure there is a subjective resonance which is activated by an external, objective, sensory impression. Much of this I would suggest is unconscious.

The chapter will be separated into two parts: theories of failure and clinical illustrations. However, both sections will intertwine. The reader may be disappointed that I have not included visual reproductions of art therapy paintings. I decided that I would not submit these as it safeguards anonymity as far as possible.*

1. Theoretical perspectives: What constitutes failure?

It was with much trepidation that I began a literature search. This was mainly connected to a failure on my part of fitting into the 20th century, in my resistance to anything computer-orientated. However, I persevered but could only locate 21 direct references to failure within the psychotherapy literature between 1971 and 1997.

Strupp highlighted the ways in which therapists fail their patients (Strupp 1975); Baker explores how people change or fail to change within psychotherapy (Baker 1975); Older presented four current practices which may contribute to failure: taboos on touching, noisy emotions, embarrassment, long individual sessions (Older 1977). Theobold spoke of 'errors and mistakes' as aspects of failure (Theobold 1979). Ellis turns our attention to the person of the therapist and explores various beliefs and ideals within the therapist which incorporate failure (Ellis 1984). Gold gives an account of psychodynamically informed, integrative psychotherapy that ended in failure (Gold 1995). Fine speaks of the depletion and despair of the therapist when dealing with issues of surviving, coping and managing, 'suffering through' and creative renewal (Fine 1980). In their paper 'Failure: An exploration and survival kit' (1982) Jenkins, Hildebrand and Lask tell us: 'There is a need to find a place between, on the one hand, the polarised positions of attributing blame to the self in a rather pervasive, non-specific and unchangeable way, and on the other making an entirely defensive and external attribution' (Jenkins *et al.* 1982, p.8).

They go on to construct a survival kit to deal with this. The 'Factors in premature termination in long-term psychotherapy' were examined by Greenspan and Mann Kulish (1985); this was the only research paper that I

* I would like to thank my co-therapist, Jonathan Wood, for working with me in this group. I would also like to thank my co-editor and friend Andrea Gilroy for the helpful 'creative butchery' to my text which would not have been completed without her help. I would also like to thank Jenny McDonaugh for typing the manuscript.

stumbled upon as part of my 'failure' search. Bohart (1995) suggests that what looks like failure from the therapist's side may not be from the client's perspective. Powell analyses six cases of therapeutic failure and found common threads: failure to form therapeutic alliance; the absence of a symptom being functionally autonomous and free of secondary gain; difficulty in accessing or titrating the client's anger; appearance of counter-transference-based thoughts and feelings (both positive and negative); the dangers of applying new and exciting therapies to the client; and the absence of an integrative strategy (Powell 1995). Powell recognised a negative outcome with misuse of hypnosis. He speaks of how a male patient recovered murderous, raging feelings from when he was sixteen. This led the client to abandon therapy, and Powell to alter both his theory and method. As one sees from this wide selection of literature, there is much to be considered in respect of failure from various perspectives.

Kottler and Blau's book *The Imperfect Therapist: Learning from Failure in Therapeutic Practice* (1989) was very informative.

Before reading this book I was under the impression that there was a dearth of literature on failure in psychotherapy. In their opening pages to their book the authors say:

> Furthermore, failure is seldom discussed in the literature. After making an error of judgement on a strategic mistake, many of us feel too guilty and vulnerable to air our dirty laundry in public. And certainly editors must agree that the therapist's imperfections should be ignored or buried since little research with nonsignificant results is ever published. (Kottler and Blau 1989, pp.1–2)

It was also my assumption that the literature search I did would reveal some material on failure within the art therapy literature, but there was none. I also turned to the family therapy literature and was happily surprised that people had been less shy in speaking out. Jenkins *et al.* in their paper 'Failure: An exploration and survival kit', say:

> The fact that, at some time, all therapists fail and most experience periods of temporary or more profound demoralisation has, as a result, not been widely discussed. This sense of failure may reflect the therapist's view of his own competence or be the result of working in a field where it is notoriously difficult to evaluate our effectiveness, both in specific cases and in terms of outcome research (Gale 1979). We consider failure warrants exploration; at its best it is a common experience and at its worst it may lead to a prolonged feeling of ineffectiveness and inadequacy. Left to eat away at the professional soul, failure leads, in the short term, to

cynicism, self doubt and feelings of worthlessness, and in the long term
to 'burn out', withdrawal from clinical work or a change of profession.
(Jenkins *et al.* 1982, p.307)

The seeds of an interest in theories around failure were the result of an art
psychotherapy group I conducted between 1990 and 1992. At first glance,
failure appeared to be an extreme end of a continuum which has success at
the other end. Therefore failure is synonymous with success. We often
become preoccupied with success and subsequently miss out the value of
failure. With each failure we want to get away from it as quickly as possible. In
our work situation success may be evaluated through such factors as
cost-effectiveness and profit, rather than seeing success as being linked to
change from the client's perspective. Therefore failure is linked to illness and
success aligned to the client getting better, but the dominance of administra-
tion and finance claims a prerogative within such a definition of change. S. H.
Foulkes has illuminated how opposite conceptions are semantics which are
brought into play for the purpose of differentiation, but are intrinsically
connected:

> Progress in all the sciences during the last decades has led to the same
> independent and concerted conclusion; that the old juxtaposition of an
> inside and outside world, constitution and environment, individual and
> society, fantasy and reality, body and mind are untenable. They can at no
> stage be separated from each other, except by artificial separation.
> (Foulkes 1948, 1983 reprint, p.10)

In the light of Foulkes' comments failure need not be separated from success
as something that constitutes badness and negativity, with success consti-
tuting achievement and all that is good. Further, we are tempted to view
successful achievement as aesthetically pleasing or beautiful and see failure as
ugly. Therefore I agree with Foulkes, that these conceptual positions have
been separated on artificial grounds.

The installation of hope, as one illustrative point, through the therapeutic
process must accommodate the linear concept of being in a failed-like
position, moving from failure (hopelessness) to success (hopefulness), or
from unhealthy to healthy. However, this linear process may not be so easily
applied to particular facets of therapy. A simple illustration can be shown, i.e.
the concept of 'secondary gain'. Here the patient comes with various
symptoms, with an apparent wish to change. If these symptoms are removed
this may lead to further breakdown as the symptoms served the purpose of
defence. The success of removing the symptoms (defensive structure) may

lead to many underlying emotions and conflicts being opened up and then having to be dealt with. So success is achieved in removing the symptoms, but failure follows in its wake as the secondary gain defences no longer serve their purpose of protection – as one function.

A patient comes to the therapist wanting to get better. We provide a method of therapy most appropriate to meet this demand. Both therapist and client begin with a desire to change. In this fashion success is desired and failure not. Failure may be tolerated, but not for long. There are many variations as to how this particular theme works. Coming from both sides (patient–therapist) there may be a value judgement applied, in that to be good is successful and to be bad is a failure. This emerges in many forms. For instance, the patient feels the need to please the therapist by presenting non-conflictual material in order to be liked by the therapist. Alternatively, the therapist may be tempted to push the patient in many ways towards success and resolution of difficulties at a particular cost to the patient. Hence fuller understanding of the dynamics of success and failure are missed or avoided.

> 'What is failure?' Our dictionaries give an interesting answer. The root word for failure has to do with committing a fault on purpose, deceiving, or escaping. Success, on the other hand, comes from the word 'cede', which has to do with the act of giving over. (Keith and Whittaker 1985, p.8)

Keith and Whittaker's comments on failure seem clear and straightforward, but less so when looking at success being derived from 'cede' and the act of giving over. Possibly it is clearer when we see a champion sportsperson succeeding previous champions, or the 'heir to the throne' succeeding the previous monarch. Extracting the 'giving over' part of Keith and Whittaker's quotation, we can equate psychotherapy as a giving over of conscious/ unconscious elements along with interactions between patient and therapist or, more expansively, within the group.

Success in therapy often seems to depend on the success of a thorough assessment and subsequent selection of a particular type of therapy for one's client/patient. A request comes from the referring agent (predominantly the General Practitioner or Psychiatric Services in Britain) for psychotherapy for a client with specific problems. This then leads to a well-accepted assessment formula aimed at establishing a psychodynamic formulation. This allows the psychotherapist license to select a therapeutic method which is appropriate, i.e. individual, group, short- or long-term therapy. But we can fail even before we get started. It is not uncommon for potential clients not to attend initial

meetings, or to fail to proceed after our first meeting. I recall a number of occasions when a patient came for one assessment interview (I average three initial assessment meetings) and did not return, with no clarification. For example, I saw a woman on two occasions which I felt were productive and we were on course for individual psychotherapy. She did not return or respond to my letters. My only explanation was that in my last comments to her I said that certain questions which I had not asked could be asked at our next meeting. I said it was late (9.45 pm) and I had been working all day and that I was tired! Possibly she felt rejected, or left in the dark by my not saying what these questions were.

If we were to accept at face value Keith and Whittaker's definition, this would in part tie us to a conscious explanation but would omit examining unconscious components. The final form of failure as described would then miss crucial elements of what led to such failures, such as making mistakes and errors. (I will return to these two elements a little later.) We could equate such elements of error and mistake as particular ingredients within failure. Failure could, in some instances, be seen as an outcome of errors and mistakes.

A square peg in a round hole

The phrase 'a square peg in a round hole' has direct association with failure. It is an analogy used to describe the process of trying to force two obviously untenable things together that will clearly be a misfit. The fitting together of many different diagnostic formulations with therapeutic method can succeed or fail for many reasons. This may, at such times, be like trying to fit a square peg into a round hole if incorrectly assessed.

For example, one may choose to place a person with a severe 'borderline personality' or 'narcissistic character structure' within a group. In my opinion this may fail in various ways, due to the range and severity of the individual's condition and the condition of the particular group. The borderline personality may be too fragile or damaged and may require individual therapy before entering a group, otherwise they may create high levels of anxiety within the group, as well as feel overwhelmed by the experience, leading to failure and drop-out. On the other hand the severe narcissistic personality disorder may use high levels of projection and intellectualisation and deal with their anxiety (seldom personally experienced as such) by attacking the conductor and the group. There is also something to be said about the timing of entry into the group, e.g. the new person may fail to stay in the group if the group is in a state of crisis. Others, such as people with a low sense of self, or

those who have been abused as children, carry great feelings of failure, and therapeutic success may be difficult to achieve. In therapy with someone who has experienced severe trauma we may feel that open disclosure of events – cathartic enactments through psychodrama and the painting of the scene in art therapy – may lead to success and resolution. In some cases this may be so, but it can also fail by releasing too much, and possibly too quickly. Therefore to achieve a round peg in a round hole depends on successful assessment and sensitive handling of the early stages of therapy.

Therapeutic drop-out as a form of failure

The term 'drop-out' is one which we apply to those who either leave therapy prematurely, often after one or two sessions, or those who finish before therapy is complete. There is at times a positive element in dropping out under such circumstances, in that the patient brings into play a self-protective dynamic. The failure in drop-outs, however, has extensive meanings and reasons. This can be as simple as the 'fitting a square peg into a round hole' analogy, i.e. the patient doesn't fit into the group, or there was faulty selection in the first place. The patient may have bitten off more than they can chew, possibly at the wrong time. Another reason, which is fairly common, is that the new person entering the group may disclose more than they intended and feel a loss of defensive control followed by heightened feelings of shame, which they cannot come back to in the group.

Another factor is when someone drops out after an extended period of therapy, when they feel they reach a crisis which is a watershed. Here they have reached a plateau, in that the next stage is exploration deeper than the level to which they can realistically go. Here they need to get out with some dignity, and at times the whole therapy experience is seen to be a failure and negated. It is difficult for those left behind, and has similar dynamics at play as suicide. However, I think such closures may be a successful move for the patient. I can think of a number of patients who left under such circum-stances. This point was illustrated in the literature by Keith and Whittaker (1985, p.14): 'Does failure in psychotherapy produce a paradoxical effect in which the individual suddenly sees himself going downhill, renews his efforts to integrate himself, and becomes successful a year or two later?'

Errors and mistakes

Before speaking about the aesthetic areas within both solely verbal group analysis and group analytic art therapy, let me say a little on errors and mistakes. As I suggested earlier, errors and mistakes both lead to and are part

of failure. Drawing upon Roman Catholic language, it seems less of a sin to make an error than a mistake. Therefore to make an error can be described as a venial sin, but to make a mistake is more akin to a mortal sin. On the positive side, to err on the side of caution is seen as a sensible solution to a predicted scenario which could go wrong, ending in failure. A positive mistake is a little more difficult to accommodate, but to own one's mistakes can be seen as being strong enough to recognise one's faults, or a willingness to own the mistake accompanied by a sense of doing penance.

When I turn to my clinical illustrations, the topic of errors and mistakes will become clearer. Its relevance at this point is to state generally that errors and mistakes are, in my view, components of that which is ultimately perceived and experienced as failure. Examples of these components, as applied to the group later described, are: errors in judgement of timing for the group to begin; mistakes in the selection of clients for the group; and errors of judgement about co-working the group with two male therapists in an all-female group. Theobold says:

> We can start by noticing a few differences in the common facts of usage. Thus we either say that we have done something 'in error' or done something by mistake! On the other hand, we 'make mistakes' and we also 'make errors', for example errors of judgement. Of course these commonplace facts do not in themselves take us very far, but they do suggest that whatever differences there are between errors and mistakes are important enough to merit different expressions in conversation. (Theobold 1979, p.557)

One of my central tenets is that failure is not only a negative and ugly thing, but something with positive attributes which could also be attributed to beauty. Bearing in mind my comments on errors and mistakes, I would suggest that when these occur in life generally, in psychotherapy or the creation of an artistic masterpiece, they play a part in the overall outcome. How many errors, mistakes or 'happy accidents' contribute to a finished piece? How many first sketches of pictures or drafts of books or scores of music have been destroyed or thrown in the bin? How many great artists or musicians are totally happy with the final outcome of their work and experience the same aesthetic appreciation as the viewer or listener? A common saying is 'beauty is in the eye of the beholder', but can the same beauty be experienced by its creator? I would suggest it is common for those who are loved by another to struggle to see what it is that makes another confer love upon them, from the other's point of view. Therefore, can we truly say that aesthetic appreciation is established by the conscious,

deliberate structure of a successful picture, piece of music, or sense of positive change in life? To what extent is it influenced by subjective experience in which errors and mistakes can contribute to something perceived as beauty? Hanna Segal writes eloquently about the psychodynamic view of aesthetics. She says:

> Ugly and beautiful are two categories of aesthetic experience and, in certain ways, they can be contrasted; but if beautiful is used as synonymous with aesthetically satisfying, then its contradictory is not ugly, but unaesthetic, or indifferent, or dull. Rickman says that we recoil from ugly; my contention is that it is a most important and necessary component of a satisfying experience. The concept of ugliness as one element in aesthetic satisfaction is not uncommon in the tradition of philosophical aesthetics; it has been strikingly expressed, however, by the artists themselves. Rodin writes:
>
> 'We call ugly that which is formless, unhealthy, which suggests illness, suffering, destruction, which is contrary to regularity – the sign of health. We also call ugly the immoral, the vicious, the criminal and the abnormality which brings evil – the soul of the parricide, the traitor, the self seeker. But let a great artist get hold of this ugliness; immediately he transfigures it – with a touch of his magic wand he makes it into beauty'.
> (Segal 1955, p.401)

Guilt is seldom seen as either positive or to have beauty within. Melanie Klein brought our attention to the positive attributes of guilt as a necessary part of the wish for reparation. Generally speaking guilt engenders bad and negative feelings in the present with associations of badness and ugliness from the past. I recall the first time I read Klein's 'reparation' view of guilt and the warm glow I felt with this new experience. It was, indeed, a beautiful moment. In my opening points on the guilt surrounding the client's suicide, the desire to see and acknowledge what went wrong incorporated the wish to make things better, if not for the dead person, for others I have come in contact with.

Perspectives of art therapy

From this point I intend to move the focus to the art therapy field, both generally, and specifically to group analysis. Generally speaking we may see the success or failure of our method resting primarily upon the patient getting in touch with their inner–outer world through concrete expression in imagery. This has been widely documented over the years in the art therapy

literature. With the earlier art therapy theory and practice, in which most attention was focused on the concrete imagery, it was simpler to consider aesthetics. In more recent developments one still considers the aesthetic elements in individual art therapy, whilst also taking more account of the relationship between the people in the art therapy room. For example: Wilks and Byers examine the role of the art therapeutic relationship in working with the elderly (Wilks and Byers 1992). Rust describes the re-experiencing of early maternal relationships in women with eating disorders. She also states in diagrammatic form the triangular configuration of image/patient/ therapist (Rust 1992). This particular image has become widespread in British art therapy and is now common parlance used to describe the art therapeutic relationship. Mahoney and Waller (1992) describe (in a case presentation) how both patient and therapist relate to the 'concrete' aesthetic level of the imagery.

In discussing the relationship dynamics in art therapy a number of authors concerned themselves with transference and countertransference. Dalley recognised a scarcity in art therapy literature of discussion on transference, with it being insufficiently recognised and often misunderstood (Dalley 1987). Schaverien considers transference from different perspectives, i.e. transference and the picture in the treatment of anorexia (Schaverien 1989), drawing parallels with both food and the picture becoming an embodied image. A year later she turns her attention to transference and countertransference in respect of the power and necessity for the picture to seduce the therapist. She states that this is the manifestation of Eros in the transference and is only one form of seduction produced in the pictures (Schaverien 1990). In the same journal edition which published this latter paper both Wood (1990) and Case (1990) write about the triangular relationship in art therapy. The collection of these three papers in one journal helped to raise the profile of this important (triangular) configuration.

However, the emphasis on the individual in art therapy may fail to comprehend the complexities of the therapeutic relationship beyond three or more people (McNeilly 1984, 1987, 1989). This is much more of a complex issue due to the increase in quantity of imagery, as well as the incorporation of group analytic methodology.

Waller presents clear illustrations of particular relationship difficulties she encountered in leading training groups in her 'group interactive art therapy', where she had to deal with powerful projections of anger, driven by anti-authoritarian demands from established authority figures, hence making it difficult for images to be produced in her group (Waller 1993). There are

echoes of this in Skaife's comments about the attack she suffered in her attempts to conduct her group (Skaife 1990). Both of these illustrations show us that relationships between patients and therapists have to be worked with, as much as the concrete imagery. Mann (1988) also highlighted his countertransference feelings, along with his co-therapist, in an art psychotherapy group setting. A central component was that both therapists and the group as a whole were struggling with one woman group member. Their powerfully negative feelings were leading them to a wish/plan to terminate her therapy. He speaks of their not acting on such a wish, and eventually the patient stayed and changed. The points he raises in respect to the therapeutic relationship struggles were similar to the ones I will be addressing later.

Aesthetics and psychodynamics

Collins' Concise Dictionary defines aesthetics as

> 1) the branch of philosophy concerned with the study of such concepts as beauty, taste, etc. 2) the study of the rules of the principles of art.

As I stated at the beginning of this chapter, I suggest that there is a dynamic basis to the beauty that is within aesthetic imagery. But when we consider that many of our clients' art works are an expression of underlying painful feelings, unresolved conflicts, expressions of depression and anger, it seems idiosyncratic to see them as aesthetic statements of either beauty or repulsion. Surely they are a means to an end, just as the use of language in solely verbal psychotherapy is a means to creating greater communication and change. I recall many occasions in verbal group analytic groups where I was touched by the beauty of words used to express deep feelings.

However, to see these as beautiful things in themselves would be to idealise them and take them out of the context of their production within the therapeutic situation. Therefore I believe we need to be cautious in our thinking when we see our patients'/clients' art work as aesthetic art expressions in the truer sense of the word. In my experience some images created in art therapy sessions had a similar impact upon me as great works of art. But if I accepted them as such I would have been seduced into the view that the image was an artistic statement, as compared to an image arising within a therapeutic environment. However, I do agree with Schaverien (1990, 1995) that seduction is a desirable component. I do not doubt that powerful aesthetic imagery, when created in art therapy, can be powerful aesthetic works of art. I have on my shelf one such painting created by an ex-patient

that continually holds my attention, fifteen years after it was created. A fantasy may exist that some magical component has taken over and changed the imagery created within a therapeutic structure, turning it into an artistic expression as evidence of the healing processes of art. To me it is the evidence of healing processes of art that is enabled within art therapy. Some people go on to use the artistic/creative faculties which have been activated via art therapy to become artists or use their creative attributes after therapy is completed. When this occurs they have become artists, not ex-art-therapy patients.

The situation is different in groups. Although each member of an art therapy group will create their own individual imagery (apart from collective images), the fact that it is produced within the group will bring its own unique elements. All of the factors are at play which were evident in individual therapy, but the group analytic art experience widens our horizons. It moves from the dyad of patient–image, patient–therapist to a multifaceted structure which includes many such dyads. Creation of concrete imagery within the group can be for many individual and group reasons. As well as each individual's inner/external agenda there may be intergroup images of rivalry, the wish to please the conductor with a beautiful image, the creation of shocking images to make an impact on the group, and the process of identification through copying. (See McNeilly 1989.)

In the art therapy group, images are created within the 'group as a whole', which can be seen as a horizontal conception, while incorporating the vertical expression from patient to paper. Clients/patients create their images separately and explore these collectively in the later, verbal section of the session.

The dynamics of failure are expressed both visually and verbally in many ways within the art group. It is difficult to find meaning if images of failure are isolated from successful or beautiful images. Beautiful imagery will also be created within the group and needs to be acknowledged, but the aesthetic impact of beautiful imagery can give rise to envy and rivalry, which in turn may be mobilised and become destructive urges within the group.

The clinical illustration that follows will highlight the dynamics of failure. The various elements that I have spoken about so far were key issues which denoted the failure of this group. This extended from speedy and faulty selection, not enough thought being given to the mix of the group, to a basic resistance on the clients' part to the method of art therapy. It also includes failure on my part to recognise the full potential of the group's destructiveness and the difficulty incurred when trying to help them mobilise

the resistance and anger. Added to this was how the group as a whole manifested a collective depression which was hard both to understand and challenge without it being seen as punitive. Further, over the life of the group the negative countertransferences emerged and crystallised, thus making therapeutic movement continually difficult to achieve, and almost blinding my co-therapist and myself to possible ways of achieving therapeutic 'goodness'. Increasingly a feeling of 'badness' permeated the whole experience for everyone within the group, and my dislike of going into the group verged on a feeling of hate. In many ways I feel, in retrospect, that I was trapped in the countertransference, in respect not only of individuals' projections but also of the group as a whole. As to aesthetic aspects, the overall feeling of an ugly group experience emerged and became consolidated. With this said there were times of productivity and satisfaction, along with aesthetically pleasing images being created.

2. Clinical illustration

The following illustration is of a weekly group analytic art group which was to last for approximately thirty months. Although it began as a slow-open group with no set life span, I eventually had to close the group down in October 1992. I will clarify the reasons for this at the end of the illustration.

The clients involved had no other form of therapy. I had undertaken a stringent assessment procedure with each person. During the assessment procedure it was made explicit why an art therapy group was suggested rather than another form of therapy.

The group began with seven clients who were women, conducted by myself along with a co-art-therapist who was male. Each client came in with various emotional and relationship difficulties; some had a specific clinical diagnosis, e.g. depression, neurosis, eating disorder, etc. The membership was to change considerably over the group's life and ended with four of the original members still being present. New members were never to stay long, the longest being approximately four or five months, some as little as one session. All members were given a written list of 'group guidelines' before joining and these were often a bone of contention. Also the fact that both therapists were male brought its own difficulties, along with various dynamics which emerged in our working together. There were also incidents of acting-out behaviour (the term 'acting-out' is connected to certain destructive behaviours coming into play as an evasion of group conflicts), e.g. continual lateness (particularly by one member); absenteeism; forming relationships outside the group (particularly by two members), which was not

permitted in accordance with the guidelines; increasing resistance to image-making and its exploration (even though we extended the whole weekly session from 90 to 105 minutes to give more time to concrete image-making).

At the beginning of the first session we sat in the circle of easy-chairs and introductions occurred. I explained the basics of an art therapy group. The aims were linked to free art expression with no set topics in the first 30 to 45 minutes, followed by free discussion. The room was organised with tables and upright chairs in one half and a circle of lower chairs in the other half (where we were sitting at this point in time). When the introductions were complete I asked the group to use the materials to paint or draw and indicated that when everyone had finished we would speak together. After this first session we expected people to come in and create images straight away, followed by group analytic dialogue. In reviewing my notes I find there were many practical and theoretical points of reference which helped me to understand what went wrong, such as polar positions, group associations, interpretive interventions, and adequate and inadequate use of imagery. Although what went wrong is central, there were also times when the group went well, was analytic and creative.

One of the interesting points from our first session was that the seeds of failure were there from the beginning, as can be seen from the following extract from my notes:

> In the last 10–15 minutes of the session (verbal circle) the clients had moved to speaking generally about their previous therapeutic contacts along with new expectations of the group, which had also incorporated talk about the paintings they'd created. They were speaking of their fear of letting others know that they were involved in psychotherapy. This was synonymous with telling others that they were failures. I said that what I felt was at play here was a search for belongingness in the new group, along with a sense of commonality, but it was also built around feelings of failure. I also pointed out that there were also elements of success in taking the risk in joining a new group and creating the concrete images in the pictures.

I felt that the seeds of failure were here at the beginning and based in the feeling that everyone's previous therapy had not been helpful or good. There was a fear of letting others know that they were in therapy, almost as if they were ashamed of it, which in itself was synonymous with failure. Right from the beginning this cemented the group's identity with an unconscious need to keep everything still and hence fail.

There were a number of fundamental errors and deficiencies written in from the start, despite the fact that many of the group's sessions had constructive ingredients in which analytic work was in progress. However, there was a difficulty in following through with the healthy parts of people, and the idea of risk and change were fought against, achievements in these areas being later attacked, diminished and eventually undone.

One of our first errors was the speed used in setting up the group, which blinkered us to the necessary rigours of selection. The reasons for this were threefold. The first was that my colleague needed to have experience in co-working an art therapy group, as he was planning his own group to be established later. Second, the speed blinkered us to the major implications of two male therapists working with a group of women. It was not our intention to have only women, but various practical difficulties meant that men never joined. In addition, each of the women had various difficulties with men. While I am not highly verbal in my technique, my co-therapist was predominantly totally silent throughout the group's life. This echoed the difficulty with men in the group, in that we seemed relatively inaccessible, thus exacerbating their difficulties. One way that the group developed to differentiate us was to see my co-therapist as the art therapist (using him to speak of the concrete imagery), and seeing me as the psychoanalyst (group analyst), even though they knew I was also an art therapist. A third error was simply a practical one. There was a waiting list with a pressing demand to get people started in a group.

Cumulatively these factors blinded me to particular traits in the group members that, had I been more careful, I would have seen. Probably the strongest feature here was their dependent character structures. For example: an expressed wish to be treated and made better; an intense passivity, giving the impression of waiting to be fed; a resentment about being given group therapy and not individual; an appearance of motivation to change which in fact was superficial keenness; questionable levels of insight which in effect are more accurately described as intellectual awareness; a resistance to change while complaining that that was required; a marked avoidance of anger or acknowledgement of it; resistance in expressing anger directly and a clear denial of its existence. It is possible that such a list of faults corresponds with the therapists' errors, faults and mistakes. I think this was an indication of the strong negative countertransference which was generated and unresolved over two and a half years. Such countertransference has left me with a lingering sense of accusation and not fully knowing who to blame, if not myself.

On reflection I think that the combination of these dynamics maintained the destructive processes in the group, played a strong part in the rejection of new members, and constantly thwarted our work with the group. Unlike my experience with other groups, I felt constantly angry and frustrated and the recipient of many projections and projective identifications which I struggled to make sense of and put back into the group. The destructive forces I allude to were both conscious and unconscious, the latter being a strong contributing factor in the final closure of the group. There were further elements of intransigence which were masked as destructive dependency: the repressed feelings of anger and resentment, the unresolved negative transference to the therapists, the destructive attacks on motivation and insight, the denial of rivalry and jealousy, all of which gave form to the destructive impulses.

I think that the many defence mechanisms and acting-out behaviours intensified these processes to eventual impasse and disintegration. Theoretically speaking it was a dependent group with sado-masochistic features. The acting-out methods I alluded to earlier, such as absenteeism, lateness and forming relationships outside the group, made this evident. Lateness in itself fed a further acting-out process, i.e. the resistance to image-making at the beginning of the session. Although there was an initial excitement and willingness in the early days to paint and draw, gradually it became somewhat of an obligation. There was a decrease in the group's minimal use of time to create concrete imagery. Sometimes they spent as little as five minutes painting/drawing and at times refused to paint and draw. There was also a provision of large white/coloured paper for use, but the group nearly always chose to use the white paper, cutting one sheet into two and four. Rarely did anyone use paint and then mainly only one person, but in a limited way. Also there was a dual 'fear of' and 'wish for' interpretation of the imagery by us (the therapists) in opposition to their own analytic work with the imagery. Probably by far the most significant point of acting-out was their resistance to communication. Resistance to the image-making was an expression of the group's dependency and was verified by the resistance against verbal communication in the second part of the session.

The group's life process
Let us examine the first six months.

> On Concorde you get champagne and caviar, here you don't get a cup of tea.

This was an interpretation I made in the second session, which was received with laughter. This was built upon concrete images of hope (one person painted a rainbow), in comparison to dependent wishes for comfort through my giving direction or wanting us to give them cups of tea.

Also in the second session, the symbols created brought critical fears as expressed in paintings of eyes. Parallel to their wish for me to be directive they received my interpretations as negative criticism.

The third session brought elements of competition and aesthetic rivalry when one member's beautiful painting of a flower gave rise to envy. Her response was that this was the only thing she was good at. Here I recall saying that the emotional content was missed in favour of the aesthetic. I was attempting to highlight how the group became involved in the aesthetic beauty of the image, but were missing the self-deprecatory feelings in the term: 'That's the only thing I'm good at!' In some ways these comments backfired, as the patient and the group as a whole felt diminished by my comments. The aesthetic allure of the picture was captivating and it may have been better to stay with the power of the image, but as this was the third session I may well have been pushing the group too quickly into in-depth areas. Extracts from these early sessions give a glimpse of what was to come.

During the first six months these dynamics were continually expressed in many forms, i.e. the wish to be dependently led, the desire for hope, the evasion of deeper emotional levels with difficulty in handling them as they emerged, competition in masked forms. There were also more direct demands upon myself and my co-therapist to give individual attention, particularly from one woman.

Between sessions four and eight a sense of security developed, accompanied by a persistent yearning for alternative therapy which would satisfy dependent wishes. This was illustrated clearly in session four when Mary brought her child into the session due to having no childminder, which gave form to such dependent wishes. Session seven brought a new member, and at session eight we had our first drop-out.

It was during sessions seven and eight that both the concrete imagery and the verbal and silent interactions revolved around depression, anger and getting away. One member painted herself locked in a room, representing her depression. Three members painted idyllic outdoor scenes, or socialising in a garden. On the verbal plane there was dialogue about suicide, a dream of having one's leg cut off (the woman in question had a physical circulation problem aggravated by heavy smoking, which she had painted), and mother's dying.

Session ten was the first occasion when I was absent, which brought a feeling of relief along with greater art expression and use of colour! This led to the group beginning to see my colleague and myself as different in the ways mentioned earlier. The group felt more relaxed and there were open transference statements about me as cold, unemotive, and saying little. In one woman's picture I was painted as a Red Devil.

By session eleven the focus had turned to direct conflicts in a more concrete way. The images created had more direct and indirect symbolic meanings: abstract signs and symbols, bowls of fruit, nebulous shapes (linked to tablets), an open country scene with a lone tree in the distance. This conflict was enacted by one woman taking a herbal medication in the session, dialogue about who was taking medication for depression, and Kim's ongoing meetings with another professional, which she would not stop – nor would this professional stop seeing her (see McNeilly 1990). One of the 'guidelines' is that group members do not have other therapeutic relationships with other clinicians while attending the group.

In this session there had been a better response to my comments than in previous sessions. Between sessions thirteen and twenty the group went through a good working period in which there was not the same resistance to image-making and using the verbal section, although the destructive elements of intransigent dependence, anger and evasion were still present. For example, in session twelve the pattern of talking directly about the concrete imagery was developing well and the group was able to link this to their personal experiences. One woman had drawn a barrier which was a reflection of an inner barrier she had erected after childhood abuse. Her presentation of her story of abuse was distant and felt sterile. This then brought into play the dependent element, in which she handed over her words to the group as if it was a passive container. Here the 'effect' of presenting herself in this way ensured the group maintained a mirror image of how she has been since the abuse. The result was collective flat feelings of doom and gloom.

I recall writing at the end of session thirteen: 'It feels as if a group identity is slowly emerging in which people are taking more risks and the place of the art work is becoming more significant, although not fully exploited as yet.' This was connected to the stage they had reached in being able to be more daring in opening up to each other, using the art work creatively, speaking about inner mess (and the need to express it in the pictures) and exploring their difficulties with control and the loss of it.

Session sixteen brought the first major rebellion, in which they all refused to draw and paint. This in a way was an angry gesture for our not meeting

their dependency wishes, which had come to the fore again after a constructive phase. But by session twenty-one the group had again moved on to being more creative in their image-making and linking this to their lives, e.g. Kim's brightly coloured painting of angels (in symbolic form) and black circles were unresolved feelings about death. During this session a great deal of analytic work was undertaken but the group did not experience it as such. My colleague wrote in our notes about the end of the sessions, in response to an interpretation: 'They found the art group was far from meeting their needs or expectations but making them feel worse – what was so frustrating was the lack of direction and leaderless approach they encountered. The group were denouncing the value of therapy.'

This strong group feeling carried on into the following session, although there was some recognition that the imagery they created was a true reflection of how they felt, e.g. Alison's painting of a game of 'tug of war' reflecting her struggle with her husband. As I was absent for this session it gave more room to express the negative transference to myself and the split they perceived between my colleague and myself. Once again I was perceived as the serious one, even at points of humour. The dependency is again being confirmed in my colleague's notes: 'Although questioning the group (attendance made one woman feel worse) they did have a consensus of opinion that each found a need and unexplained compelling urge to attend, and guilt, if not.'

It was during this session that there was a further evaluation of the group, the impact of the two people who had left and eventually some acknowledgement that they needed to do more psychotherapeutic work. Unfortunately this latter point was voiced only by one woman and it was as if she was a lone voice.

Sessions twenty-four, twenty-five and twenty-six brought analytic work back to the overall process. During these sessions the art work was more free and willingly expressed, along with a readiness to see my colleague and myself as part of the group and less critically authoritarian. During session twenty-four there was much exploration about their struggles at home in helping or hindering their family members, e.g. Alison's husband bailing out their son when his business went bust. This raised a dilemma about what was seen to be more caring: practical/material help or letting individuals take responsibility for themselves and the group. Further statements were made about experiencing parents as critical. Depressive feelings were also expressed. This set of dynamics had clearly been activated through the image-making and resultant pictures: houses being superimposed one across

the other; a house with a cross through it; abstract images denoting stages of emotion; a drawing of a family having a meal. One interpretation I made addressed these areas:

> I initially spoke about the dynamics of crossing things out, which was also connected to not speaking about my previous two weeks' absence, in a sense they were crossing me out. The idea of being crossed out was being shared in the whole group, such as with the houses in both pictures crossing over (Alison's break-up with her husband) or having a cross through it (Sara's being made to leave home) and likewise Mel's feeling crossed out at the dinner table in the presence of her parents and husband. Both Alison and Sara showed that their way of crossing out was portraying themselves in a passive way in the face of a challenge to change their homes. They perpetuated this via their passive (apparent) acceptance. I was more challenging in my interpretation to Alison and Sara. Sara's response was to withdraw. However, she left the impression with the group that she had no choice in these matters. I also pointed to how people were crossing out their anger and Kim particularly was cutting off from it.

This interpretative input mobilised the group and there were further deeper feelings released and worked with.

As I said earlier, this stage of the group brought a greater sense of achievement at all levels of the group's structure and process. However, these constructive periods only lasted between two and four weeks in succession. In session twenty-seven the dependency issue emerged with a vengeance and was illustrated by Kim demanding that I give her what she wanted, i.e. to be cured. I think that my overinvolvement verbally in that session was the start of recognising that this group would not totally move away from the depressed and intransigently dependent position, no matter how analytic some sessions were. In retrospect it was a desperate attempt to breathe my own life, hope and motivation into the group.

So far I have gone into some detail about particular elements and dynamics which were expressed in the first six months of the group's life. The next six to twelve months brought many new experiences, with some people leaving and others joining. However, the pattern had been set of productive sessions not lasting long and eventually being turned over by the various destructive forces I have described.

I would like now to speak in detail about one session that I felt was an illustration of how group-analytic this group could be at certain times. This occurred about fourteen months into the life of the group.

The pictures were as follows:

1. Sam: a picture of a (?) and another of two clowns' faces.

2. Mel: painting herself both free and in a cupboard.

3. Alison: painting of numerous feet.

4. Mary: two paintings, one an undefined abstract and the other a circle.

After a few practical announcements from me at the start of the verbal section after the pictures were complete, people quickly moved into open dialogue about their pictures and areas of their life. It was primarily Sam who took the initiative and she moved from speaking of her holiday to the struggles about coming back. Although she spoke about her daughter at this stage, she pointed out that the clown faces in her picture were representative of herself and how she had swings of feeling up and down or happy and sad. For Sam this bridged the space between both her daughter's fear and her own. There was also dialogue about Sam's child and the possible reasons for the child's fear, and associations to childhood experiences with clowns and how these brought both happy and terrorised feelings. Sue spoke about having seen a clown that day and thinking that he was very frightening. Sam went on to speak of how she felt as if she was brought back down to earth through being back from her holidays, in that when she was away things were so much more free and she could be more herself. Now that she was back she was either someone's mother or wife or indeed some other piece of property. As she spoke she kept moving from serious statements to superficial laughing; this seemed to be an enactment of the clown imagery in her picture.

Alison went on to speak of her picture of feet as representing either being walked on by others or how she had walked over others herself. She initially spoke of her son leaving home and how she felt walked on by him. There was some dialogue about his illness and how he did not look after himself, and her own concerns that he might find this difficult when on his own (he lived with her and her husband). Here there were mixed feelings of anger and relief, alongside a continuing concern for her son's health. It was interesting that she spoke of him not learning the lesson of his stroke, which he had had when he was much younger, and how this had left him with a physical disability. Part of her history and presenting difficulties were physically related in that Alison had circulation problems and she did not heed the consequences of not giving up smoking. Within the session no one made any

comments about this despite their shared knowledge of her history. This led to further dialogue about how people did things, even when they knew that it was either wrong or would do them damage in the end, e.g. Sam spoke about taking salt, which had been warned against because of her weight. From this point there was an increased contribution from Mel about how she did not allow herself to say things, even though she disagreed with what was happening, and how this was reflected in many parts of her life; she either restricted herself or felt restricted by others. She linked this directly to her early childhood when her parents would tell her not to let others get her down and to just ignore things or 'grin and bear it' if she was getting into problems at school. She made a direct reference to her picture of either being free or being locked in a cupboard. There followed a lot of questioning about Mel's childhood, which developed into associations about everyone's child-hood feelings of restriction and freedom along with their fears. There then appeared to be an increase in the energy that was being generated in these areas and for Mel one could see a powerful struggle when she longed to speak her mind, being near to tears on a number of occasions. Everyone was highly involved in what she was saying and the focus was strongly with her; it was as if people were working a lot out through her.

This then led on to them speaking about fathers. Sam went over a lot of the pertinent points that brought her to therapy in the first place, particularly around the death of her mother, the struggles with her new stepmother and her subsequent recognition that father was to blame for this. This was linked to her stepmother, who treated her cruelly, and her father not protecting her. By this time she had moved completely away from needing to oscillate between the enacted clown imagery and was reflective and tearful. At one point I suggested that she and the others seemed to be having a lot of difficul-ties with mixed feelings about either pertinent people in their lives or particular events in their childhood. Focusing on Sam, I suggested that she moved between putting her father on a pedestal and the difficulty in experi-encing anger towards him, or even expressing it. An added complication was that the timing either felt too late or that the person they felt they wanted to express these things to, e.g. Sam's father, was either ill or too fragile. Two other members of the group also had sick fathers. In the opening part of this session Sam had spoken about coming back from holidays and having to fit back into a subservient role of mother or wife. This highlighted dependency demands, and this seemed to be echoed by the whole group. This raised resentment and anger along with a difficulty of mobilising the anger creatively, e.g. Alison's painting of the feet denoting being walked upon

whilst letting it happen. Not learning from one's experiences seems clear in Alison's son's problems and her difficulty in giving up smoking. The whole group then resonated to the self-punitive and destructive dynamics. In a dynamic continuum the matter of restriction, loss of freedom and fear was generated. In the closing stage the focus moved to the death of mother (Sam) resulting in being left with fathers who did not protect the child from the new stepmothers. This, as I suggested earlier, highlighted the dual position of fathers needing to be on pedestals along with a difficulty in seeing them as bad and generating justifiable anger. Here there was a parallel with the clown faces of happy and sad, which could also be seen in aesthetic terms: the pedestal is shining on high and beautiful, whereas the anger and fear is the ugly, lower position. This gives a clearer picture of how this was related to the transference in their need to keep us (therapists) on pedestals in order to fulfil the dependency wishes, while being resistant to expressing their anger towards us for not protecting and oppressing them. I think also that this sequence of dynamic elements can be applied to the earlier struggles revolving around dependency, depression, anger, resistance to change and destructive processes.

Ending stage

My colleague left the group approximately one year before it was to finally close. This was approximately six months after the session just illustrated. During the last nine to twelve months of the group's life we went from times when the future looked good and people were able to use the group creatively, back to the depressed, angry and dependent state. During my colleague's leaving process there was an acknowledgement that the group was working better, but this was followed by such statements as: 'Now that Jon is leaving, could we stop the drawing and painting?' This was back to the old art therapist–group analyst split between my co-therapist and me. There were also practical difficulties in the closing nine months which I was unable to resolve, where I think I enacted my feelings about the failing nature of the group. Many of my notes were still part of a backlog of tapes that had never been typed, and for some months I did not record the sessions: the group was failing, so what was the point in recording anything?

After twenty-eight months I reached the decision to close the group; this was confirmed two weeks later when the group returned to a central sense of apathy. Once again the constructive processes had collectively been undermined and the feeling in the group was of the same nature and intensity as when we began. I felt as if I was fighting a losing battle. In many ways this

did not come as a great surprise to the group and in our exploration together over the following weeks the group gradually acknowledged the part that they had played in the group failing as a result of the dependency dynamic never having been fully resolved. However, to resolve it would have been defeating the issue as the group demand was to satisfy the pathological dependency wishes, which in turn undermined conflict resolution.

In the closing six weeks there was also, at times, a re-emergence of analytic work which brought with it a catch-22 in that, as they were now working better, there was no reason to close the group, but if I changed my mind then things would probably go back to intransigent dependence, passivity and further failure. There was a greater use made of the concrete imagery created, which also made me wonder if I was making a mistake in closing the group. Was I failing at dealing with a failed group? Was success my prerogative and not the responsibility of the whole group? In the penultimate session I made a comment about the struggle between opposing forces of power and powerlessness, coining the term 'powerful powerlessness'. This concept helped me to recognise the power in an apparently powerlessness situation.

Although the last session was like the others in initial art-making followed by discussion, the group went on to recognise the importance of it finishing. We did move from the feeling of failure to one of recognising that for many reasons the group had not achieved what had been expected. There was success in this recognition.

Conclusion

I have often wondered whether these comments at the end of my last two paragraphs were reflections about a failed group (also having reached some degree of success), or whether it was a group that had acquired a state of power within powerlessness. This latter point I would suggest was there for all of us in the group. Did it not reflect the many life experiences of each individual? The clients had experienced many facets of trauma and abuse and had hopefully entered therapy to address these difficulties. Or had they? Could it also be said that the many ways of surviving such experiences had created multiple individual and group mechanisms of defence and coping strategies? On a conscious level change was required, but to do so would be a betrayal of that which had worked relatively well before entering psychotherapy. For the therapists it could be said that at the time we were either unaware of such paradoxical complexities or blinded by our own

countertransference reactions, whilst trying to create positive therapeutic outcome and a professional effectiveness.

At the beginning of my chapter I presented my primary reason for focusing upon failure as a powerful feeling of being wrong, along with intense feelings of 'if only' I had known or done something else, then things would have been different. No one likes to fail, never mind admit it. Before it is a technical or theoretical point of interest, failure is a deeply personal feeling of awfulness or wrongdoing, leading to guilt, desire to make amends and the fear of reprimand. However, I trust I have opened up a new area in the art therapy and group analytic literature which tells us that there is something of value in failure and aesthetically significant, or at least of merit.

Before embarking upon my studies of failure I was of the opinion that there was little written about it, as I suggested in the opening section of my chapter. Kottler and Blau (1989), as referenced earlier, were also of the same opinion. However, the various theoretical points of reference I have cited in my chapter regarding failure give me reassurance in that others are likewise seeing value in the dynamics of failure.

Also I have tried to explore the aesthetic element throughout the text, giving credence to a dynamic basis to both the beautiful and ugly presentations of failure, whether focusing upon the aesthetic attributes of a beautiful or ugly concrete image produced in the art therapy group, or dealing with beautiful and ugly emotional experiences. Also in keeping with Foulkes' comments (Foulkes 1948) upon juxtapositions of emotions and concepts, I have postulated that ugly and beautiful are not necessarily opposites but at times may be two sides of the same coin, separated for semantic reasons.

Hanna Segal's interesting comments (Segal 1955) upon aesthetics (a psychoanalytical approach) give some profound statements which help us consider beauty and ugliness anew. In one sentence she encapsulates much: '…my contention is that it is a most important and necessary part of a satisfying experience (the concept of ugliness)'. Here, as I quoted in full earlier, is a statement which brings ugliness and beauty together when trying to comprehend the overall aesthetic nature of beauty and ugliness as a unified whole. When equating this with the art therapy group in question, one can see a particular satisfaction in the overall group experience. Taken, analogously speaking, as a tapestry within a timeframe of thirty months, one has to view all aspects of the weft and the weave. This includes beauty and ugliness on all levels. It embraces the imagery created as aesthetically pleasing or not, and how this reflected personal expression and resolution. It also includes the imagery of language, the silences, the unexpressed concrete imagery

(people refusing to paint/draw); the aesthetic expression of communication
on many verbal and non-verbal levels. At the end of the quote Segal speaks
of the artist transfiguring ugliness into beauty 'as if by a touch of his magic
wand'. An equation can be made to my group, both in the wish for the thera-
pist's magic wand, but also in the transfiguring of personal states of being
and change, when the analytic process was operative in the group – as if by
magic.

When contrasting the living experience of the art therapy group in
question with the literature I have cited, I found reassurance in the comments
I have referenced from the psychoanalytic/psychotherapy and family therapy
examples, e.g. Jenkins *et al.* (1982) tell us that at some time all therapists fail.
However, as I said earlier, there was little in the British art therapy literature
which helped me to understand failure as practically experienced in my
group. This, in part, is understandable, as the majority of art therapy theoreti-
cians have concerned themselves with individual art therapy. We owe a great
debt to the originators of art therapy in this country (Hill, Adamson,
Champernowne) who began to establish art therapy as a separate discipline
(Waller and James 1984). The early models of art therapy focused upon the
healing capacities of art; connections with psychiatry in that the art work was
used in diagnostic or symptomatic explanatory terms. Art therapy was also
being linked to the psychoanalytic/psychotherapeutic schools of thought.
The aesthetic point of view does not appear to have been given as much
credence.

The more recent literature that I have cited in this chapter has shown that
art therapists are now giving more attention to relationship dynamics when
considering the triangular relationship (Schaverien, Wood, Case, Mann).
With respect to my group experience the points raised by these writers have
been of interest to me. Mann's struggles in his group echo my own, both with
respect to strongly negative countertransference and the position of
co-therapy. But whereas Mann focused upon one member of his group, I have
addressed the group as a whole, inclusive of individuals.

Likewise Schaverien's views on various transference configurations have
been helpful in understanding what was occurring in my group, particularly
her comments about the image becoming a scapegoat. What I would not be
in full agreement with is when she speaks of the image becoming an
embodied transference. Transference and countertransference, I feel, occur
between people and environments where particular conflictual dynamics are
permitted admission. However, an image produced in art therapy can be both
a source and a receptacle for unconscious resonances and varying degrees of

projections being enacted. The transference and countertransference may be going on at the same time. Therefore what appears to be an embodied image of transference may either be the outcome of strong intrapsychic conflict being projected onto the paper or, alternatively, it could be a diversionary expression of transference feelings for the therapist which are safer to be put onto the paper. These may be either conscious or unconscious.

However, the recent art therapy literature on the triangular relationships/configurations and transference/countertransference studies have not been enough to help us fully understand what goes on in group analytic art therapy groups. Similarly the understanding of transference/countertransference, along with therapeutic technique as it occurs in individual psychotherapy, cannot be applied wholesale to group psychotherapy. Also, individual concrete images produced in the art therapy group cannot be seen as isolated pictorial statements out of context of the overall group images. Nor should they lose their own unique individual power.

One last area I would like to address briefly concerns the aesthetic conceptions of the triangle symbol and the process of transposing a flat, two-dimensional image into a three-dimensional (mental) one. As I mentioned earlier, there have been key theoretical developments in understanding and describing triangular relationships/configurations in art therapy. In my early paper on directive and non-directive approaches (McNeilly 1983, 1984) I also spoke about how this is expressed in the art therapy group. However, no one has yet begun to look at the triangular structures from a 3-D perspective, i.e. a three- or four-sided pyramid. If we begin a chain of dialogue we may see things in a different light, e.g. who is at the point or base of the pyramid? Is the concrete/pictorial image at the pinnacle or the base? Is the therapist or the group a side of the pyramid? What is in the centre of the pyramid? What would this then mean for how we view things aesthetically?

When considering a work of art in the world of visual aesthetics is there a difference in what is seen in a sculpture or a painting? Is there a difference between the artists' creation of paintings and sculptures? When the viewer looks upon a great work of art, e.g. a painting, I believe that it loses its two-dimensional material structure of paint on canvas. At the juncture of 'seeing', the viewer's internal world becomes alive and his/her imagination converts a 2-D work into a 3-D imaginary experience. Applying this to the art therapy experience I pose the question as to why the triangular relationships/configurations have been described in art therapy literature (to date) a

rather flat/2-D way? Possibly there are invisible 3-D transfigurations occurring, not only in art therapy, but in all psychotherapy.

I would like to finish with an extract from a dream that a patient described in one of my groups – not art therapy. The group is in its final three months of closure.

> She dreamt that she was with a man in an old Victorian bathhouse. There was a beautiful, multicoloured mosaic of tiles on the floor and walls. Unfortunately someone had crudely covered these with cement and it was an ugly sight. She and the man began to dig up the concrete and when they had cleared it away all the beauty of the tiles was showing, even though they were all broken.

I feel this dream reflected an inner feeling of things having been broken into fragments in the past, but now that her life was more together, there was a recognition of inner beauty, even though things had been broken. A cracked pot is no longer a cracked pot just because it is glued together. Her dream may also have reflected how the group was coming to a close and although it was 'cracking up' it remained whole inside her.

References

Baker, C.B. (1975) 'Why people don't change'. *Psychotherapy: Theory, Research and Practice 12*, 2, 164–171.

Bohart, A.C. (1995) 'Reflections on failure cases'. *Journal of Psychotherapy Integration 5*, 2, 155–158.

Case, C. (1990) 'Heart forms – The image as mediator'. *Inscape*, Winter, 20–26.

Dalley, T. (1987) 'Art as therapy: Some new perspectives'. In T. Dalley, C. Case, J. Schaverien, F. Weir, D. Halliday, P. Nowell-Hall and D. Waller (eds) *Images of Art Therapy*. London: Tavistock Publications.

Ellis, A. 1984) 'How to deal with your most difficult client – You'. *Psychotherapy in Private Practice 2*, 1, 25–34.

Fine, H.J. (1980) 'Despair and depletion in the therapist'. *Psychotherapy: Theory, Research and Practice 17*, 4, 390–395.

Foulkes, S.H. (1948) *Introduction to Group Analytic Psychotherapy*. London: Heinemann Medical Books. (Reprinted 1983 – London: Karnac Books)

Gold, J.R. (1995) 'Case report of a failure in psychotherapy'. *Journal of Psychotherapy Integration 5*, 2, 113–120.

Greenspan, M. and Mann Kulish, N. (1985) 'Factors in premature termination of long-term psychotherapy'. *Psychotherapy 22*, 1, 75–82.

Jenkins, J., Hildebrand, J., and Lask, B. (1982) 'Failure: an exploration and survival kit.' *Journal of Family Therapy 4*, 307–320.

Keith, D.V. and Whittaker, C.A. (1985) 'Failure: Our bold companion.' In S. Coleman (ed) *Failures in Family Therapy*. New York: Guilford Press.

Klein, M. (1975) 'Notes on some schizoid mechanisms.' *Collected Works*. Vol. 111, London: Hogarth Press and the Institute of Psychoanalysis. See also: *The Selected Melanie Klein*. Harmondsworth: Peregrine Books (Penguin Books).

Kottler, J.A. and Blau, D.S. (1989) 'The imperfect therapist: Learning from failure in therapeutic practice'. In S. Coleman (ed) *Failures in Family Therapy*. New York: Guilford.

McNeilly, G. (1983) 'Directive and non-directive approaches in art therapy'. *The Arts in Psychotherapy 10*, 211–219.

McNeilly, G. (1984) 'Group analytic art therapy'. *Group Analysis, 17*, 3, 204–210.

McNeilly, G. (1987) 'Further contributions to group analytic art therapy'. *Inscape.* Summer, 8–11.

McNeilly, G. (1989) 'Group analytic art groups'. In Gilroy A. and Dalley T. (eds.) *Pictures at an Exhibition: Essays on Art and Art Therapy*. London and New York: Routledge.

McNeilly, G. (1990) 'Group analysis and art therapy: A personal perspective.' *Group Analysis 23*, 3.

McNeilly, G. (1997) 'Resonance and intuition in group analysis and group analytic art therapy'. Unpublished paper presented to Brazilian/Portuguese Association of Group Analysis, Lisbon, Portugal.

Mahony, J. and Waller, D. 'Art therapy in the treatment of alcohol and drug abuse.' In D. Waller and A. Gilroy *Art Therapy: A Handbook*. Buckingham, England: Open University Press..

Mann, D. (1988) 'Counter-transference – A case of inadvertent holding'. *Inscape*, Summer, 9–13.

Older, J. (1977) 'Four taboos that may limit the success of psychotherapy'. *Psychiatry, 40*, August, 197–204.

Powell, D.H. (1995) 'What we can learn from negative outcome in therapy: The case of Roger.' *Journal of Psychotherapy Integration 5*, 2, 133–144.

Rust, M.J. (1992) 'Art therapy in the treatment of women with eating disorders'. In D. Waller and A. Gilroy *Art Therapy: A Handbook*. Buckingham, England: Open University Press.

Schaverien, J. (1989) 'Transference and the picture: Art therapy in the treatment of anorexia'. *Inscape*, Spring, 14–17.

Schaverien, J. (1990) 'Desire, alchemy and the picture: Transference and counter-transference in art therapy'. *Inscape*, Winter, 14–19.

Schaverien, J. (1995) *Desire and the Female Therapist: Engendered Gazes in Psychotherapy and Art Therapy*. London and New York: Routledge.

Segal, H. (1955) 'A psycho-analytical approach to aesthetics'. In Klein M., Heimann P., Money and Kyrle R. (eds.) *New Directions in Psycho-Analysis*. London: Tavistock Publications. (Reprinted 1978. London: Clunie Books.)

Skaife, S. (1990) 'Self-determination in group-analytic art therapy.' *Group Analysis 23*, 237–244.

Strupp, H.H. (1975) 'On failing one's patients.' *Psychotherapy: Theory, Research and Practice 12*, 1, 39–41.

Theobold, D.W. (1979) 'Errors and mistakes'. *Dialogue 18*, 555–565.

Waller, D. (1993) *Group Interactive Art Therapy – Its Use in Training and Treatment*. London: Routledge.

Waller, D. and James, K. (1984) 'Training in art therapy.' In T. Dalley (ed) *Art as Therapy: An Introduction to the Use of Art as a Therapeutic Technique*. London: Tavistock Publications.

Wilks, R. and Byers, A. (1992) 'Art therapy with elderly people in statutory care'. In Waller D. and Gilroy A. *Art Therapy: A Handbook*. Buckingham, England: Open University Press.

Wood, C. (1990) 'The beginnings and endings of art therapy relationships'. *Inscape*, Winter, 7–13.

Teachers, Students, Clients, Therapists, Researchers
Changing Gear in Experiential Art Therapy Groups

Jane Dudley, Andrea Gilroy and Sally Skaife

Introduction

This chapter describes a collaborative research project that has been in progress for eight years in which we have looked at processes in art therapy education with specific reference to experiential learning in art therapy groups. We will describe the history and context of the project, the research methodology, and some of our findings. The most significant of these is our growing awareness of the influential nature of the total context in which we operate on the educational process that the students undergo, and the crucial role that we have as role models to neophyte art therapists. We will discuss the subtleties of transference and countertransference and the enactment of these in practical ways in experiential art therapy groups, and go on to describe the central dynamic of balancing education and therapy within experiential learning.

The experiential art therapy groups that we conduct take place within the postgraduate Diploma in Art Psychotherapy at the University of London, Goldsmiths' College. It is a two-year full-time/three-year half-time course of professional education, involving a tripartite educational structure of theory, supervised clinical practice and experiential learning. Students are required to be in personal therapy throughout the course. The model of education is one of active, problem-based learning where the student becomes their own

expert through exploration of issues with tutors, as and when they arise. Clinical issues are brought from placement to supervision and are related to psychodynamic and art therapy theory, and to the 'as if' experience of art therapy in the experiential groups.

The project has its origins in informal lunchtime discussion prior to conducting the weekly experiential art therapy groups. At that time we had recently begun running three concurrent experiential art therapy groups, following changes in staffing; this prompted an informal review of our practice. Our relationships with each other had a history and so our initial dialogue involved the establishment of trust between the three of us, who brought to it somewhat differing experiences and perspectives. It also involved acknowledging anxiety about our adequacy as educators and clinicians. We became aware of a dual process in which anxiety, revolving around the fantasy that there was 'a right way' of conducting experiential art therapy groups, prompted a desire to learn and explore, but this was coupled with a fear of being 'found out': we needed to be able to be doubtful with one another about our practice.

Three things stimulated us to frame our work as research. First, experiential art therapy groups were not, at that time, discussed in the literature. Second, one of us had just completed research that included consideration of changes in such groups (Gilroy 1992, 1995) and, third, had also attended a one-week course in experiential, participatory research (Reason 1988, 1994; Reason and Rowan 1981), a research methodology which seemed to suit the discursive nature of our work.

Before describing the research method, the content of our discussions and the findings, we will place our work in the context of the literature on experiential groups that, in the main, is about verbal groups.

The literature

In order to review the literature we have divided it into four groups. First we look at the American literature, as it describes experiential groups most similar to our own (Grotjahn, Kline and Friedmann 1983; Mills 1964; Munich 1993; Yalom 1975). We then go on to look at the British literature that is mainly on focused workshops (Hobbs 1992). Third, we review the literature on block training in group analysis as we have found some of the issues raised have relevance to our discussion (Balmer 1993; Hilpert 1995; Reik 1993; Tsegos 1995). Lastly we refer to the limited literature on experiential art therapy groups (Gilroy 1992, 1995; Waller 1993; Waller and James

1984). We have paid particular attention to what is said in the literature about the significance of context, transference and countertransference, role modelling, and the balance of therapy and education.

We begin with a brief history of experiential group work. Verbal experiential groups originated in Britain with the work of Bion (1961) who found that groups, like individuals, were motivated by predictable, unconscious processes. His work influenced the Group Relations conferences that were set up at the Tavistock Clinic in London, under the auspices of A. K. Rice, in order to explore group dynamics. As a spin-off from these, National Training Laboratories were organised in the United States in the 1950s to train professionals in using groups for working with, amongst other things, difficulties in racial tensions (Munich 1983). Munich points out that since that time, though experiential groups have been used in many residency programmes in the United States, there has been 'controversy and confusion about goals' (Munich 1983, p.346). He goes on to describe a basic model which emphasises an educational agenda over a therapeutic one, focusing on authority relations and group process rather than individual dynamics. Mills (1964) draws similar distinctions between a therapy group and an experiential group:

> ...the purpose, procedures and products of the learning group are quite distinct from those of the therapy group. The aim of the former is learning, not personal help – although of course learning may be helpful. Procedures are designed to gain insight, not to remove symptoms – although of course insight may dissolve certain symptoms. Its scope is more limited than therapy in the sense that its termination is decided by the academic calendar rather than the emotional state of its members... The role of a member is that of a student, not of a patient; the role of the leader is that of a teacher, not of a healer. (Mills 1964, p.15)

Yalom (1975) describes experiential groups as offering trainees the opportunity to learn to identify with patients, to feel anxiety about self-revelation, to feel hostility towards the leader and to fellow group members, to understand the dynamics of group support and to experience transference distortions. To learn these there has, inevitably, to be some regression in the group and so Yalom suggests to student members that they consider personal material they would like to work on in the group. However, he advises that the conductor limit the amount of self-disclosure, make mainly process comments and keep the group in the 'here and now'. He suggests that the experiential group leader allow the group to structure the time as they wish, and then encourage them to analyse the experience.

Yalom (1975) also discusses potential confusion in the dual role of the conductor as educator and therapist and feels that a separation between these roles is important; this is because otherwise undue attention is placed on authority issues. If this cannot be helped he advises that the conductor confront the issue directly in the group, or alternatively be open in self-disclosure him/herself in order to facilitate a feeling of trust. Munich (1983) has more of a systems approach. He sees the experiential group as offering a unique opportunity to explore transferential issues and authority issues within the interlocking system of group and institution. He talks about the importance of focusing on individuals' relationship to the group, the group as a whole and its relationship to its larger context (the training establishment), and suggests that the conductor avoids making any interpretation of individual dynamics. He sees the experiential group as a powerful means of learning about the roles an individual student might take in the group process, about the potency of unconscious group processes in shaping institutions, and in particular about issues of authority.

Yalom (1975) describes the difficulty of running experiential groups: '...the pace is slow, intellectualization is common, and self disclosure and risk-taking minimal' (p.512). Realising that their professional tool is themselves, the students are in double jeopardy from self-disclosure, i.e. their personal and their professional competencies are at stake. He describes how students often deal with competitive feelings by denying differences between them. Yalom also discusses role-modelling, saying that the conductor should role-model a research attitude by 'consistently using the group as a source for data about the process and progress of the group' (p.517). He also suggests that the conductor acts as a role model in the way he deals with rivalry and competition in the group.

Although experiential groups have long been part of the training of group and individual psychotherapists in some educational establishments in Britain, there appears to be little literature on them. However, Nitsun (1996), in describing destructive group processes, discusses an experiential group in the context of major staff conflict and reorganisation of a training institute. He describes how the conductor of an experiential group came to be perceived as persecutory, representative of the institution and, despite the conductor's best attempts, the group appeared to fail in being a useful training experience for the participants and was an extremely upsetting experience for the conductor. Nitsun uses this as an example to illustrate the importance of the holding context and of 'malignant mirroring' (Zinkin 1983, p.113). Nitsun explores this as a useful and creative 'anti-group'

process, forming a natural tension that is part of a group's developmental process, and adds that sometimes this can be heightened because of the particular circumstances of the organisation. Nitsun also discusses how the leader brings to the group, consciously or unconsciously, how he or she is affected by the system, particularly the status afforded the group by the organisation. He also describes how this process can work the other way round, so that the group may, for example, project their chaos onto the institution.

Structured, focused workshops for professionals with counselling roles are described in the British literature. Hobbs' (1992) edited book on experiential learning describes the use of trainees' personal experience as a means of helping them in their counselling relationships with issues such as sexuality, bereavement, etc. He makes the important point that leaders need to be able to talk about difficult things such as sexuality; this is to model to students that although the difficulty is understandable, nevertheless one should make the attempt. The chapters in Hobbs' text mostly address conscious feelings. However, Smith (1994) describes using experiential workshops to bring out 'deep unconscious concerns that are at times so powerful that they inhibit course development' (p.173). He uses specifically structured workshops to bring out hidden conflicts relating to social relationship dynamics. He talks about the importance of allowing negative transference to emerge so that students may separate successfully from the institution and develop independently as therapists.

Recently in Europe there has been a growing literature looking at issues raised by block training in group psychotherapy (Balmer 1993; Hilpert 1995; Reik 1993; Tsegos 1995). Block training came about as a means of providing training in group analytic therapy for people living out of large cities and therefore away from major centres of learning. In these circumstances students are likely to experience their personal therapy in groups comprising their fellow students and located within the training establishment. It appears that these groups are therapy groups, but the fact that the membership is entirely comprised of students and that the groups occur within therapy training implies that they might be experiential groups.

It is therefore perhaps not surprising that the major issues in the block training literature are boundaries and how the institution affects the training group, and vice versa. Hilpert (1995) says that the course itself becomes an 'inestimable transference object which thrusts itself into the relationship between training group and group conductor' (p.301) and feels that the implications of this have not received sufficient attention. He discusses the

difficulties that are posed in maintaining a boundary between the fantasy level appropriate to analytic work and the reality issues of the institution. He thinks that issues that are important for the institution, such as its standing in the hierarchy of therapeutic trainings, must affect the workings of the training groups through such things as some students being pushed in front in order to enhance the institution's reputation. Similarly students' tendency to act out personal issues through their relationship to the institution inhibits the exploration of these within the groups. He thus leans, as does Tsegos (1995), towards using more of a therapeutic community model (Jones 1953), whereby the institution as a whole is seen as the matrix, with large groups, support for staff and regular staff meetings containing the splits. He discusses the difficulties in keeping the 'abstinence boundary', which we understand to mean the conductor avoiding a relationship with the students other than within the group. Reik (1993) also discusses this but suggests that the 'abstinence boundary' should be shifted to the training as a whole, emphasising that it should be firmly kept.

Waller and James (1984), discussing art therapy training in general, refer to experiential art therapy groups as being one of the most difficult areas of training for students because they are required to involve themselves in the process as well as stand outside and look at it analytically. Amongst other things, they cite distinguishing between art-making for achievement and art-making as self-exploration as being a learning factor in experiential art therapy groups.

In her book on interactive art therapy groups Waller (1993) describes her experiences as a conductor of a number of short-term experiential art therapy groups. These were mostly groups to introduce mental health workers or art teachers to art therapy, sometimes overseas (and therefore including an interpreter) and often in the context of block training events held in unfamiliar physical spaces. Consequently Waller highlights the importance of having an appropriate space in which to conduct experiential art therapy groups and of the availability, or not, of appropriate art materials. She describes an occasion where 'traditional' artists' materials, such as watercolours and fine brushes, were not entirely suitable because of the associations with the work, role and function of artists in that particular culture, and so a wide variety of non-traditional art materials had to be acquired. These were considered essential to the introduction of art therapy as a practice that enhanced creativity through experimentation with materials such as household paint, wrapping paper, sand, junk, cardboard boxes, pieces of fabric and straw (Waller 1993).

Waller also describes the difficulties of maintaining a balance between therapy and education in experiential art therapy groups, particularly in a situation where group members and the group leader encounter each other outside the group. She goes on to discuss the considerable 'pull' in an experiential group to make it into a therapy group rather than a training group, and shows how difficult this can be both for the group and for the conductor. Waller echoes the earlier American literature on experiential groups (Mills 1964; Munich 1983; Yalom 1975 – reviewed earlier) in her emphasis on the importance of the experiential art therapy group leader maintaining the educational purpose of the group through didactic comments and whole group interpretations that keep the group's focus on learning.

Gilroy (1992, 1995) researched the influence of art therapy education in general, and experiential art therapy groups in particular, on art therapists' art. She illustrated how experiential art therapy groups are a key factor in art therapy education as an arena where students' personal lives and occupational choices meet and influence one another, and further influence their art work during and after training. She describes the changes in art therapy students' perceptions of themselves and of other group members in experiential groups. Drawing on Liebermann *et al.*'s research on psychosocial relationships (1973), she uses their definition of group members with a

> 'VCIA role', i.e. they were individuals who were Influential and Active and whose Values were Congruent with the goal of the group. Such people were found to take risks, were spontaneous, expressed themselves and were helpful to the group through their influence and activity. (Gilroy 1995, p.68)

Gilroy found a correlation between an increase in students' VCIA roles in experiential art therapy groups and a 'decrease in fears of unconscious meanings in art work and an increased ability to learn about themselves and their art work, and vice versa' (Gilroy 1995, p.75). In other words, she showed how art therapy students' ability to be open, spontaneous, take risks in their behaviour and art work and express themselves influenced their role in the experiential art therapy groups and consequently their ability to learn – about themselves and their art (amongst other issues), and change. Gilroy found that students' increasing awareness of latent meanings in their imagery in the experiential groups could be either an inhibiting or a liberating factor. Most art therapy students' fears about their art work made in the groups either decreased or was contained, and so they were able to increase their activity and influence in the group and hence increase their capacity to learn.

However, as the group progressed some students became more fearful about what their art work might mean and so their influence and activity in the group declined, rendering the group a difficult place for them to learn anything about themselves, others, or about art therapy groups. This increase or decrease in students' fears of the content and meaning of their imagery was linked to experiences of loss and other distressing experiences in their lives that were associated with their occupational motivation and career choices, and to their art (Gilroy 1992, 1995).

Gilroy's work also illustrated the importance of the group conductor's ability to be open, honest and spontaneous in an experiential art therapy group. The two groups that she conducted during her research showed different levels of spontaneity and openness that reflected her degree of comfort and discomfort as the group leader with the influence that her research had on the groups' processes (Gilroy 1992, 1995).

In summary, Yalom's observations (1975) about the potential role confusion of the experiential group leader, the importance of the leader's role-modelling and students' 'double jeopardy' inhibitions in training groups we have found relevant to our own groups. Nitsun's discussion of a destructive process in an experiential group highlights our own awareness of the importance of the institutional context, particularly the way the therapist brings unconscious attitudes from the institution to the group. The model of experiential groups described by Munich (1983), which uses systems theory to work with issues about the student's relationship to authority and to the institution, has similarities to our own approach. The significance of context is also in the literature on block training; it describes issues that arise from personal therapy rather than experiential groups, and also raises issues to do with therapeutic community models that have relevance to our working model of art therapy education. The importance of the physical and organisational context are also evident in Waller's descriptions of short-term, block art therapy experiential groups, and both Waller's and Gilroy's work echo the significance of the art therapy experiential group conductor's role. A number of authors emphasise the importance of differentiating between education and therapy in experiential groups, particularly in the kind of interventions made by the conductor.

Role distinctions between therapist and educator are taken a step further when adding 'researcher' too. In the following description of our research method we explain why this model (collaborative research) seemed appropriate for our investigation. This discussion has particular relevance to our

subject as collaborative research is also, in itself, a form of experiential learning.

The method

We are ourselves a group, researching experiential art therapy groups, within a training model based on groups. The method of research chosen, variously called 'collaborative inquiry', 'new paradigm research' and 'experiential participatory research' (Reason 1988, 1994; Reason and Rowan 1981), seemed particularly appropriate because it often has a basis in group work and can involve the use of non-verbal means of expression (see Reason 1994). Prior to beginning the research described in this chapter one of us (AG) had attended a course on 'new paradigm research' and subsequently wrote:

> New paradigm research prefers holistic approaches; it implies and requires the participation of the researcher and considers the experiences of all as part of a total system which integrates theory and practice... The fundamental premise of this model is that the research process is not linear, from hypothesis through to the finite result, but cyclic; it revolves repeating cycles of action and reflection, experience and thinking. (Gilroy 1992, p.239)

For our small research group this meant that we had regular discussions about our practice in the experiential art therapy groups that were taped and subsequently transcribed. From the tape transcripts particular themes emerged that we then focused upon, elaborated and followed with action. This process began in 1992, and continues.

This research method of co-operative inquiry gains its validity because it involves the study of people by people who have an active relationship with each other and who together take part in the activity that is being researched (Reason 1994). This means that the knowledge gained is experiential (i.e. based in direct experience), practical (through doing) and propositional (involving statements and theory). Reason describes how co-operative inquiry involves four cycles of reflection and action, the first of which involves the following:

1. A group of co-researchers gather to explore an agreed area of activity. They decide on a focus, develop a series of questions they wish to explore, agree to some action that is pertinent to the inquiry and how they will record their experiences. (Reason 1994)

As we said earlier, our research process involved us coming together initially in lunchtime discussion prior to the weekly experiential art therapy groups; this was like an informal review of our practice as art therapists, group conductors and educators. Our relationships with each other had a history: we did not know each other well, but two had taught on another programme together and one had been in another's experiential art therapy group. We had differing experiences as clinicians and educators and had been working with each other, and with experiential groups, for differing periods of time. The process has been one in which we have functioned very much as one might in therapy or peer supervision, the development of trust between us allowing unprocessed spontaneous material to emerge. As our conversations developed we felt we were discussing matters that had a direct bearing on our behaviour in the experiential groups that we conducted later on in the afternoons. It was this that led us to frame our continuing conversations, or 'reflections' and subsequent 'actions', as research. At first we did not have a focus or research question, other than *to explore the way we operated as leaders of experiential art therapy groups.* We decided to document the process through taping and transcription of our discussions, and then to reflect further on what we had said and subsequently done in the groups.

2. In the second phase the co-researchers engage in the actions agreed upon and record/observe what happens to themselves and others. (Reason 1994)

We continued to conduct our experiential art therapy groups and began to meet in a more formal and organised way for taped discussion. We also read through the transcriptions, highlighted the key issues, and engaged in further taped discussion about what had emerged and happened.

3. Phase three Reason (1994) describes as the 'touchstone' (p.43) of the method. It is the stage at which the participants become fully engaged with the experience and 'develop a degree of openness to what is going on so free of preconceptions that they see it in a new way. They may deepen into the experience so that superficial understandings are elaborated and developed. Or they may be led away from the original ideas and proposals into new fields, unpredicted action and creative insights' (ibid.). Reason also says that at this stage the co-researchers can become so enthralled by what is happening that they forget they are part of an inquiry group. He also says that this phase involves mainly experiential knowledge that may be expressed in a creative way.

As we reflected about what we had said and done we realised that specific themes were emerging that went beyond the experiential art therapy groups into consideration of the micro and macro systems in which we worked. We discussed ourselves as role models, the practicalities of how we each operated in the groups, how we trod the line between therapy and education, our self-images, the curriculum, course dynamics, issues arising from working as therapy educators within a university, and the Research Assessment Exercise (RAE). One of our most energised conversations was about ourselves as artists. It was this subject, and its resonance with all the other issues we had identified, that really 'enthralled' us.

4. Reason (1994) says that in phase four the co-researchers review their original propositions and questions in the light of their experiences and may modify them accordingly. For the next cycle they may decide to focus on the same aspects of the research inquiry, or on quite different aspects, maybe also deciding to record experiences and take actions in a different way. This stage usually involves some kind of propositional knowledge, i.e. theorising.

At this stage in our research two things happened. First, we decided to write about it (Dudley, Gilroy and Skaife 1998, and this chapter). This involved us in giving our discussions a context within the literature on experiential learning and therapy education and hence with theorising about our work. Second, we began to take what had emerged from our discussions out of the microcosm of our small inquiry group and into the context of the programme as a whole. This involved discussion with the staff team about various matters and significant changes in the curriculum; for example, giving more time and attention to students' art practice – that is, we moved into new areas of action outside the immediate arena of experiential art therapy groups. Since that time we have continued to discuss and record our experiences, documenting the changes that have followed our actions in much the same way as before.

To date we have not directly involved students or clients as participants, preferring at present to work as a small group of three art therapy educators researching our practice as experiential group leaders, although this may well be part of further collaborative inquiry that we engage with later on. To date we have been able to discover and explore particular themes that continue to preoccupy us as art therapy educators, working during times of significant change in higher education and mental health care, that we will now go on to describe.

The discussion themes

Although our initial intention was to discuss the experiential art therapy training groups we often found ourselves talking about other aspects of our work. We wondered at first if this might be an avoidance of the task but concluded that it was in fact impossible to talk about the groups without talking about their **context**, and that indeed the processes within the groups could not be understood without reference to the immediate and wider environments in which we worked. At one level this was obvious: no group happens in isolation. However, what emerged as significant was the effect on *us* of our environment and how that was transmitted to the students, influencing both their and our practice. This related to the development of our awareness of our significance to the students as **role models**. Although this was familiar territory we came to realise the extent to which we tended to keep certain aspects of our influence outside our awareness. We were surprised to discover how, at an unconscious level, we embodied aspects of our wider culture of higher education (the context) and enacted this in our roles as experiential group conductors. Further, that this too was likely to be internalised by the students for whom we were role models. This led to discussion about the differences between the three of us in our practice as leaders of experiential art therapy groups, and exploration of the relationship of these differences to transference and countertransference within our groups.

The balance between **education and therapy** within the groups was always central to our discussions, but we found we were particularly preoccupied with how students' motivation to train as art therapists often involved unconscious aspects derived from their personal histories. We were interested in how this interacted with the educational process, particularly within the experiential art therapy groups. The exploration of these three main themes that follows will be interwoven with the literature and with description of our discussions and findings.

Context

In order to describe the nature of our discussions it is important to outline the way we work, as art therapy educators, with interlocking groups that occur within the postgraduate Diploma in Art Psychotherapy at Goldsmiths' College. It may be helpful to envisage this as a series of circles within circles, at the centre of which are ourselves as conductors of the experiential groups. As well as being experiential group leaders we are members of a staff team

teaching on a particular programme of postgraduate professional education. The programme is one of several that, at the time, operated within an 'Art Psychotherapy Unit' that had been within a faculty. This in turn was/is part of a college, which is a school of the University of London, funded by the Higher Education Funding Council of England (HEFCE). We also have primary connections to systems of mental health care, education and social services through the clinical placements and through our own clinical work.

The full-time and half-time nature of the programme, where both staff and students spend a considerable amount of time together in the same physical location, distinguishes it from the usual model of psychotherapy education that tends to have a very part-time staff and student group. This enables the art therapy programme to have some parallels with therapeutic community principles in that staff have multiple roles and students are in inter-connected, dynamically oriented groups. These are all considered in the context of the whole community of the programme and of the particular cluster of art therapy and group psychotherapy programmes which, at that time, comprised the Art Psychotherapy Unit (now 'Art Psychotherapy' within a Unit of Psychotherapeutic Studies).

As stated earlier, we kept finding ourselves talking about wider issues relating to the 'outer circles' of our working environment, i.e. to changes in higher education and in mental health care that have had a major impact on both students and staff. Students were facing increasing economic and practical difficulties and often worked a significant number of hours whilst studying, simply in order to finance themselves through their education. Throughout the time of our discussions the funding of teaching and research in higher education was under review and economies were being made. Student intake targets were steadily increasing, and the Research Assessment Exercise (in which all academics' non-teaching activities are regularly reviewed and measured) continued to be an immediate focus of concern and staff activity. None of this was particular to our institution, but through our discussions we discovered the degree of influence the changes were having on us as art therapy educators and conductors of experiential groups.

Our small collaborative inquiry group also became acutely aware of the changes in art therapy clinical practice that were apparent through our supervision of students' work on their clinical placements, and the knock-on effects of this on our teaching and their learning. This included issues such as the loss of many art studios with the closure of large psychiatric hospitals, the fragmentation of care in the community, and the increasing use of short-term interventions, all of which raised questions about the curriculum. Further,

these changes in mental health care are such that, in our experience, it is likely that a trainee art therapist will be seeing more seriously mentally ill clients than hitherto. Our discussions brought home to us the increased amount of disturbing clinical material from the students and their patients that has to be contained and processed.

Changes in the state health and education services in recent years seem to have eroded the containing ability of the wider community and systems in which we work. In our discussions we realised that this, together with increased numbers of students who were working with higher levels of disturbance in their patients, had the potential to overwhelm and fragment both staff and students that could, in turn, significantly undermine the 'nuclear community' of the programme as a whole. If this should occur, the suitability of an educational model based in experiential learning and therapeutic community principles could be called into question. However, when the larger community (by which we mean the educational institution and broader network of clinical placements) is able to be 'good enough' and work effectively, so too is the small nuclear unit of the training programme. It is able to respond appropriately to the most difficult of issues both within the programme and within the wider community. The nuclear community of the programme as a whole acts as a container for, and processes the feelings of, individual students as well as the whole-course student group, but within this nuclear community the staff group processes *all* the material; naturally this is contingent upon the staff team operating satisfactorily. We realised that when it does not – for example, when staff are for some reason under stress and/or are unable to process their own and the student group's material – the entire nuclear community of the programme is inevitably affected. At such times it is likely that staff meetings can be eroded, i.e. when they are needed most. Thus it is imperative that the staff group have a consistent arena in which to address here-and-now issues to do with educational and dynamic processes, such as countertransference issues and 'mutual mirroring' between staff and students (when each may act out each other's processes).

As a result of the research and our heightened awareness of the importance of creating strong structures to process material and to contain ourselves and the students, we were able to organise additional regular staff meetings. At a time of significant change in our external environment it has been all the more important that we have ensured that we are adequately contained ourselves. Although staff meeting and thinking space is widely acknowledged to be important on psychotherapy training courses (Hilpert 1995; Reik 1993), and we were well aware of this ourselves, it was not until

we had rediscovered this anew, through repeated cycles of discussion and reflection' that we found the impetus to take some action and initiate change. In this context it¹ is interesting to note that the students spontaneously remarked that the staff group seemed better cohesed the year such changes were implemented! Nonetheless we find it a continuing struggle to create adequate space for staff groups, especially during times of attack from without and vulnerability within the nuclear community of the programme. This is despite its importance for processing our own as well as student material, and for containing the inevitable splits, as well as for role-modelling good practice to trainees.

Role-modelling

As stated earlier, what emerged in the research was a growing realisation of the nature of our responsibility as experiential group leaders. It is through us that students absorb influences and attitudes from the wider context that influence their subsequent clinical practice when they graduate. This realisation came about as we considered which influences had informed our own clinical practice. A major influence had, not surprisingly, been the experiential groups that we ourselves had been in; these had been variable in quality and quantity and had therefore been both positive and negative influences. The experiential art therapy groups are the only place on the programme where students see and experience tutors somewhat 'in role' as clinicians (although of course they see placement supervisors 'in role' with patients), and very few students receive art therapy within groups as their personal therapy. It is therefore inevitable that we are internalised as significant role models. We came to realise that this includes us as educators, clinicians and as artists, and everything we do and say in the experiential art therapy groups – a rather frightening prospect! It also includes the room we work in, the art materials we provide, and the subliminal influence of the institution's attitude to our work that we come to embody to the students.

To understand the implications of this we needed to explore issues around transference and difference. A major finding that emerged concerns the influence of our countertransference responses. The first of these was that we bring to the experiential groups a particular envy of the students. In our discussion of students' art-making we found that we had in common a wish to be in their position; they had the luxury of two hours every week in which to paint, draw, build and make things within a group of like-minded people. There are limited opportunities for art therapists to participate in making

images together in general; for the educators of such a small, specialised profession the venues for such activity are almost non-existent.

Linked to this were the difficulties we faced in maintaining our own art practice. This was because of a constant feeling that it was indulgent and that other aspects of our work should take priority; for example, research, publication and curriculum development, giving the written word greater significance and currency than art. This is so in many areas of social and cultural activity, including the health-care services, and is not surprising within an academic setting where a major part of the assessment process focuses on written work. However, within art therapy as a discipline, and notwithstanding the pressure to demonstrate the efficacy of our clinical work through research and evidence-based practice, we would suggest that publication is more highly regarded than an exhibition. Prior to this project we had not fully appreciated the way such attitudes might be affecting our practice in the experiential groups and, through the students' internalising us as role models, in turn be affecting the nature of their subsequent art therapy practice.

Although we were well aware that keeping in touch with ourselves as artists is fundamental to our practice as art therapists, we were surprised at the extent to which we were neglecting it. As the cycles of reflection and action continued we realised that we returned to this issue repeatedly. However, it became evident that there was a paralysis around our ability to change our priorities and attend to our own art as a practice that contributes to the maintenance of that which makes art therapy unique. It seems to us that this reflects a dynamic within the profession as a whole that, although it has its origins in the practice of art, sometimes finds it hard to maintain a continuing dialogue with it (Gilroy 1989, 1992). This led us to consider the model of professional practice that we were communicating to the students at both conscious and unconscious levels. If we were finding it so hard, how could we realistically expect students to maintain an art practice? How could we expect them to give images and words equal consideration if we were unable to do so? We have called this process the cascading down of assumptions at an unconscious level. By this we mean the unconscious transmission of attitudes from the social, cultural and political context that are embedded in our working environments that we, as tutors, may embody, enact and communicate to students and which, in turn, influence their clinical practice and hence the profession at large. It is part of a process of professional socialisation through which people learn about and adjust to the occupational norms that enable them to do their job (Becker 1964; Moore 1968; Wheeler 1966),

so that 'the individual turns themselves into the kind of person the situation demands' (Becker 1964, p.44). Our professional socialisation influences are primarily those of the health service and higher education, situations that do not 'demand' an involvement with art but rather value clinical, teaching and research competencies (Blum and Rosenberg 1968; Gilbert 1984). This is part of what we transmit to students as they begin to take on the role, like us, of art therapists through the professional socialisation processes of art therapy education that values introspection and self-discovery through art but may also, inadvertently, run counter to the maintenance of an art practice (Gilroy 1992).

Our realisation about our envious responses to the students as members of experiential art therapy groups led us to think that we might be enacting another countertransference response through a kind of withholding, reflected in the experiential art therapy groups through our provision of rather minimal art materials. Basic quality watercolour paint, pastels, crayons, chalks, clay and 'junk' materials were said to mirror the materials that would be found in art therapy settings in the National Health or Social Services, and Waller (1993) has discussed their role in enhancing experimentation and creativity in a way that is not associated with 'Art' and artists. However, we came to wonder if we provided these kinds of art materials for another reason that was to do with our reluctance to give the students something that we did not have ourselves. If we were unable to have the time to work with quality paints and pastels (and perhaps had not had during our training), why should the students? Experiential art therapy groups do not, and indeed perhaps should not, mirror precisely the circumstances of clinical practice. Students are, after all, a different client group from those in a clinical setting; they usually have a background in visual art and are therefore familiar with the art-making process, and the purpose of experiential groups are different from therapy groups, as Mills (1964) has described. Of course, the spontaneous art-making activity associated with art therapy, sometimes a difficult matter for students with a visual art degree, as Waller and James have described (1984), can be assisted by the use of inexpensive and freely available non-traditional art materials, and there are the ever-present tensions between art therapy and art teaching in clinical practice which can be exacerbated by the provision of materials such as oil paints. But we realised that the message we may inadvertently be giving to our particular clients – art therapy students – through the rather meagre art materials is that the content of the imagery is more important than the art-making process, and that talking is more significant than doing. Further, we wondered about the extent to which

this affects the difficulties experiential art therapy groups sometimes encounter in moving between making and speaking and, following on from that, the way in which students can place undue emphasis on theoretical discussion of their clinical work, sometimes at the expense of the making and simple looking at their clients' art work.

However, we had noticed that when students had a longer time span, i.e. beyond the usual two-hour session in a two-day experiential art therapy group, there seemed to be a significantly greater engagement with art-making and discussion seemed to be in more depth, although it should also be acknowledged that this was in the context of well-established experiential groups. Nonetheless we have come to think that the one-and-a-half or two-hour weekly session that mirrors the classical timeframe of group psychotherapy may be a model that limits art therapy practice in groups. We found ourselves thinking about introducing an 'experiential open studio' for students, based on the 'open studio group' where patients have much longer periods of time for art-making. If we were to do this, would it deter the wholesale transfer of a model of practice from experiential art therapy groups to the students' approach to art therapy groups with clients? The question is one of balancing (and modelling) the consistency of therapeutic practice with the educational task of exploring differing models of practice appropriate to differing client groups.

Our principal action, following discussion and reflection about our envious and withholding countertransference responses to the students in the art therapy experiential groups, was to initiate regular art practice days for staff. We have also timetabled more time within the core days of the programme for students to attend to their own art practice. The impact of these actions remains to be seen.

In the context of ourselves as role models it was very interesting, and rather discomforting, to discover that we worked very differently. It was also interesting that we found it hard to accept that we may just be different, rather than either right or wrong. We wondered where these differences came from and about the effect they had on the students. Though we three may share a similar model of practice and have similar theoretical orientations, given our very different life experience we were inevitably different; no two therapists can be the same. Yalom (1975) writes about students defensively appearing the same to avoid feelings of competition, and Hobbs (1992) identifies the significance of the experiential group leader's role in modelling the importance of discussing difficult areas. Perhaps it was the same for us and we had to explore our differences in order to better enable

students to explore theirs. Interestingly, around the time we were discussing our differences the students remarked that we all dressed the same! We considered that this comment might reflect fears about these differences: in dressing the same we might be enacting our fears of our differences, but the remark could also be about students' fears of our differences, projected fears of their differences, and fears of the differences between themselves and us.

We found it to be crucial that we, as the group leaders, were able to explore the differences in our practice as experiential group leaders in order to facilitate students doing the same with their clinical practice. Our reluctance to explore our differences, which is probably not unusual, we discovered was also connected to our subliminal wish to fit the transference projection from the students onto us of being 'all-knowing'. We became aware of an almost delusional state of believing that we really did practise, or should practise, in the same way. Perhaps the temptation to fit the projection of being the same, all-knowing tutors comes about because, as educators, we are put in touch with what we do *not* know by the students' unrealistic expectations of us. However, if we are not able to acknowledge the differences between us and subject our practice to scrutiny there could be a danger of transmitting a prescribed and inflexible model of practice. This could lead to some students' unquestioning, wholesale acceptance of a 'Goldsmiths' model' (whatever that might be), and graduates experiencing difficulties in separating from us and from the institution and developing their own style of art therapy practice. This may lead to residual feelings about the training continuing into the life of the profession.

The differences that emerged between us tended to be of a practical nature. For example, we discovered that we did not all sit on chairs in a similar place in the room during the art-making. We were indeed shocked to discover that one did not sit on a chair at all! She sat on a high bench because, in a crowded room, this was the only place out of the way, far from a draughty door. The other two group leaders suggested she might be enacting an authoritative stance, but she justified her position by saying that she could oversee the group and the door and was on watch, protecting the group from invasion in order that they might suspend their own watchful eye enough to involve themselves fully in their art work.

A further example was that the rooms were not arranged exactly the same at the beginning of the experiential art therapy groups. In one group the leader always ensured that tables were left put away and the chairs stacked, her idea being that the setting-up of the room was part of the group's purpose and task and that group issues were sometimes enacted through the physical

placing of the chairs and tables. Another difference was in whether or not we left the room before or after the students at the end of the group. The leader being the first to leave punctually creates a different dynamic to a leader who stays in the room, perhaps assisting with the clearing up, until the last person leaves and she can lock up. On examination we felt that these seemingly small differences might have quite an impact on what the students internalised of us and seemed to translate directly into practice, despite discussion in the experiential groups and in supervision of the appropriate use and modification of approach for various client groups, i.e. as distinct from themselves as students.

We have always felt it important that we role-model the taking of time and space for reflection about all aspects of our work, including the various groups on the programme. However, we realised that although we had regular post-group discussion and feedback about the experiential art therapy groups, we experienced tremendous guilt about even thinking of looking at students' art work outside the groups themselves, both work that had been made in our own groups as well as that made in the other two groups. It felt like an invasion of privacy. We wondered how far our fear of being 'caught' looking at the students' art work was to do with an anxiety about exacerbating students' paranoid fantasies regarding the personal material that emerges in the experiential groups when they were part of assessable coursework. If we were found to be looking at their pictures, were we attempting to read their minds, to diagnose them and assess their suitability as potential practitioners? Of course this assessment process is part of the dynamic within experiential groups between members, and between members and the leader, and also occurs in a different way in students' personal therapy, but our anxiety about it seemed to be a countertransference response about the necessary coursework assessment (which we will explore further in the section on education and therapy).

The experiential art therapy groups' processes unfold as they will, but the students' consciousness of themselves as future group leaders is a constant, even if it is one that occasionally fades into the background in the face of personal material and the pressures of postgraduate education. The overall process is one where we are educating students to become our colleagues and peers and so, alongside difference, competition and rivalry inevitably emerge: between us and the students, and between the students themselves. Of course these are always issues in a group but in this context there is the reality of students as experienced people, many of whom have a number of years' professional experience in related fields and who will soon be

competing with each other (and us) for jobs. We came to realise the importance of our role-modelling the ability to discuss these difficult issues directly in the groups, as Hobbs (1992) and Yalom (1975) have described, and of addressing the competition and splits between different areas of the programme that are common, as are the splits between the groups and between us, the conductors of the three experiential art therapy groups.

Education and therapy

The experiential art therapy groups that we conduct are part of an overall coursework assessment process on the programme that includes supervision, lectures, seminars, etc. This is because the groups have an educational purpose and are not for students' personal therapy, although, as Mills (1964) says, 'learning may be helpful' (p.15). Waller (1993) speaks to the importance of keeping the balance between therapy and education in experiential art therapy groups, and of keeping the group 'on task' through educational or whole-group comments. In our experience this is not an easy path to tread for either the group or the conductor, but our discussions affirmed that the tension created, and the open involvement of the conductor in the dynamic interchange between therapy and education, can be creative and lead to useful learning for the students. To be too didactic inhibits the dynamic process, and to be too therapeutically oriented is both inappropriate and confusing in an arena which is necessarily part of the entire, assessable, educational process. This is a difficult area of art therapy education as the (natural) tendency for group members to regress in a group can sit uncomfortably within an academic organisation that assesses students' 'performance' and learning and applauds those who do well, as Hilpert (1995) has described. Conversely, the educational arena means that it can be difficult to address transference issues. However, our discussions enabled us to see just how important it is to address transference issues in the context of an experiential art therapy group. The learning gained enables students to separate from ourselves and from the institution when the programme ends, and not carry transference material into the profession, where it may be acted out.

To elaborate further: in the experiential groups we move between the roles of art therapist and tutor, and the group members move between students and 'as if' patients. During our discussions we came to realise that the transferences onto us, both positive and negative, are extremely powerful; we are seen as experts and gurus, as useless, and as punitive authority figures who have significant power within the programme. This gives rise to strong countertransference responses in us, some of which are seductive (power has

its own allure!) and some threatening (feeling inadequate and incompetent); both are equally easy to collude with. If our knowledge and experience is challenged it is all too easy to retaliate and become overly didactic. Equally, interesting and/or sensitive material and images makes it easy for the experiential art therapy group conductor to become too therapeutically oriented and overly interpretive with individual students. For example, the conductor may be immersed in the process and content of the group and in students' personal material and art work, and neglect to make useful teaching points, especially if, as sometimes happens and as Waller has described (1993), the group's pull to be a therapy group rather than an experiential group is very strong. Collusion with this can also occur if the conductor's counter-transference leaves them uncomfortable with the underlying assessment processes in experiential groups. This can also be a form of withholding by the conductor of the necessary teaching element in experiential art therapy groups and can lead to students being pathologised, both in the group and on the programme as a whole, and a consequent neglect of the principal task of experiential art therapy groups – that of education.

As mentioned earlier, quality assurance mechanisms in higher education required us to define the criteria we used to assess student progress in the experiential workshops: what were our 'benchmarks' (i.e. identifiable markers of students' learning) and learning outcomes? We realised that although we worked as though we had benchmarks and learning outcomes (as a staff team we talked with a shared understanding as to whether a student was 'on course') we had not, at that time, articulated exactly what these benchmarks and learning outcomes were in the context of experiential learning about a therapeutic method. There were certain factors about art therapy and group process that we expected students to learn during the art therapy experiential groups, which included issues referred to earlier by Yalom (1975) and factors particular to art therapy groups that Gilroy had identified (1995). However, we felt we were still in the process of delineating precisely what these latter factors might be, and that this research was in fact part of that process. However, we also became even more aware of the impossibility of isolating the experiential groups from their context within the whole programme. We were also aware of the differing variables within assessment where, at any one time, a student's individual tutor might have concerns about his or her progress, whilst the experiential group leader might feel the student was doing fine. This might later be reversed.

We discussed how this related to students' motivation for training as art therapists, as it often stems from an unresolved personal dilemma that they

seek, initially at an unconscious level, to explore through therapy training (Edwards 1993; Gilroy 1992 and 1995). In our experience it seems that once students are on the programme there is usually an attempt to repress this as they deal with the many tasks expected of them, though inevitably it will be influential in their clinical work. We had noticed that aspects of the dilemma often appeared and were held in the students' art work, as though they attempted to keep in touch with it through their imagery. During our discussions we explored how working with interlocking groups, held within the larger group of the programme by the staff team, enables us to make connections between the students' growing capacity to work as art therapists on clinical placement, their way of relating in group settings and tutorials, and their art work and behaviour in the experiential groups. This can be seen in the following example.

EXAMPLE

The art work Teresa made in the experiential art therapy groups often depicted images of death and illness but she did not say very much about them. In tutorials she spoke about the difficulties a client she was working with on her clinical placement had with using the art materials. With exploration it emerged that this difficulty might not only belong to the client but might also reside with Teresa herself.

The clue to this first came from Teresa's written work; although she could understand the theoretical ideas she was studying she could not relate to them and they remained unintegrated and undigested in her academic work. Her tutor attempted to help her link into theory by asking her about her own experience of making art. Teresa said that she found the experiential groups alien and could not relate to the art work she made in them. She could not feel part of the group as she did not share the emotional involvement the others had in it. She felt rather repulsed by the show of feelings in the group. The tutor discussed this with the experiential art therapy group conductor, who said she felt disturbed by Teresa's images that depicted rather horrific things and were rigid and unplayful. In a tutorial Teresa said that the tutors were like her sisters. Soon after, she revealed that until the age of eight she had no conscious awareness that she had had a sister. When she was four, her seven-year-old sister had died, and Teresa still could not recall either her sister or her death. During Teresa's childhood the sister was talked about, albeit in hushed tones, as their mother had instructed the children not to talk about the event and showed no feelings about it herself.

What had happened was that aspects of this repressed personal issue had been expressed in different areas of the programme. Teresa had internalised her mother's repression of emotions and therefore felt it was inappropriate to discuss feelings in the experiential art therapy group. The sister's death had been split off from Teresa's other experiences because the mourning process had been blocked. Because of the split-off feelings and the need to keep things separate, Teresa could not make personal sense of theory and could not help her client become involved in a therapeutic process using art whilst she was blocked in her own process. However, the central dilemma, the unremembered illness and death, was meanwhile expressed and held in the art work.

Teresa herself made the links between all these different processes once her own therapy had enabled her to be more aware of her family's response to their bereavement.

It can be seen how a student's personal issue, of which she was not consciously aware, was impeding her progress on the training and became apparent through the linking up of different areas of the programme. This illustrates how the experiential art therapy groups we run operate within the context of the postgraduate Art Psychotherapy Diploma as a whole and are worked with by the community of staff and students. The experiential groups allow for the personal dilemmas that are often unconscious motivating factors for training (Gilroy 1992, 1995) to be known and explored within an educational framework, and addressed in relation to the students' progress on the programme as a whole.

It is interesting that the absence of a significant memory about a loss that influenced the student's learning and clinical practice was held in the art work. This raised further questions for us as to whether or not it is necessary to talk about the art work for it to do its work. We discussed how often there is a tremendous amount of art work made which never gets addressed. Our feeling is that the cupboards and drawers in our art therapy studios are full of extremely powerful material which the groups do not have the time and space to explore, but the example illustrates how the significance and role of the imagery is not necessarily lost. Added to this, neither we nor the students always have a conscious awareness of the meaning of the art work. This phenomenon is common in art therapy, but in experiential art therapy groups there is the added issue of some students' inhibitions about gaining insight into and understanding their art work.

Yalom's (1975) description of experiential groups as often slow, very intellectual and with little risk-taking is familiar to us. We found that we all

had the experience of these groups becoming lifeless, stagnant and frustrating for the participants, and for us. Often the groups would make images and then discuss their work only at a superficial level. Also we discussed how, in comparison to other art therapy programmes we run (short introductory and foundation art therapy courses), the students on the qualifying programme sometimes seemed less playful with the art materials, less creative somehow. This seemed to us to relate to some art therapy students' concerns and inhibitions about their personal and professional competencies in and out of the experiential art therapy groups. The 'double jeopardy' that Yalom describes is certainly something we recognise with regard to some of the interactions in experiential art therapy groups, and Gilroy (1992, 1995) has described this with reference to students' art work and ability to learn in experiential art therapy groups. We think that this creates a potential 'triple jeopardy' that is one of the most powerful phenomena in art therapy education. That is, disclosure of the general personal and professional competencies that Yalom describes (1975), plus the risk of disclosure of a particular personal and professional artistic competency that is associated with knowledge and understanding of art therapy students' own art practice. Yet despite this anxiety-provoking 'triple jeopardy' many art therapy students subsequently report that the experiential art therapy groups are one of the most useful learning experiences on the programme. This emphasises the importance of addressing the 'triple jeopardy' of competencies within the creative and dynamic tension that exists between therapy and education in this particular learning arena that so challenges both staff and students.

Conclusion

The research process we are using has many similarities to an art-making process, to therapy and to supervision, in that it involves spontaneous exploration of thoughts, feelings and ideas, followed by reflection and assimilation of those ideas, deepening discussion, followed by some action. Perhaps in this instance it has been closest to peer supervision. However, the use of tape transcripts has given it another layer that has allowed us to reflect systematically on the content of our discussions and to relate the material to the literature, and to follow this with particular actions. It is this process which has highlighted two important areas.

The first of these is the significance of the art therapy experiential groups as part of a system, and the importance of paying attention to one point in the system to help another. Hilpert (1995) and Tsegos (1995) both lean towards

a therapeutic community model of therapy training that views experiential groups as part of a larger matrix formed by the organisation, with various large and small groups that contain the entire educational process. Hilpert also describes differences between therapy and experiential groups, suggesting that exploration of fantasy in therapy, and of the realities of organisations in experiential groups, is a crucial differentiating factor. Similarly Mills (1964), Munich (1983) and Yalom (1975) speak to the importance of keeping the focus on systemic rather than interpersonal issues in experiential groups. Our discussions and reflections about our practice as leaders of experiential art therapy groups lead us to concur with this.

Giving attention to the entire matrix of the institution in which we work, as well as to the programme as a whole, as we have, does several things. First, it emphasises the fact that no group happens in isolation; this reinforces the fact that art therapy education is a network of interlocking experiences. This in turn gives increased credence to the therapeutic community model of therapy education. The centrality of the experiential art therapy groups to students' learning about themselves and their clinical practice emphasises that these groups should not be separated from the main body of the teaching programme and its attendant assessment procedures. This under-lines the importance of keeping the emphasis on the educational process and distinguishing between education and therapy in experiential art therapy groups.

The second important area is a developing awareness of the importance of ourselves, as individuals, and the way we perform or practice in relation to the students' education. Whilst both of these things are obvious, paradoxically it is their obviousness that often blinds us to their importance. We have realised the dangers of not paying heed to them. If we do not pay attention to the needs of staff in their attempts to contain and process pressures within the system, the whole model of experientially based education is in jeopardy. A modular education would be one way of dealing with the pressures of larger numbers of students, overworked staff, and a greater diversity of clinical problems for students to deal with. However, we feel that the model we have is a very successful way of teaching students about art therapy, and is something we would be loath to give up. Similarly, if we do not pay attention to what we actually do in the experiential art therapy groups, and the influence of the immediate community and larger systems upon them, then we are not in charge of our teaching through our influence as role models.

We felt that the discussion of the differences in our practice was of great importance. It caused us some anxiety, but accepting the potency of the

rivalry in some way enabled us to keep a realistic idea of our own competencies and weaknesses, as they exist outside the students' transferences. It is far too easy to separate oneself from students, or clients, and study them from afar. It felt to us that our attempts to acknowledge the effects of the realities of our behaviour in our practice as educators was part of a movement within therapy as a whole to recognise the importance of the person of the therapist and the influence of the context in which they work.

References

Balmer, R. (1993) 'Therapeutic factors in group analysis: Meeting them in the block training setting'. *Group Analysis 26*, 2, 139–145.

Becker, H.S. (1964) 'Personal change in adult life'. *Sociometry 27*, 1, 40–53.

Bion, W.R. (1961) *Experiences in Groups and Other Papers*. London: Tavistock Publications.

Blum, A.F. and Rosenberg, L. (1968) 'Some problems involved in professionalizing social interaction.' *Journal of Health and Social Behaviour 9*, 1, 72–85.

Dudley, J., Gilroy, A.J. and Skaife, S. (1998) 'Learning from experience in introductory and therapy groups.' In S. Skaife and V. Huet (eds) *Art Psychotherapy Groups: Between Pictures and Words*. London: Routledge.

Edwards, D (1993) 'Putting principles into practice (1)'. *Inscape*, Winter, 15–23.

Gilbert, D. (1984) 'The development of professional identity of psychotherapy trainees.' Unpublished PhD thesis. Northwestern University, Illinois.

Gilroy, A.J. (1989) 'On occasionally being able to paint'. *Inscape*, Spring, 2–9.

Gilroy, A.J. (1992) 'Art therapists and their art: A study of occupational choice and career development, from the origins of an interest in art to occasionally being able to paint'. Unpublished D.Phil. thesis, University of Sussex.

Gilroy, A.J. (1995) 'Changes in art therapy groups.' In A.J. Gilroy and C. Lee (eds.) (1995) *Art and Music: Therapy and Research*. London: Routledge.

Grotjahn, M., Kline, F.M. and Friedmann, C.T.H. (1983) *Handbook of Group Therapy*. New York: Van Nostrand Reinhold Co.

Hilpert, H.R. (1995) 'The place of the training group analyst and the problem of personal group analysis in block training'. *Group Analysis 28*, 3, 301–311.

Hobbs, T. (1992) 'Skills of communication and counselling'. In Hobbs, T. (ed.) *Experiential Training: Practical Guidelines*. London: Routledge.

Jones, M. (1953) *The Therapeutic Community*. New York: Basic Books.

Liebmann, M.A., Yalom, I.D., and Miles, M.B. (1973) *Encounter Groups: First Facts*. New York: Basic Books.

Mills, T.M. (1964) *Group Transformation: An Analysis of a Learning Group*. Englewood Cliffs, New Jersey: Prentice Hall.

Moore, W.E. (1968) 'Occupational socialisation'. In D. Goslin (ed.) *Handbook of Socialization Theory and Research*. Chicago: Rand McNally College Publishing Co.

Munich, R.L. (1983) 'Variations of learning in an experiential group'. *International Journal of Group Psychotherapy 43*, 3, 346–361.

Nitsun, M. (1996) *The Anti-Group: Destructive Forces in the Group and Their Creative Potential*. London: Routledge.

Reason, P. (ed.) (1988) *Human Inquiry in Action: Developments in New Paradigm Research*. London: Sage Publications.

Reason, P. (1994) *Participation in Human Inquiry*. London: Sage Publications.

Reason, P. and Rowan J. (eds.) (1981) *Human Inquiry: A Source Book of New Paradigm Research*. Chichester: John Wiley.

Reik, H. (1993) 'The creative capacity of boundaries within the block training experience'. *Group Analysis 26*, 2, 157–161.

Smith, B. (1994) 'Training student counsellors: The hidden agenda'. *Group Analysis. 27*, 2, 173–181.

Tsegos Ioannis, K. (1995) 'Further thoughts on group analytic training'. *Group Analysis 28*, 3, 313–326.

Waller, D. (1993) *Group Interactive Art Therapy.* London: Routledge.

Waller, D. and James, K. (1984) 'Training in art therapy'. In T. Dalley (ed.) (1984) *Art as Therapy.* London: Tavistock Publications.

Wheeler, S. (1966) 'The structure of formally organized socialization settings'. In O.G. Brim and S. Wheeler (1966) *Socialization after Childhood: Two Essays.* New York: John Wiley and Sons.

Yalom, I.D. (1975) *The Theory and Practice of Group Psychotherapy.* New York: Basic Books.

Zinkin, L. (1983) 'Malignant mirroring'. *Group Analysis 16*, 113–126.

The Contributors

Caroline Case is in private practice as an analytical art therapist. She is also a child psychotherapist working in the National Health Service. She is co-editor of *Working with Children in Art Therapy* (Routledge 1990) and co-author of *The Handbook of Art Therapy* (Routledge 1992), both with Tessa Dalley. She supervises and lectures widely and has contributed many articles and chapters in art therapy journals and books.

Tessa Dalley is an experienced art therapist working both in the National Health Service and in private practice. Currently she is working in St. Albans Child and Family Clinic, supervises other practising art therapists and lectures occasionally at Goldsmiths' College on the postgraduate Diploma in Art Psychotherapy and MA programmes. She has published many books on art therapy.

Jane Dudley is joint head of an art psychotherapy department and a group psychotherapist within adult psychiatry in the NHS. She teaches postgraduate diplomas at the Unit of Psychotherapeutic Studies Professional and Community Education at the University of London, Goldsmiths College. She worked for many years as a RMN in psychiatry, including as a charge nurse at the Henderson Therapeutic Community for the treatment of personality disorders. She is currently completing an MA in Womens Studies, specialising in attitudes to gender and sexuality within psychiatry.

Andrea Gilroy Ph.D. is an experienced art therapy educator and researcher. She is the Programme Co-ordinator of Art Psychotherapy in the Unit of Psycho-therapeutic Studies, Professional and Community Education, University of London, Goldsmiths' College, where she teaches on the postgraduate Diploma and MA Art Psychotherapy programmes and supervises research students. She is involved in the development of art therapy in Australia through her continuing involvment as an educator and researcher at the University of Western Sydney, Nepean. Her publications include *Pictures at an Exhibition: Selected Essays on Art and Art Therapy* (Routledge 1989) with Tessa Dalley; *Art Therapy: A Handbook* (Open University Press 1992) with Diane Waller; and *Art and Music: Therapy and Research* (Routledge 1995) with Colin Lee.

Katherine Killick is a Jungian analyst and art psychotherapist in private practice and is well known for her work with profoundly disturbed clients. As Senior Art Therapist at Hill End Hospital (1979–1994) she developed an art therapy service specialising in the treatment of borderline states and psychosis, and she is a member of the Society of Analytical Psychology. She teaches widely, has published several papers, and is co-editor, with Joy Schaverien, of *Art, Psychotherapy and Psychosis* (Routledge 1998).

Gerry McNeilly is a senior adult psychotherapist, group analyst and art psychotherapist. He currently works with the Psychotherapy Service, South Warwickshire Combined NHS Trust. He has been involved in training with Birmingham University and the Institute of Group Analysis in England, Russia and Greece. He is an art therapy educator and is developing group analytic art therapy training in Lisbon with the Portugese Art Therapy Society.

Joy Schaverien Ph.D. is in private practice as a Jungian analyst and art psychotherapist. She is a member of the Society of Analytical Psychology in London, Professor Associate at the University of Sheffield and Visiting Fellow at the University of London, Goldsmiths College. Her experience as an art therapist includes NHS psychiatry and psychotherapy and she lectures extensively in Britain and abroad on gender issues and the links between art and psychoanalysis. Among her many publications she is the author of *The Revealing Image: Analytical Art Psychotherapy in Theory and Practice* (Routledge 1991) and *Desire and the Female Therapist: Engendered Gazes in Psychotherapy and Art Therapy* (Routledge 1995), and co-editor (with Katherine Killick) of *Art, Psychotherapy and Psychosis* (Routledge 1998). She is an Associate Professional Member of the Society of Analytical Psychology.

Sally Skaife has worked in adult psychiatry for a number of years and is also qualified in analytic group psychotherapy. She currently teaches on the postgraduate Diplomas in Art Psychotherapy and Group Psychotherapy in the Unit of Psychotherapeutic Studies, Professional and Community Education, at the University of London, Goldsmiths' College. She is past Chairperson of the British Association of Art Therapists and has been a member of the Editorial Board of *Inscape*, their journal, since 1984. She is co-editor, with Val Huet, of *Art Psychotherapy Groups: Between Words and Pictures* (Routledge 1998).

Subject
Index

Author Index

Adamson, E. 66, 87, 98, 168
Arts Therapies Research
 Committee 7

Baker, C. B. 144
Balint, M. 28
Balka, M. 97
Balmer, R. 173, 176
Becker, H. S. 187, 188
Bick, E. 94, 99, 100
Binswanger and Boss 134
Bion, W. R. 84, 92, 94, 95,
 100, 101, 102, 106, 112,
 174
Blackwell, D. 115, 126, 128,
 129
Blum and Rosenberg 188
Bohart, A. C. 145
Bollas, C. 19, 49, 50, 51
Bourgoise, L. 96
Bowlby, J. 134
British Association of Art
 Therapists 7
Brown, D. and Zinkin, L. 122,
 126, 127–8

Case, C. 9, 18, 21, 27, 28, 29,
 32, 38, 39, 48, 59, 88,
 91, 152
Case, C. and Dalley, T. 57, 102
Chagall, M. 134–5
Champernowne, I. 66, 168
Cohn, H. 134
Cregeen, S. 67
Cunningham Dax, E. 66

Dalley, T. 152
Dalley, T., Rifkind, G. and
 Terry, K. 88, 118,
 119–20, 121, 132
Damarell, B. 39, 67
Deco, S. 70, 130
Diamond, N. 134, 135
Didier-Houzel 20
Donnelly, M. 70
Dudley, J., Gilroy, A. and
 Skaife, S. 182

Eddy, W. H. C. 125
Edwards, D. 194
Eigen, M. 101–2, 109
Ellis, A. 144
Engels, F. 125

Fine, H. J. 144
Foulkes, S. H. 122, 126, 127,
 146, 167
Freud, S. 29n, 39, 126, 132,
 134

Gilbert 188
Gilroy, A. 59, 66, 117, 120,
 173, 178–9, 180, 187,
 188, 193, 194, 195, 196
Gilroy, A. and Lee, C. 57
Gold, J. R. 144
Gold, M. 67, 68
Goldsmith, A. 67
Goldwater, R. and Trevees, M.
 135
Greenson, R. 61, 118
Greenspan, M. and Mann
 Kulish, N. 144–5
Grotjahn, M., Kline, F. M. and
 Friedmann, C. T. H. 173

Harris, R. 132
Hegel, G. W. F. 125
Heidegger, M. 129
Henzell, J. 66
Hill, A. 87, 98, 168
Hilpert, H. R. 173, 176–7,
 185, 192, 196–7
Hobbs, T. 173, 176, 189, 192
Hughes, R. 67

Jackson, M. 104
Jenkins, J., Hildebrand, J. and
 Lask, B. 144, 145–6, 168
Jones, M. 177
Jung, C. G. 102
Junge, M. and Asawa 57

Karban, B. 68
Keith, D. V. and Whittaker, C.
 A. 147, 149
Killick, K. 99, 101, 102, 107,
 108, 112
Killick, K. and Greenwood, H.
 99, 103, 113
Killick, K. and Schaverien, J.
 67
Klein, M. 19, 118, 126–7, 151
Kline and Freidmann 173
Kottler, J. A. and Blau, D. S.
 145, 167
Kuhns 39 init

Lanham, R. 66, 133
Learmonth, M. 61
Levens, M. 86
Levine, S. K. 129
Liebermann et al 178
Liebmann 121

Lloyd, B. and Kalamanowitz,
 D. 87
Lyddiatt, E. M. 66

Maclagan, D. 59, 66, 133
McNeilly, G. 7, 38, 57, 70,
 121–2, 135, 154, 160,
 169
McNiff, S. 133
Mahoney, J. and Waller, D. 152
Mann, D. 153, 168–9
Marx, K. 125
Meltzer, D. 90, 100, 111
Merleau-Ponty, M. 135
Mills, T. M. 173, 174, 178,
 188, 192, 197
Moore, W. E. 187
Munich, R. L. 173, 174, 175,
 178, 179, 197

Nitsun, M. 115, 126, 127,
 138, 175–6, 179

O'Shaughnessy, E. 85–6
Ogden, T. 19–20, 21, 115,
 125, 126–7, 128–9, 130,
 132, 133
Older, J. 144

Plato 125
Powell, D. H. 145

Reason, P. 173, 180, 181, 182
Reason, P. and Rowan, J. 173,
 180
Reik, H. 173, 176, 177, 185
Rice, A. K. 174
Rodin, A. 151
Rust, M. J. 152

Samuels, A. 57
Schaverien, J. 9, 27–8, 56, 58,
 59, 60, 61, 63, 64, 65, 68,
 80, 86, 118–19, 120,
 121, 123, 124, 129, 130,
 132, 140, 152, 154, 169
Schlapabosky, J. 126
Schuff, H. 104
Segal, H. 21, 151, 167–8
Simon, R. 59, 66
Skaife, S. 27, 67, 115, 124,
 139, 153
Skaife, S. and Huet, V. 115,
 116, 121, 124
Skailes, C. 66
Smith, B. 176
Strupp, H. H. 144

Theobold, D. W. 144, 150
Thompson, M. 66
Tipple, R. 67, 68

206